Jack Dykinga

A Photographer's Life

A Journey from
Pulitzer Prize-Winning
Photojournalist to
Celebrated Nature
Photographer

rockynook

A Photographer's Life
A Journey from Pulitzer Prize-Winning Photojournalist to Celebrated
Nature Photographer

Jack Dykinga
www.dykinga.com

Editor: Gerhard Rossbach
Project editor: Joan Dixon
Layout and type: Hespenheide Design
Cover design: Hespenheide Design
Project manager: Lisa Brazieal
Marketing manager: Jessica Tiernan

ISBN: 978-1-68198-072-0

1st Edition (1st Printing, February 2017)
© 2017 by Jack Dykinga
All images © Jack Dykinga unless otherwise noted

Rocky Nook, Inc.
1010 B Street, Suite 350
San Rafael, CA 94901
USA

www.rockynook.com

Distributed in the U.S. by Ingram Publisher Services
Distributed in the UK and Europe by Publishers Group UK

Library of Congress Control Number: 2016930700

This book is printed on FSC certified paper.
Printed in Korea

For Margaret, whose strength,
courage, and love brought me
back from the darkness.

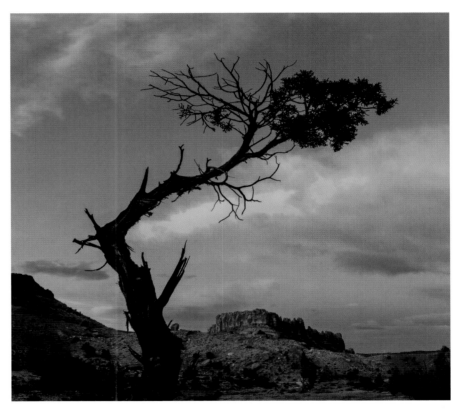

Canyons of the Escalante, October 2016: Sitting alone, 40 miles from the nearest human in a labyrinth of sandstone canyons, I stare at this struggling, solitary juniper and my feelings for my wife and our survival together pour forth.

Acknowledgments

This entire book is an acknowledgement of so many wonderful people. However, it would have remained an aspiration and not a book without the attentive care and skills of my editor, Joan Dixon.

Rocky Nook's gifted publisher Gerhard Rossbach, who I am happy to call my friend, literally made this book happen. I can't thank him enough.

Table of Contents

Introduction

I'm falling behind. My body is doing all it can and it's not enough. Tears well up in my eyes. There's no sense of pain, just the sadness of leaving the people I love. Mercifully, there's no panic, just a sense of peace.

The monitor in the emergency room clearly displays my condition. Pulse 130: blood oxygen level 82, despite having both a cannula and a facemask ramming oxygen into my compromised lungs. It's just a matter of time. My heart will give up under the strain. My mind is foggy, but I can see the future. My mouth is dry. I feel the need to make amends: to tell people I love them, to arrange things I can no longer control. I email Chuck Bowden, a writer friend, and request he write my obituary. I'm surrounded by my family. I'm tired . . . really tired. I begin to drift off.

Suddenly people are yelling at me. A head nurse named Jody is violently shaking me and loudly telling me, "Don't you leave!" LaVon, a small wiry nurse assistant, is shouting, "Stay with me!" In the confusion, my grandson appears in my mind. I can't recall if his name was mentioned or he just appeared in my stupefied state. Yet that image ignited an urge to stay . . . to see him grow up.

Thus began the rollercoaster ride of racing to stay ahead of death. Relying on the amazing science of modern medicine, the medical practitioners throw everything at my failing body to stretch out time. They're not sure I can handle a lung transplant. A battery of testing is required to establish if I'm a worthy candidate. Time is not on my side. Most people spend months waiting for a transplant . . . but I do not have months. I go straight from the Mayo Clinic's emergency room to St. Joseph's Hospital's Norton Thoracic Institute for transplant surgery.

Life is a series of portals where we enter one way and emerge totally transformed.

A New Beginning

I was born again in my 71st year. When my lungs ceased functioning and a donor's lungs were transplanted into my chest, my life began again.

I had always been extremely competitive, and at times successful, in my chosen profession. I had always been eager to earn and accept accolades that reinforced my ego, so essential to competitive professionals such as photojournalists.

While lying in an intensive care unit and recalling the generosity and selfless sharing that made my life possible, I began to reflect on the people who had made me what I am today. Throughout my life, there have been decisive turning points resulting from someone or something that changed my perceptions and nudged me in another direction.

Imagine leading a photo trip into the Grand Canyon and having your lungs fail dramatically. My life hung by a thread. Having been fiercely independent all my life, I was now totally dependent on others: health professionals, friends, and my family. Daughter Camille and her husband Marc; son Peter and his wife Maureen; and especially, my wife Margaret, were my strength. Each put his or her own needs on hold to take care of me.

While in the hospital, I began to notice and appreciate the virtual army of medical professionals who were keeping me alive on a daily basis. Of course, we think of the miraculous doctors who perform their life-giving craft. But I also noticed the physician assistants, nurse practitioners, nurses, pharmacists, x-ray techs, lab techs, physical therapists, and cleaning staff who paraded through my life each day, making sure I survived. They were strangers, yet they gave me life and hope.

Self-examination is good, so my wife Margaret the psychologist tells me. As I recovered, I reflected on my life, seeing it as a journey filled with people who subtly, and sometimes abruptly, changed my life. In short, I owe much to many. These changes along my life's journey have often been reflected in the images I produced.

I realized that my creativity is a byproduct of many people's influences merging together to change my point of view, my life, and my vision.

In this retrospective, I celebrate the people who were my guides, muses and mentors, while presenting the images embodying subtle yet distinct passages in my life.

PART 1 **Learning Discipline**

CHAPTER 1 **Early Days**

So, how does one assess one's life? You could look at success as something you worked hard to achieve. You could say you deserved good fortune. At various times in my life, I felt both entitled and deserving.

Those are the feelings of the young, formed at a time when there's no sunset ahead and boundless open roads to travel. My great ah-ha moment came when a cataclysmic event nearly took my life. I learned that, indeed, there is an open road for us all to travel. However, the road is not straight—it's full of hazards, turns and many stop signs.

My journey in photography has run parallel to my life's journey . . . at times intersecting and at times diverging. Balancing the two can be immensely difficult for a committed photographer. My parents passed on values forged in a generation surviving the great depression. "Don't put off until tomorrow what you can do today" and "Waste not want not" were drummed into my head.

Imagine a chubby kid in high school, who was overly energetic, a poor reader, left-handed, dyslexic, and the youngest of four boys in a middle-class family. My brothers were 18, 14, and 10 years older than me, so I was virtually an only child. I enjoyed the protection my older brothers provided, but not the punishment they sometimes handed out. My parents taught me to be independent; probably because they were worn out by my three older brothers by the time I arrived. That independence freed me for a life of exploration in the surrounding prairies. I collected garden spiders, watched garter snakes, and built forts with railroad ties "borrowed" from the nearby Burlington Railroad tracks.

I made rockets and bombs, watched stars with a telescope, and collected fossils from nearby quarries. My parents tolerated, encouraged, and even joined me in my fossil hunting. They encouraged my boundless curiosity. After seeing *Collier's Magazine's* in-depth illustrated articles about the coming space age, I fantasized about space travel. I spent time daydreaming and looking out the windows at the forest preserve land adjacent to my high school. I wanted to be "out there."

My brothers Dick and Don had been in the Army and Navy and had served in World War Two and the Korean War, and both brought images made in foreign lands to our living room, while my brother Ernie tutored me on the use of a 35mm camera. Their slide shows taught me that images could inspire and inform. It also looked like fun.

I was one of those kids who sat in the high school library ogling *National Geographic Magazine*. While my classmates focused on the African women's breasts, I was riveted by the photographs of exotic places, and I felt a visceral longing to see and photograph them too. I never would have dreamed that 50 years later I would be doing assignments

for the *Geographic*. However, as an adolescent, I was assimilating a sense of design and the potential for sharing visual information.

Every kid has a moment when things snap into focus. For me, it was during my senior year of high school when I won the National Newspaper Snapshot Award, which was sponsored by *Look Magazine*, *National Geographic*, and the *Chicago Daily News*. That photograph of a high school football game was anything but memorable. At the time, however, that singular affirmation launched my lifelong partnership with a camera.

High school was a painful time for me, marked with poor grades resulting from dyslexia: a reading handicap that wasn't widely recognized in the 1960s. Every time I took a test I didn't complete, it meant the unanswered questions were counted as wrong answers. In hindsight, I now see how that disadvantage in reading skills heightened my visual acumen. But at the time, I felt I would never be a successful student.

After spending many hours in the school counselor's office unsuccessfully attempting to find out why I wasn't working up to my potential, I somehow graduated in the lower quarter of my high school class. That limited my prospects for college. My fascination with photography continued, albeit at a very slow pace.

St. Procopius College, a small Benedictine all-male school, decided to admit me due to my two years of working after high school. Based largely on a personal interview, I was admitted, even though I wasn't Catholic. A large priest named Father Roman took a chance on me. I had grown up ice skating, so the icing on the cake was the fact that St. Procopius had a very active hockey team (which at the time was listed as a "club").

As a twenty-year-old freshman, my life had changed. The attentive approach to teaching at St. Procopius was exactly what I needed. I fashioned a life of full-time college student by day while trying to get a job working in the lab of a Chicago newspaper at night.

My political science teacher was a retired Army Colonel who each day regaled me with his "boots on the ground" experiences. My rhetoric professor, a former Random House editor, immediately recognized my deficiencies in reading and spent many hours after class tutoring me to raise my skill level. In each case, these teachers' infectious excitement and their approach of teaching from their own personal-life experiences washed over me and changed me. I finally found excitement in learning. I was dumb-founded when I made the Dean's List.

CHAPTER 2 Mike Rotunno—Press Photographer

Working at a high school newspaper involved taking pictures, but I really did not know or think much about journalism. I didn't grasp the fact that images could really communicate. But I did learn the intimacies of film processing, making prints, and learning the fine points of various camera systems. I worked nights at a railroad freight house where my cultural horizons expanded as one of four white kids from suburbia in a sea of black co-workers. I poured the savings I'd earned from unloading heavy rolls of carpet from freight cars into purchasing my first Nikon camera and the rolls of film to load into it.

After graduating from high school, and with college not in my original plan, I managed a couple of odd jobs, including slinging hamburgers. I continued my photography and poured every cent I earned into cameras and lenses. Colonial Camera was the best camera store near my home. Perhaps because I was becoming their best customer, the storeowners gave my name to airport photographer Mike Rotunno who needed an assistant.

Mike offered me a unique opportunity. My job, as Mike explained it, would be to document important people arriving in Chicago as they deplaned. He emphasized that I needed to pay special attention to the deliberate placement of the airlines' logos in the background of each photograph. We would then process the photographs, make prints, and send them by courier to the local newspapers in Chicago. Occasionally, I hand delivered the prints while getting a chance to meet staff photographers in the process.

Rotunno, the legendary "airport photographer," had shrewdly devised contracts with the public relations departments at the major airlines, to publicize their companies by recording the "glamour" of flying by photographing the "glamorous." As just a young kid, I photographed Jimmy Durante, Richard Nixon, Barry Goldwater, and even the Beetles.

It was on one such assignment that I found myself photographing Andy Williams. On my way to meet his flight I heard the terrible news of President John Kennedy's assassination, and it was my unfortunate task to inform Andy Williams as he exited the airplane. We all remember where we were when that tragedy occurred. Decades later, the memory of 911 would be similarly burned into our collective consciousness.

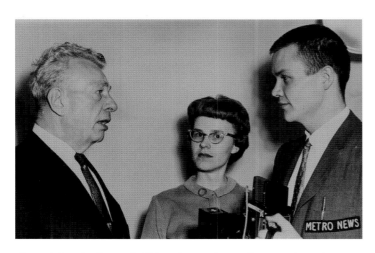

Circa 1963—At Chicago's O'Hare Airport. I was photographing Senator Everett Dirksen, while working for Mike Rotunno (unknown woman in center).

Mike's tutoring emphasized the "press photographer" ethos of assertive personal contact. Gradually, my work was accepted and printed in Chicago's four major newspapers. In some cases, feature photographs (not simply photos of celebrities) appeared with my byline. I became familiar with Speed Graphic and Aerial Linhof 4×5 large-format cameras, Mamiya medium format cameras, and my trusty Nikons. Because of the trust Mike accorded me, my work matured substantially.

It was Rotunno's foot holding the door open that allowed me to enter the real world of journalism. Because I was associated with Mike, my work got more than a passing glance from newspaper photo editors.

CHAPTER 3 **The Chicago Tribune**

In 1964, armed with an expanded portfolio and the new realization that I really should pursue a college degree, I left Mike Rotunno and airport photography. I applied for a job working nights in the *Chicago Tribune* photo lab. I reasoned that I could attend college during the day and do the mindless lab-work at night while having time to study during "down time."

Chief Photographer Al Madsen had other plans. At 20 years of age, I became the youngest staff photographer at the *Chicago Tribune*. It was sink or swim.

My nights were spent chasing crime, civil rights demonstrations, and even parades of returning astronauts. The *Tribune's* ironclad policy required their photographers to use either medium 2¼ format or 4×5 press cameras. I had been following the work of various magazine photographers, and I knew the 35mm format was unobtrusive, versatile, and portable. With their fast lenses and high ISO, I could photograph in available light, which was essential in order to record the news without the extraneous distraction of a flash. I remember getting into heated arguments over using 35mm equipment, even after capturing a front-page image in which I had violated the rules and used my Nikons.

During one assignment, I broke with tradition and used my Nikon to photograph astronauts on parade. Despite my images being published on the front page, I was castigated for not following orders. The criticism stung and my thoughts drifted across Michigan Avenue to the *Chicago Sun-Times*, a liberal newspaper conceived as an upstart challenge to the dominant *Tribune*. At the *Sun-Times*, Chief Photographer Ralph Frost endorsed my camera choice and hired me on the spot.

My ability to make such radical changes in the direction of my career simply wouldn't have been possible without support at home. My wife Margaret remains the stabilizing constant who has always allowed me to follow my dreams. We married in 1965 and ever since, she's been the single biggest influence on my life. Margaret taught me about loving and caring. She nurtured the growth of the non-photographer side of my life. Her honesty and grounded approach to life made me not only a better person, but a more sensitive and empathetic image-maker as well. When my ego teeters on the brink of exploding, she has always supplied the calming antidote.

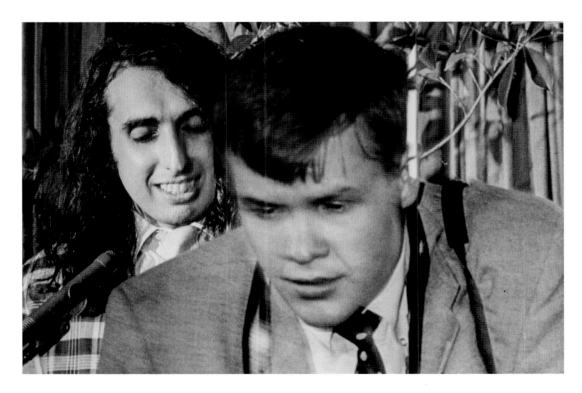

Chicago 1964—While working at *The Chicago Tribune* I covered a Tiny Tim press conference.

PART 2 **Successes and Failures**

CHAPTER 4 **Frosty**

Ralph "Frosty" Frost was a crusty, energetic Scotsman who directed the photography staff of the *Chicago Sun-Times*. Under his leadership the nimble, talented staff at the *Sun-Times* gained more than their share of photographic recognition. In 1965, when I moved from the *Tribune* to the *Sun-Times*, Frosty became my first real mentor. He entrusted me with difficult assignments, and his trust pushed me to achieve more than I thought possible in spite of several missteps. Most important, five years later, he assigned me to document the deplorable conditions at the Lincoln and Dixon State Schools for the mentally handicapped. It was that coverage that forever changed my career and my life. I become a Pulitzer Prize Winner at the age of 28.

Thus began a nine-year lesson in photojournalism. Our sister paper, the *Chicago Daily News*, had a proud tradition of great photography that intensified during the tenure of Chuck Scott, its then Director of Photography. He brought in a parade of gifted image makers who bolstered an already-talented staff. They became my competition, my teachers, and my career models. But the staff of the *Chicago Sun-Times* was also brimming with talent and we were eager to jump in the ring in this competitive four-newspaper town. Each day was, in a very real sense, a photo contest with the results being published.

The competition and collaboration among the news photographers was particularly intense because both the *Chicago Daily News* and the *Chicago Sun-Times's* photo staffs shared darkroom space. Together, we would prepare to enter photographic contests. Critiques were often intense, aggressive, and pointed. Yet, when the underlying quality was realized, criticism would morph into suggestions to improve the entry. We became a united band of rivals. My work during this period changed profoundly. I had begun telling visual stories. My images reflected more intense "seeing," along with a sense of purpose that conveyed a narrative with a beginning, a middle, and an end. The process hammered the basics of photojournalism into our collective psyche. Honesty was our goal. Anyone contriving a photograph was called out or berated. Learning the discipline of meeting daily deadlines while creating evocative images on demand, and yet being scrupulously honest, represented a major turning point in my career.

I learned the power of images as well as a photojournalist's obligation not to abuse that power. With each assignment successfully completed, the bond of trust between Ralph Frost and me grew. In 1970, he called me to his desk and briefed me on an assignment he wanted me to undertake.

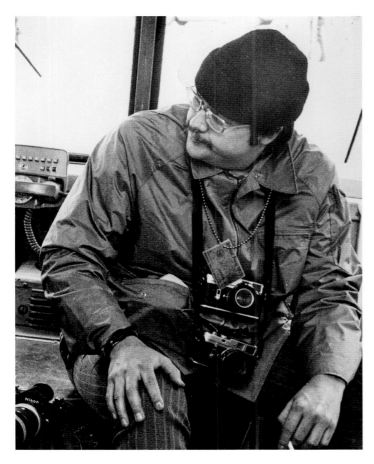

Chicago 1971—I was covering a civil rights demonstration for the *Chicago Sun-Times,* just prior to winning the Pulitzer Prize for Feature Photography.

the wards. I was shaken to the core as I simply watched, trying to gain a sense of context in an alien world. Finally, my instincts and muscle memory took over and I began to record the scenes. My memories of the experience have remained vivid for these many years. I can still recall the smells. That powerful lesson of walking through a new experience to gain a contextual overview has remained with me.

In the days and more locations that followed, I produced a series of searing images that, together with the reporting of Jerome Watson and Sam Washington, would bend the will of politicians to increase, rather than cut, funding.

On the first Monday in May, 1971, I was driving to an assignment when my two-way radio crackled with the urgent request for me to get back to the office. Not knowing why I had been ordered back, I was indignant about leaving my assignment. However, upon my return, when the entire newsroom stood and applauded, my eyes welled with tears as I was pronounced the winner of the 1971 Pulitzer Prize for Feature Photography.

When all the hoopla ended, I savored the moment with my wife, Margaret, as we had a quiet dinner, not far from where we first dated while she attended nursing school. I was too young to truly appreciate how many people would yet shape my life. At every critical turn muses appeared to magically guide the way.

As part of a team with two staff reporters, I set off to document conditions in the Lincoln and Dixon State Schools, which were state institutions housing—or more accurately described as "warehousing"—the mentally handicapped. Parent groups were up-in-arms over Illinois's then-Governor Richard B. Ogilvy's proposed funding cuts for mental health, and they had contacted the *Sun-Times* to plead for coverage of the schools' rumored deplorable conditions.

Though I was toughened by years of covering the streets of Chicago, when I entered the first institution, nothing could have prepared me for the onslaught to my senses. It was overwhelming. Screaming. Acrid odors of excrement. Dimly lit rooms. Naked people staring vacantly. And all with little or no supervision. This is what greeted me as I entered

Failure

My journalism career was anything but a smooth ride to glory. There were more than a few times before winning the Pulitzer when my fledgling career teetered on the brink of utter failure. In 1966, Art Petacque, a street savvy reporter with his ear to the inner workings of Chicago's machine politics, had located a missing character who was being sought for charges of theft from the state payroll. No one had been able locate Frank "Porky" Porcaro, but Art thought he found his man "on the lam" somewhere in southern Illinois. Art wanted to scoop the other newspapers with an exclusive interview before Porcaro was caught.

We hopped a small commuter plane, rented a car, and zeroed in on Porky near Peoria, Illinois. I photographed dimly lit streets, neon neighborhood signs, and Art the intrepid reporter working the streets. All the shots were made with my Leica in low light on black-and-white film, pushed to a very high ISO. Finally, after several failed attempts, Art located our missing suspect. All I had to do was to grab a couple of flash images and we could head home. No problem. I shot several images of our squeamish subject and it was a wrap. We made a quick flight back to Chicago and headed into the lab to process the film. Done.

We were pretty full of ourselves, having scooped the other papers with a major break in an ongoing story. The lab processing involved opening film cassettes in the darkroom (something I could literally do blindfolded), winding the 36 exposure rolls of Tri-X onto stainless steel reels, dropping it into the circular tank, and closing the lid. At that point, I could turn on the lights and add the developer, the rinse, and the fixer. I gently agitated the cylinder like a cocktail shaker until fifteen minutes had elapsed.

After allowing a minimum amount of time in the fixer, I unreeled the processed film, scanning the frames for a quick confirmation that all was as expected. But all was *not* as expected. Every image made in low-light situations was perfect. The street scenes were dramatic. However, all the images of Porky were merely a thin slice of exposure about a millimeter wide, with the remaining portion of every frame unexposed!

Apparently, I had attached the flash synch cord to the wrong plug on the Leica. Leica ranger finder cameras employed two separate synch plugs: one for strobes and one for flash bulbs. I had used the wrong one. My response was quick and predictable for an over-caffeinated twenty-something. I threw the film across the darkroom and let loose a string of profanities that alerted the photo department that all was not well.

Once the heat of my blood and the pulse in my forehead normalized, I resolved that my career was over. My mind raced ahead to me cleaning out my cabinet and heading out of the *Sun-Times* for the last time. I recovered the film evidence of my failure and headed to the newsroom to face Photo Editor Maury Falstein. I had never felt so wretched.

Maury, who'd been a photo editor for a very long time, listened to my confession and responded by saying, "Oh." Maury had seen it all, so to him, my cataclysmic career-ending screw-up was only worthy of an "Oh." But while Maury gave me a pass, I did not. Throughout my time as a photojournalist, I learned to be a very harsh critic of my own work. The wisdom gained from successes, as well as from failures, became the reference points for personal growth.

Lessons

I've come to realize, it takes a village to raise a photojournalist. That is to say, my fellow staff members, the competing staff members from our sister newspaper, the *Chicago Daily News*, and the virtual parade of talented writers, collectively made me what I am today. Together they taught me more than any school of journalism could have. My abilities as a photographer were tested like no other time in my life. Each test was a gift of learning sometimes-painful lessons. I hate lists because you run the risk of overlooking someone, but I'm compelled to shout out to all those people who shared their joy, skill, and intuition so necessary in the business of journalism:

Gene Pesek, Jack Lanahan, Howard Simmons, Larry Nocerino, Ralph Arvidsen, Eddie Dean, Maury Falstein, Jim Klepitch, Bob Kotalik, Pete Peters, Bob Black, Larry Graff, Bob Langer, and Duane Hall.

Together we experienced some profound changes in race relations, politics, and civil discourse. We were living history in the making.

After the assassination of Martin Luther King, Jr., Chicago erupted with race rioting. Entire blocks were set aflame and teeming housing projects became "no go" areas for whites. Even firemen responding to emergency calls needed back up from police and they retreated, lucky to be alive. Street-savvy skills trumped photographic prowess as we covered the streets that had become battlegrounds.

We spray-painted our newly issued white riot helmets with matt black paint. No one wanted to be a target.

One hot afternoon when tempers on the street flared, I was assigned to the Cabrini-Green Homes, a massive Chicago housing project. The police tactical units had set up a perimeter cordoning off the area in an effort to contain the violence. Here I was, a white kid from the suburbs, plunked down in a war zone. The only option for coverage was to enter the projects whenever a phalanx of riot police moved in to occupy an area. I felt relatively safe and out of range from incoming rocks and bricks. Yet my heart pounded as I tried to steady a 300mm lens trained on onrushing youths as they heaved missiles at the police and . . . by default, at me. Being shot at was a different matter. I barely heard a firecracker-like sound when a window on a nearby car shattered. No movie-like BANG . . . just a ping against the car's metal and glass. Instinctively, I dove under the nearest car. Never mind the Leica dangling from my neck. A few heart-pounding moments later, reason took over. I realized that I had become separated from my protective gaggle of cops and the rioters were on the move.

Fear makes for strange bedfellows. I was running toward secure police lines with Ed Rooney, an older reporter from the *Chicago Daily News*. I was younger and faster. Ed clumsily dropped his riot helmet during our sprint to safety, and he ran back to retrieve it while the main force of teenage rock throwers was charging directly at us from a perpendicular alley. In one of those really stupid moments, I ran back toward the mob, grabbed Ed, and dragged him away as the rain of smaller rocks fell around us. Fortunately, we weren't yet in brick range.

My blood was hot with fear as I jumped into my Volkswagen. The mob had broken free of the police perimeter and was raging its way straight toward me. Crashing glass from storefronts and a line of wrecked cars led straight to me. My hands shook as I tried to find my keys. After an eternity, the old VW came to life, but my "sewing machine" legs shook so violently that the car lurched

in ten-foot strides as projectiles landed around me. I had survived.

I grew up in a very white suburb. My earliest memories of racism were confined to travel by rail into the south where "colored" drinking fountains first caught my attention. Everything there was segregated. So was I, but I didn't know it. Throughout the 60s and 70s, I learned about race, seeing and feeling the pent up rage. During one period of racial civil unrest, a group of black homeowners banded together to protest being gouged with usury interest rates that forced many into foreclosure. They formed the Contract Buyer's League and ceased making their mortgage payments.

Entire neighborhoods victimized by predatory mortgage practices were forcibly evicted by the Cook County Sheriff's officers. My political leanings shifted. Photographers covering the racial conflicts endured the wrath of the hostile whites because we marched with civil rights protestors and with our news coverage, we gave them a voice. Yet our skin color prevented us from feeling the full force of racism. Even older staff photographers, after being accosted by police or having their film seized, or having rocks thrown at them, became liberals. The police couldn't be counted on for protection and their hostility was overt. There's nothing like being clubbed by the cops (as I was during a march in Cicero, Illinois) to know what side you're on.

One of the funny by-products of those times was my reaction to the shadows of flying birds with a knee-jerk duck for cover. To survive during street riots, one needed to pay careful attention to moving shadows that preceded a rock barrage.

A journalist needs empathy to maintain objectivity and yet must understand both sides of an issue. A photojournalist makes snap decisions; based on the ability to quickly assess situations and record one's perceived truth. It is not always easy. However, each time I covered the inequity in race relations, my political leanings shifted further to the left. I was forever changed.

Expiration date: Dec. 31, 1979

JACK DYKINGA

Is an accredited
staff member of:

The Arizona Daily Star
Tucson, Ariz.

Frank E. Johnson

Managing Editor

No. 1926

PRESS

JACK DYKINGA
CHICAGO TRIBUNE

*The State Visit to the United States
of their Majesties the
Emperor and Empress of Japan*

TRIBUNE
TOWER

435
CH

IDEN'

DYKINGA
NAME

CHICAGO TRIBUNE
COMPANY

EDITORIAL
DEPT.

SOC. SEC. NO.

McGovern/Shriver '72

JACK DYKINGA

CHICAGO SUN-TIMES 9/17–18/72

bk

PRESS

PRESIDENT RICHARD NIXON
CHICAGO, ILLINOIS
SEPTEMBER 16-17, 1970

Jack Dykinga
SIGNATURE

Chicago Sun-Times
AFFILIATION

33 **P R E S S**

Expires December 31, 1980

Jack William DYKINGA
Name
The Arizona Daily Star
Affiliation
Tucson, Arizona
Location

PRESS
PRESIDENT NIXON'S
VISIT TO CHICAGO

FRIDAY, NOV. 3, 1972

Name *Jack Dykinga*
Affiliation *Chicago Sun-Times*
No. *13-23*

PRESS

#67- JACK DYKINGA
FRENCH
PRESIDENTIAL VISIT
Valid for airport & Palmer House
FEBRUARY 28, 1970

PRESS

AGNEW ARRIVAL

JACK DYKINGA
CHICAGO SUN-TIMES

Illinois Agricultural Association

32

PRESSE ÉCRITE N° 044

PRESSE

14 JUILLET 1968

Enceinte Georges CLÉMENCEAU

(Face à la Tribune Marigny)

M. *Irving Kupcinet*

Cette carte portée OBLIGATOIREMENT au
revers du veston n'est valable qu'avec …

SOCIAL SECURITY NO.

HEIGHT	WEIGHT
6'2"	190
EYE COLOR	HAIR COLOR
Brown	Brown

This official identification card
property of the Chicago Police
ment and may be revoked for ju
The holder is entitled to pa
and Fire Lines, whenever formed
ons of Police in charge of lines

—Any person using or attempting to use the press card
herein, not entitled to the same, or any person counterfeiting,
or simulating such card, shall upon conviction be fined not t
$200 … from Chicago Municipal Code, Sec. 193-7.

**ASTRONAUTS
VISIT**

MARCH 5, 1971

GOOD AT ALL LOCATIONS

Dykinga

PRESS-RADIO-TV

**MOON MEN
VISIT CHICAGO**

AUGUST 13, 1969

**GRANT PARK
BAND SHELL**

PHOTOGRAPHER

36th QUADRENNIAL
DEMOCRATIC NATIONAL CONVENTION

Miami Beach, July 10-13, 1972

Lawrence F. O'Brien
Robert S. Strauss
Co-Chairmen
Arrangements Committee

Richard Murphy
Convention Manager

PHOTO

GATE
8 or 9
SECTION

SEAT
N° 259

Democratic National Convention
Miami Beach, July, 1972
SECOND SESSION
Do Not Detach

Democratic National Convention
Miami Beach, July, 1972
FIRST SESSION
Do Not Detach

THE BEARER

Dykinga, Jack
Is employed in the Editorial Dept. of

CHICAGO SUN-TIMES

as

Photographer

and the issuance of a Press Pass is
approved by me

James D. Peneff
Signature of Employer

The above named person is entitled
to pass Police and Fire lines whenever
formed, subject to conditions on back
of this pass.

Richard J. Elrod
Sheriff of Cook County

Jack W. Dykinga
SIGNATURE OF BEARER

SOCIAL SECURITY NUMBER

Height 6'2" Eyes Bn.
Hair Bn. Weight 215

Official Press 1972

Jack Dykinga

is a duly accredited representative of

Chicago Sun-Times

as Photographer

Jack W. Dykinga
Signature of bearer

James B. Conlisk Jr.
Superintendent of Police

N° 462
Expires February 15, 1973

CHICAGO POLICE DEPARTMENT

CHAPTER 5 Chuck Scott—Impact and Truth

In 1966, the *Chicago Daily News* hired a new Director of Photography named Chuck Scott. Those of us working at its sister paper, the *Chicago Sun-Times*, watched as this photo guru transformed its photography department. Almost immediately, Chuck hired several photographers; all out-of-towners who changed the paradigm of photojournalism in Chicago.

Many of us believed we were pretty good photographers but we suddenly found ourselves competing against a whole different breed of photojournalists. And they were incredibly talented! We knew we had to ratchet up our skills several notches. Chuck brought the highest standards of photojournalism to Chicago—standards that were honed at newspapers such as the *Milwaukee Journal* and the *Topeka Capitol Journal*. Gary Settle, Perry Riddle, Don Bierman, Paul Sequeira, Fred Stein and John White swelled the ranks of the *Daily News* staff.

One vivid reminder of Gary Settle's talent involved a time when both he and I were assigned by our respective newspapers to cover the same story about an entire family who had perished in a horrendous car crash. What could one photograph? I walked around the family's suburban home and photographed the empty playground swings in the yard. I left thinking I had captured an image that gave a sense of the grim emptiness of the home. The following morning the *Sun-Times* hit the street with my image and the story.

Later that same day, the *Chicago Daily News* came out with their story and a full page of Gary Settle's poignant images. He had gone to the same house and looked inside. Finding a bank of windows at the rear of the house, he pressed his camera against the glass. His photographs formed a poignant picture story of an empty home waiting for its occupants to return. The diner table was set, toys were stowed in cherished places, and the power of a loving home stood as a stark epitaph to the tragedy. Gary went on to win two National Press Photographer Association Photographer of the Year awards.

I felt admiration for Gary's work, and yet I determined that compromise and less than an all-out effort was no longer possible for me. No matter what anyone says, the one thing I find in successful photojournalists is that they are always searching and never compromising. Gary and I remain good friends to this day. He revels in retelling the events of that day.

Ultimately, Chuck Scott left the *Chicago Daily News* to start the Visual Communications department at Ohio University, and in 1968 Gary Settle went on to be the Midwest photographer for the *New York Times*.

Chuck Scott Part Two

Soon after I won the Pulitzer in 1971, Ralph Frost quietly retired. My newfound fame led me to be disappointed when Bob Kotalik was chosen to replace Frosty as Chief Photographer. My bruised ego wasn't too happy returning to the boring day-to-day assignments. I began to feel I deserved more meaningful assignments. Of course, a newspaper's daily fare is mostly comprised of innocuous daily happenings. Nonetheless, my ego needed to be stroked and I felt restless.

Concurrently, the *Chicago Tribune* wanted to place a stronger emphasis on photography, and to initiate this change they lured Chuck Scott back from his Visual Communication program at Ohio University. Soon, Chuck's imagination and influence became visible as greater emphasis and space was accorded to dramatic images on all the section front pages.

I remember calling Chuck from our home's basement phone and setting up a clandestine meeting to discuss a possible job. To my surprise, Chuck welcomed my call and I was soon hired onto the *Tribune*. The relationship between Chuck and me began as one of competition, but he was about to become a mentor to me. In both capacities, he had a profound influence on my life.

I had mixed feelings about leaving the *Sun-Times*, a place that was filled with friends, memories, and a liberal spirit. The *Tribune* was the bastion of conservatism, while the *Sun-Times'* progressive bent was widely known. But I was headed toward another change.

Chuck began by assigning me to photograph several stories for both the Sunday Magazine section and the feature sections of the *Tribune*. I worked on interesting, in-depth pieces on women in the military, the last soldier to die in Vietnam, a simple themed piece on "love", and a story about a middle-aged Chicagoan who wanted to climb Mt. Rainier.

A Mountain's Lesson in Tenacity

Harry Schlag owned Easy Camping in suburban Chicago. He and my friend Bill Bendt signed up to attend the Rainier Mountaineering School. Their training would culminate with a climb to the summit of the shimmering white, glaciated peak of Mount Rainier in Washington State. My pitch to the *Tribune's* Sunday Magazine to do a story on Harry Schlag—a middle-aged man attaining his life's dream—was accepted, and I was soon to be blindsided by a life-changing experience.

Jansport, the backpack manufacturer, sponsored an event every year in which retailers selling their packs could go through mountaineering training. The training included roped climbing, crevasse rescue, and cold-weather skills on the glaciated classroom of Mount Rainier.

In preparation to join the trek up Mount Rainier, we "flat-landers—pack salesman, Bill Bendt, Harry and I—thought we'd simply buy some heavy boots, break them in, and run around the block a few times to ready ourselves for the climb. Like many of life's pivotal events, I didn't see this one coming. Our plane from Chicago began to descend through the cloud layer obscuring Seattle. My headset was blaring Beethoven's *Fifth Symphony* when the clouds parted to reveal the gleaming white volcano. My heart pounded in time with the orchestra.

Schooling began with endless packing and unpacking as we refined the loads we would carry up the mountain. New terms—crampons, prussic, self-arrest, bollards, snow stakes, and ice screws—were learned. I felt like pinching myself. Clearly, I wasn't in suburban Chicago anymore.

The euphoria I felt was short-lived as we began our fight against gravity en route to the 14,000-foot summit. Everything ached as we crept upward toward Camp Muir at 10,000 feet. One team member kept up a light-hearted banter that caused periodic eruptions of oxygen-robbing laughter. He'd scream out, "But, this . . . is my vacation!"

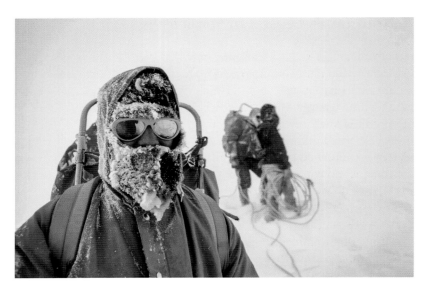

1975—Bill Bendt on Mt. Rainier

For four days, we worked, learned, and played on the glaciers next to the nearby Little Tohoma Peak until our summit day was upon us. My story of recording a man's realization of his life's dream came to an abrupt end when Harry decided he wasn't up to the climb.

At 2:00 a.m. we assembled, without Harry, fumbling in the darkness to start a very long day. The profound contrast between the best and worst life experiences was evident. Each step required five breaths and gave our flat-lander lungs a fighting chance at summiting. But it was hard. Very hard. Yet, as we punched through the cloud layer bathed in the crimson dawn light, I never felt so lucky to be alive. In an area of blue ice and gaping crevasses, kicking steps, we inched forward. I didn't yet have the experience to note the looks on our guides' faces, but I did feel the constant tugging from our rope team guide to pick-up the pace.

A woman from another rope team decided she'd never make it and the guides gave her a sleeping bag and cached her on a rocky outcrop, to be rejoined during our descent. This was beyond hard as the incline increased. The visibility suddenly vanished. We trudged upward in a whiteout, barely able to see our comrades just a rope's length away.

Finally, atop a rocky spine we stopped. We could have been anywhere . . . or nowhere, but the guides celebrated our summiting. What did I feel? Not much. Maybe it was exhaustion, maybe confusion, but definitely the cold. The jet stream had dropped ramming cold temperatures, high winds, and even less visibility onto Rainier's summit. We needed to move . . . and quickly.

The biting cold cut into our ability to think, let alone walk. Staggering and stumbling, we blindly entered the crevasse field, and though we'd passed through it earlier that

same day, it was completely unfamiliar. The guides stopped, reconnoitered, stopped again, and finally changed direction. We couldn't simply head straight down. We had to find the woman we left on the glacier en route to the summit. At one point, with winds howling and my friend's ice-covered face staring back at me, we were sure we'd be digging snow caves to just survive. Yet, as my resolve was waning, a shout cajoled us back on the route. Winds lashed us, as if celebrating our departure. Somehow we made it to Camp Muir where we looked forward to the hot chocolate and a long rest.

However, the rest we longed for was not to be. The storm had gained intensity and there was no mistaking the guides' worried expressions. They marched us—roped together lest anyone stray—down the remaining 5,000 feet to safety, to the area known as Paradise.

I thought about that trip for many subsequent years. In the fight to just keep going, I had never felt so alive, so depressed, and so exhausted. I learned that mental toughness is what matters the most. I also gained a sense of beauty in the extreme, where the land and the sky collide. I was forever changed.

My return to the *Tribune* felt like landing on another planet. I had survived death on the mountain. I couldn't explain what I had experienced . . . and no one else really cared. But I did.

Chuck gradually trusted me with greater responsibly, and I learned to layout pages and functioned as the assignment editor. Each morning my task would be to read all the overnight news reports and deploy staff photographers to cover the daily rush of news events.

In my two years at the *Tribune*, I really never felt at home as I did during my time at the *Sun-Times*. Chuck apparently felt much the same, as various department heads opposed his efforts to create greater visual impact. Each of his suggestions was met with, "We do it this way." The steady regression to the past was apparent everywhere. Finally, Chuck was asked to leave. We were both confused and disoriented.

Chuck returned to Ohio University to direct their Visual Communications program, and I remained. The *Tribune* management invited me, outfitted in an anorak and Levis, to the University Club. People I only knew in passing were now inviting me to replace Chuck as Director of Photography. Though Bill Jones, the editor, was a good friend, the rest were strangers. I muttered a little too loudly something like I would feel like I was embracing Judas if I took the job. Clearly it wasn't what they expected to hear. I offered to quit the following day, but Jones, who sensed my trip to the mountain had changed me, suggested I take a leave of absence instead. I stayed long enough for a transition to Scott's replacement, Dick Leslie, before taking leave.

We moved to Tucson for a year's leave of absence. In the end, I called Bill Jones to tell him thanks, but I wasn't coming back. He was genuinely saddened. Shortly thereafter, he died of a heart attack. I returned to Mount Rainier with my great friends Bill and Terry Bendt to reconnect with the hall of the mountain king. I was on a very different path, for sure.

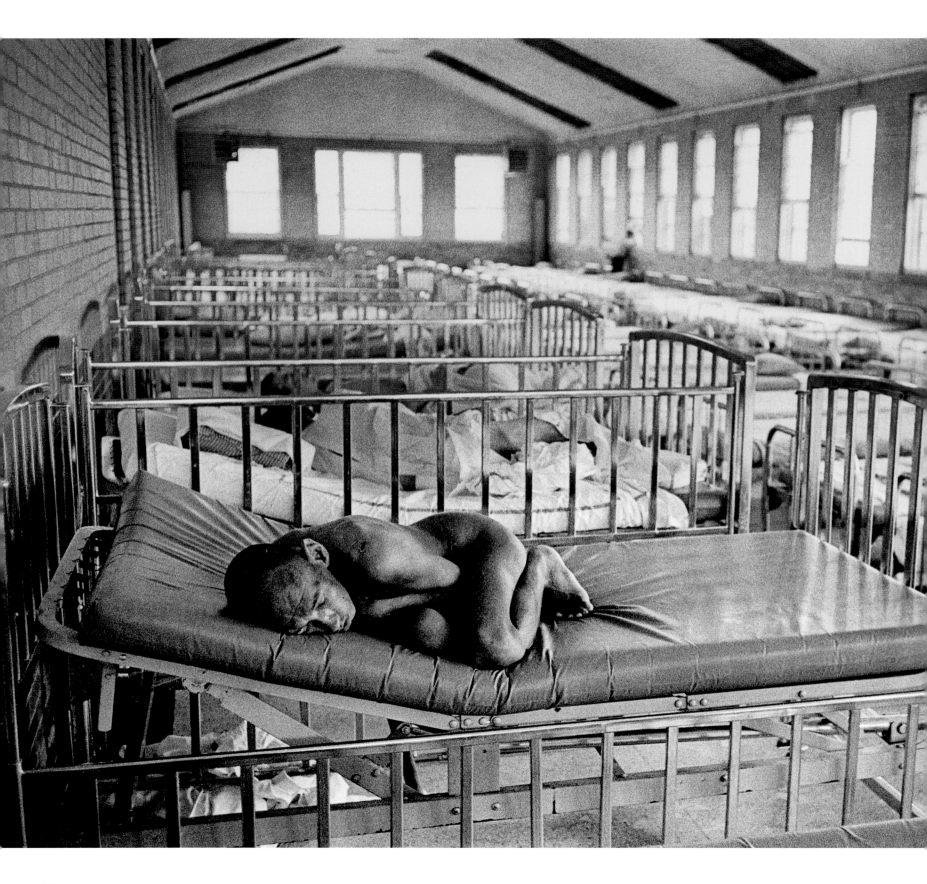

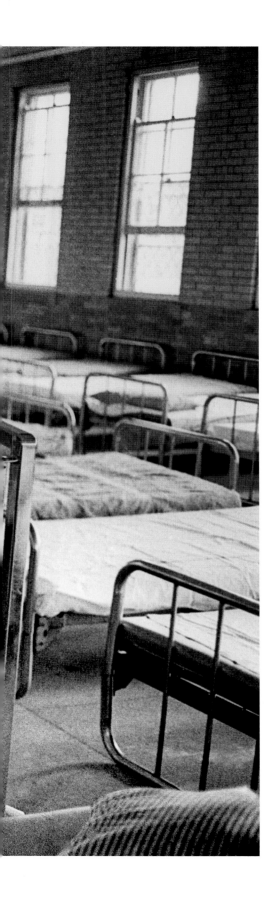
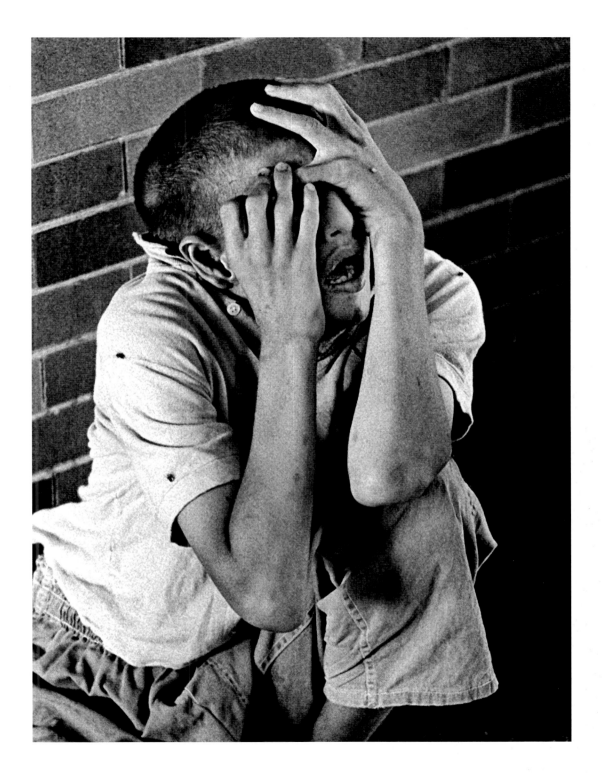

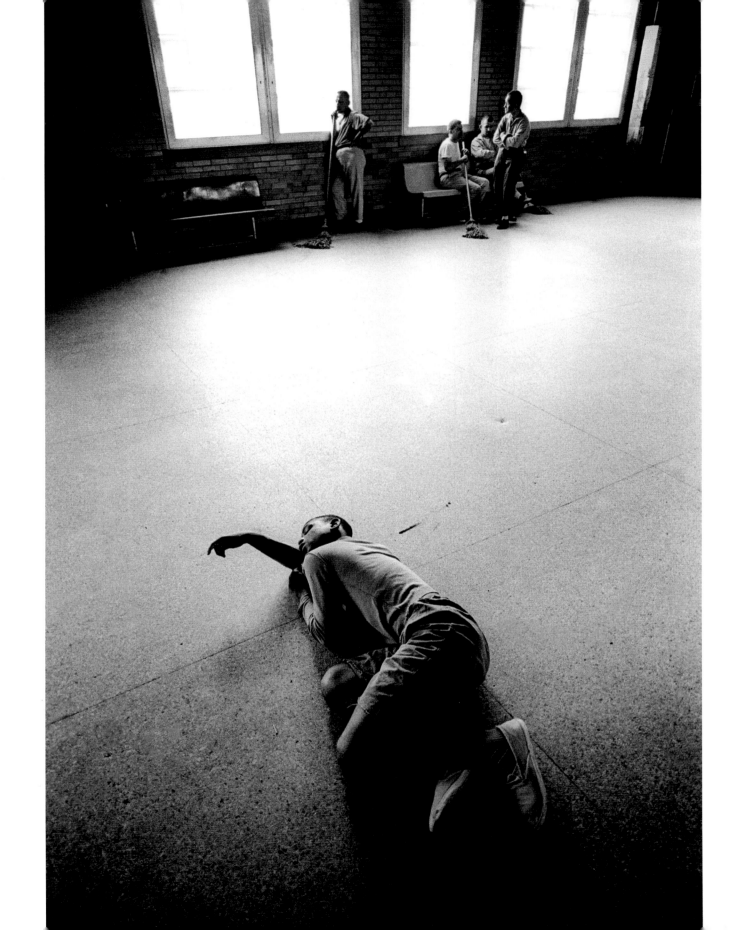

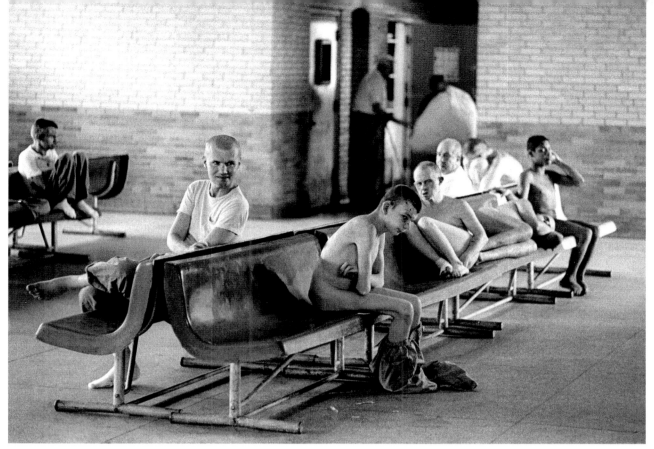

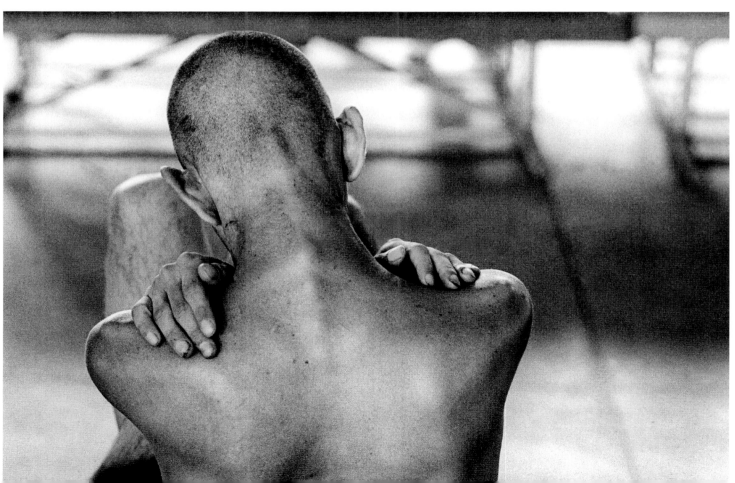

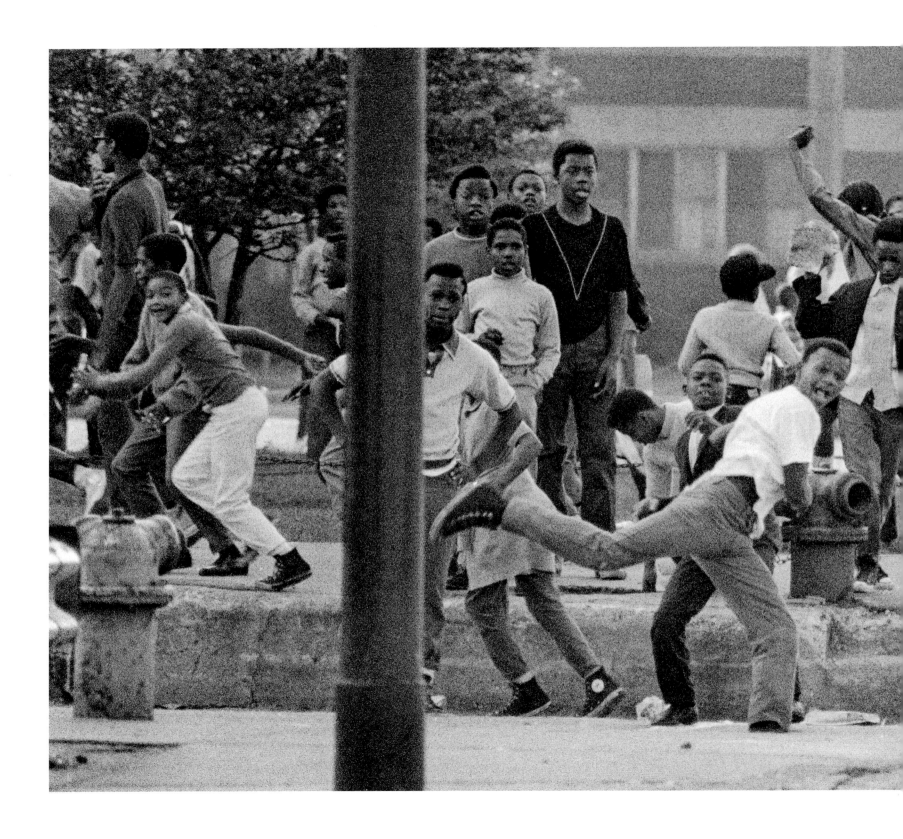

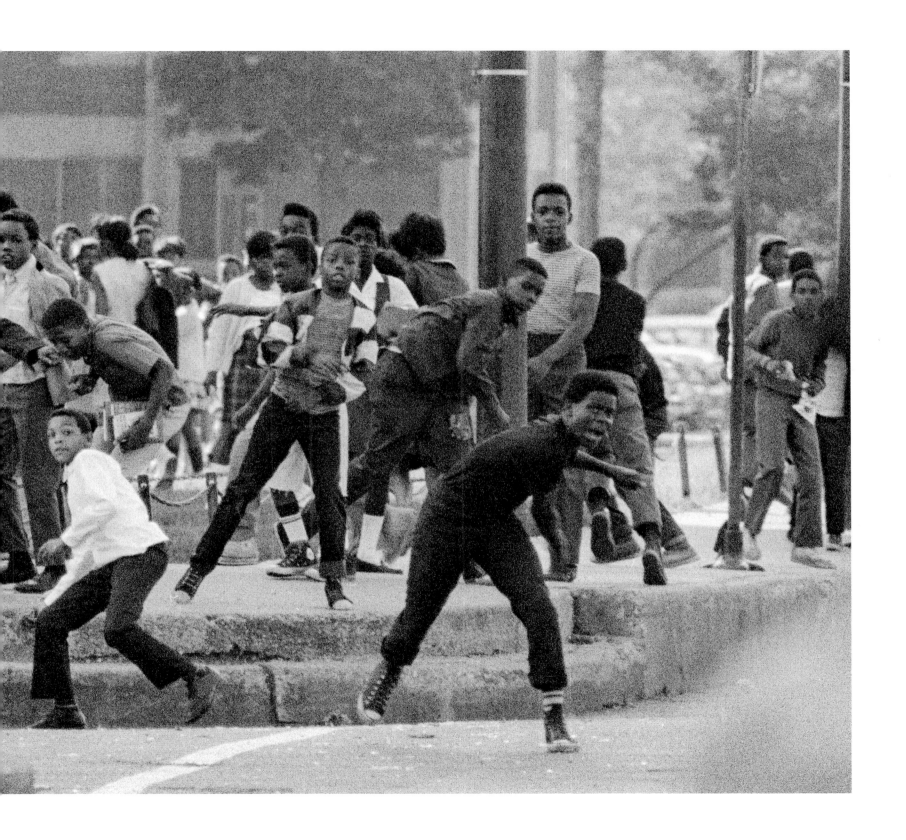

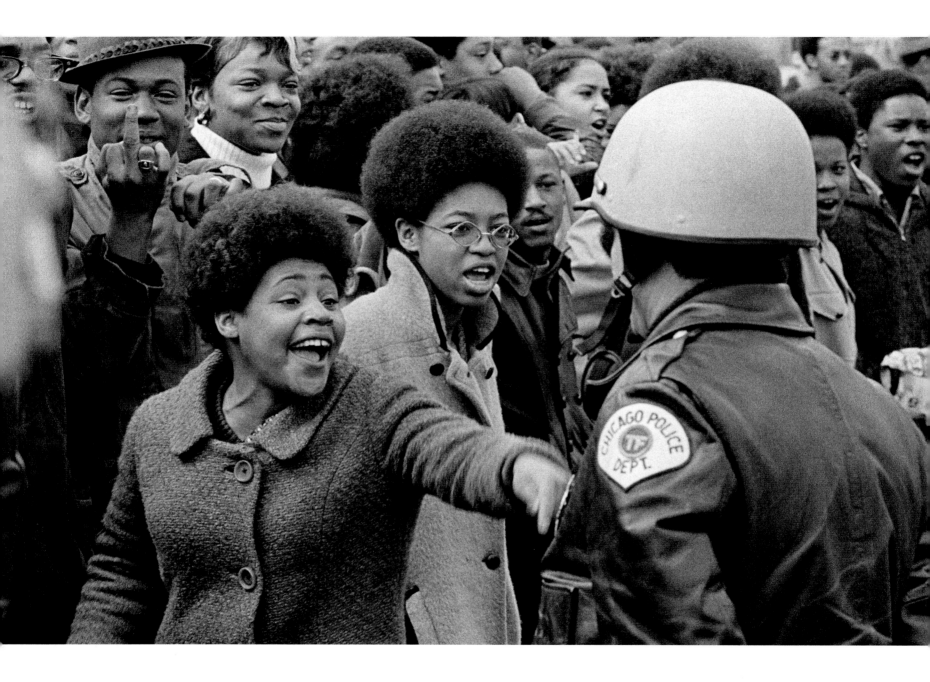

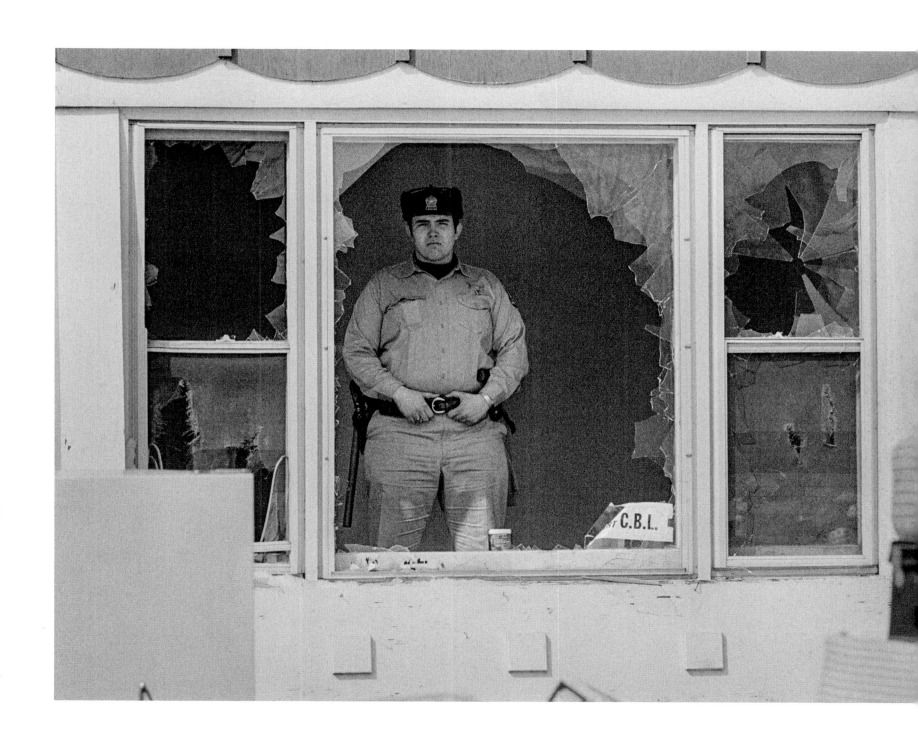

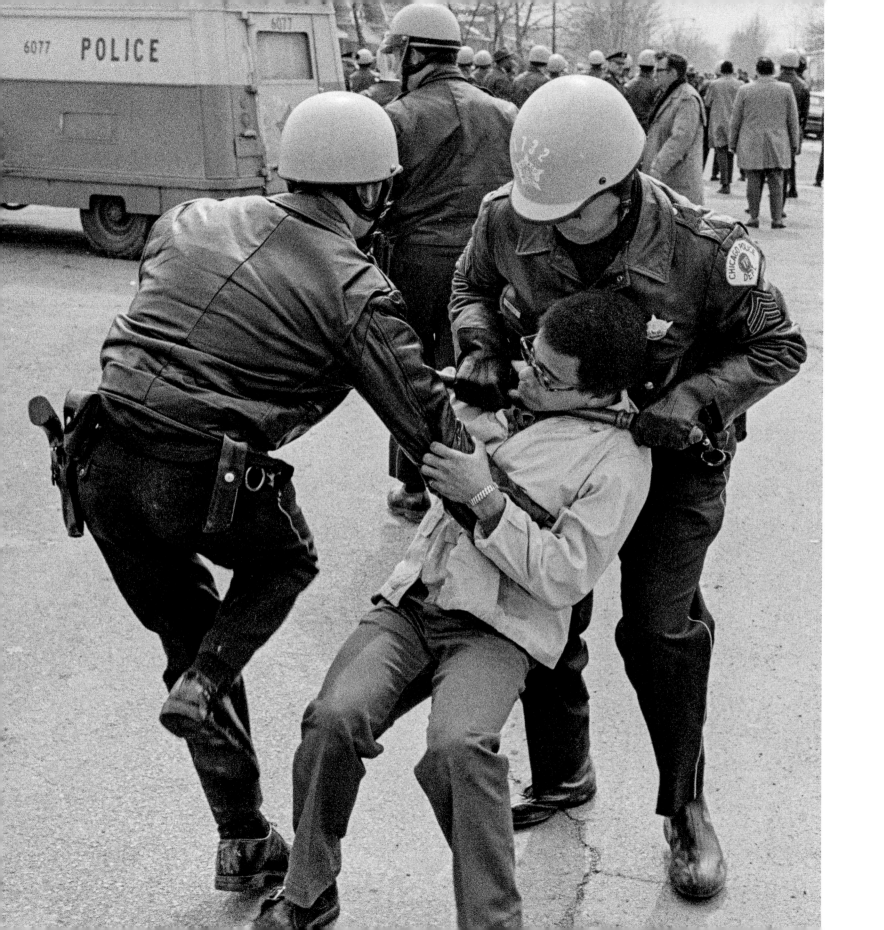

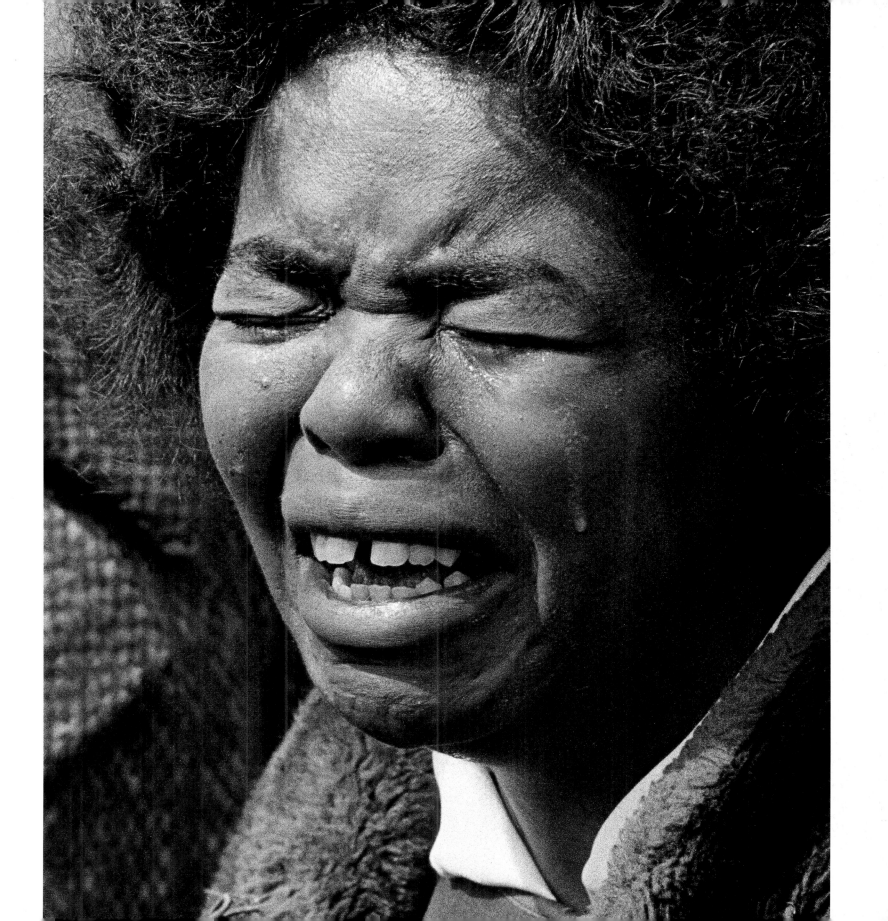

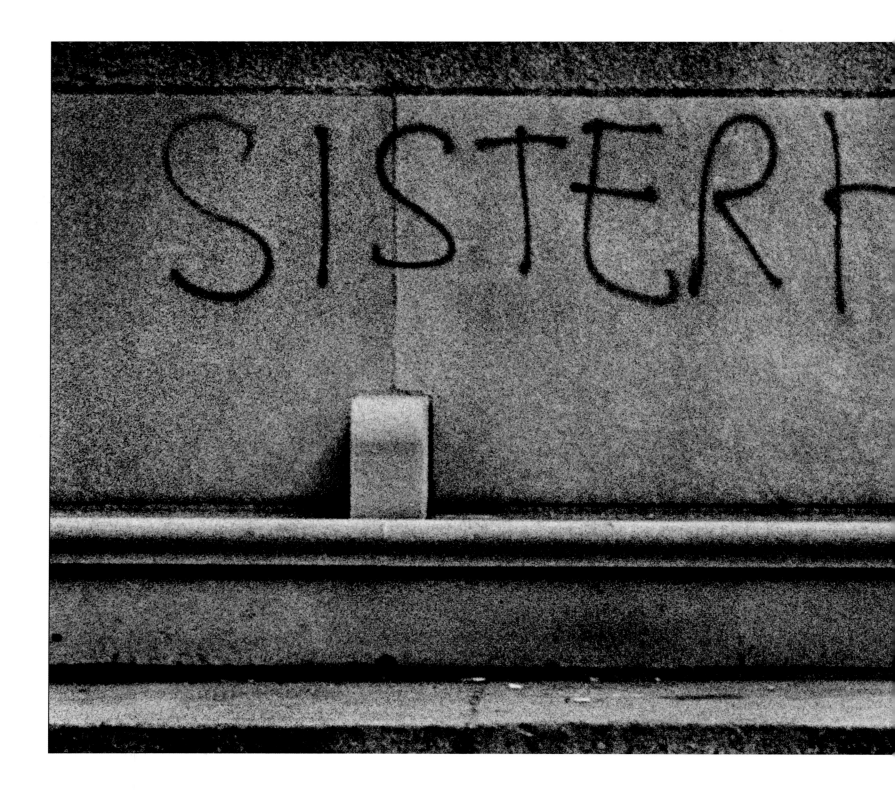

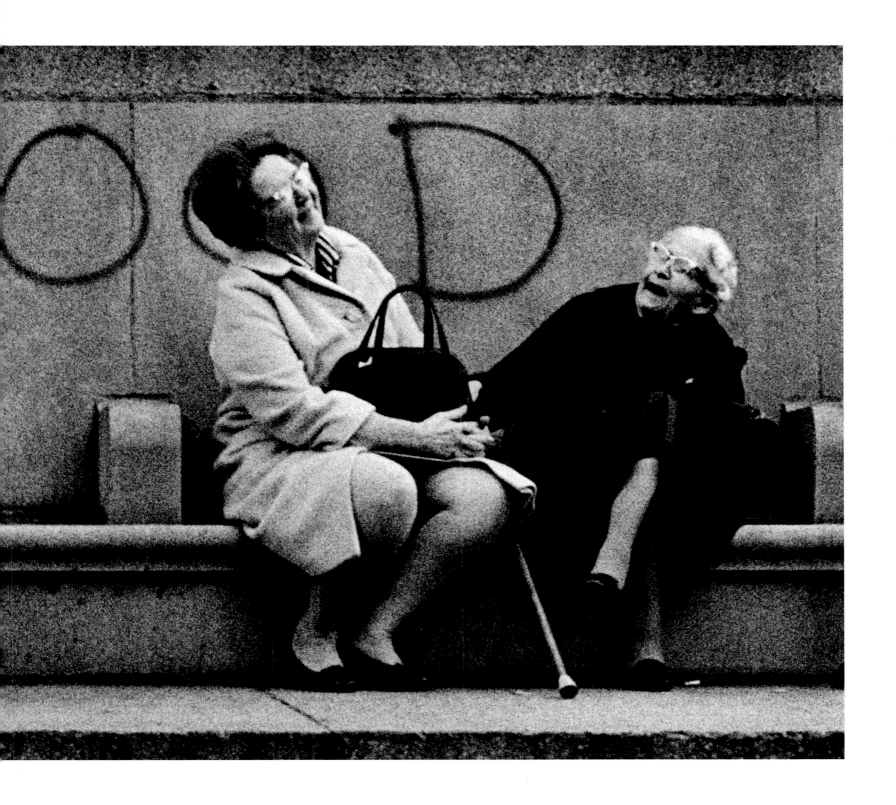

◀ Sisterhood

Creating images that succinctly tell a story and evoke responses from viewers is my goal. Capturing moments when ordinary people share feelings and emotion are instantly relatable. I constantly search for those special moments when humanity bursts forth.

For over a week I had made a mental note to watch a graffiti-marked bench in Chicago's Grant Park. I passed this bench each day as I went to and from my job as a staff photographer at the *Chicago Sun-Times*. The bench became my stage where a parade of Chicagoans came and went each day. This continued for a week of scattered attempts to find the right moment beneath the word "Sisterhood" scrawled on the concrete.

Honesty was crucial. While an advertising photographer has the luxury of hiring talent, posing the picture, and creating a statement to be marketed commercially, my values were different. My colleagues had imprinted journalistic values upon me that would forever serve as an ethical guide. I continued to wait for the decisive moment.

During these formative years, I also learned that good fortune comes to those who work the hardest. John White, another Pulitzer Prize winning photographer at the *Sun-Times* once told me he photographed every sunrise. In disbelief, I inquired why? He simply said he didn't want to miss the really great one.

That dogged pursuit of a perceived image locked in my head led me to visit and revisit that bench over and over again. As it happened, I was driving on Michigan Avenue on my day off when lightning struck. The decisive moment I had longed for was happening *now*. But, I was stuck in traffic on a very busy street and was surrounded by taxis with destinations on their minds and no interest in park benches.

In one of those ridiculous split-second decisions, I locked my brakes, grabbed my Leica and leaped onto the pavement. With cabs leaning on their horns, I quickly employed muscle memory to rapidly make several images as two wonderful ladies shared a moment of pure joy. Total elapsed time for photography: 10 seconds. Total elapsed time for scouting image potential: one week.

PART 3 **Independence**

CHAPTER 6 The Arizona Daily Star

My wife Margaret and I were familiar with Tucson from our previous visit during my leave of absence from the *Chicago Sun-Times*. Our good friends Tim and Linda Caravello had left Chicago for Tucson years earlier, with their three daughters packed into a converted Chevy van. And so, the way was paved for our move to Tucson. The warmth of the Sonoran Desert permeated all aspects of life.

I had exercised due diligence in searching out job potential in the "Old Pueblo," learning that a new executive editor, Bill Woestendiek, was at the helm of the *Arizona Daily Star*. His 14-karat credentials included time at the *Washington Post*, and it was rumored he was instituting major changes for the Pulitzer-family owned *Arizona Daily Star*.

Bill and I hit it off immediately and I was hired as Photo Editor and was in charge the photo and Art departments. I found a man committed to upgrading photography at the paper and he found a young energetic force eager to initiate change.

I remember walking into the *Star* in the fall of 1976, with a newly acquired briefcase with little inside other than a small Leica camera. I wanted to look professional, and I wanted to look like Chuck Scott. For all the time I knew him, Chuck had carried a briefcase crammed with ideas,

layouts, and a trusty Leica. In ways obvious and subtle, his mentoring allowed me to become my own person. I was the "Photography Editor."

Of course my self-doubt was deeply infused in everything I did. After a week on the job, and lonely because Margaret and the kids were still in Illinois trying to sell our home, I hit bottom. I was ready to call it quits. Luckily, the mountains were close at hand and I spent a day climbing Mount Wrightson south of Tucson. That simple physical act provided the distraction, validation, and clarity that were an essential reinforcement for a change in my life's direction.

Thoreau said, "In Wilderness is the preservation of the world," and my time in the mountains had indeed preserved me.

Following Chuck Scott's example, I slowly assembled a staff of photographers, drawn largely from Chuck's Visual Communication department at Ohio University. Combining an intern program with hiring the best and brightest from Ohio, we became a credible staff. I rebuilt the darkrooms and I appealed to reporters for visual story ideas while urging photographers to be better reporters. I wanted to provide the city desk with a backlog of potential stories.

Woestendiek wisely sensed that in order to lead, I needed to prove my mettle. Together with writer Bill Waters, I headed to Mexico to produce a special section on Mexico's newly realized petroleum boom. The resulting special section tabloid won many awards and helped to establish photojournalism at the *Star*.

A second tabloid special section focused on the vast Tohono O'dham reservation west of Tucson. The project involved three dedicated reporters and me.

Finding myself in a totally different culture, I had to pinch myself, celebrating my good fortune as I careened across washboard dirt roads to places like Topowa, Hickiwan, Vaya Chin, Quijotoa ,and Picinimo. I was truly in heaven. Chicago, with all its job security, was but a distant memory. We produced a tabloid that received wide acclaim, while I gained insight into a culture with powerful ties to the land. My Chicago-born obsession with time and deadlines slammed into an immovable force. You see, the reservation is a place where a wristwatch is utterly useless. When we would go to an appointment at a Rancheria to conduct an interview, we learned to drive near the homestead, turn off the car's engine, and wait. At one point, we waited hours, only to be told, "Come back tomorrow."

Reporter Ed Sylvester, unfazed by the temporary roadblock, returned to Tucson, hitched up a trailer and drove back to the reservation. He literally camped in the tribal elder's yard and waited. Finally, he was summoned to the house and told to turn on the tape recorder. The elder spoke for four hours with an eloquent speech encompassing everything about being Papago. Lesson learned: patience.

But the fun had to end, and I needed to be department head and not to compete against staffers by skimming off the cream assignments. Several times during my tenure, I was asked to be a photographer for special projects. But I knew that a leader needs to trust the staff and must resist generating ill will by wearing two hats.

A photo editor is frequently a translator between the "word people" and the photographers. Initially, I found myself defending images and selecting the best for front pages in each of the newspaper's sections. We were creating impact and a different visual style. Each day all the editors gathered for a 4:30 p.m. "budget" meeting at which each editor would present their best offerings to be judged and allocated space in the coming issue. I would present the strongest imagery that was processed and ready, along with the promise of images being currently recorded in the field. For the latter, I depended heavily on photographers' assessments via two-way radio, describing what they had photographed.

I learned to be a brutal editor after being burned by photographers calling in on their radios telling of the incredible images they were bringing back to the paper. Taking their claims at face value, I would go into the budget meeting and strongly request a massive six columns of the front page for the coming masterpiece. Then, when the photographs were brought in, I would scan the film, looking for the image described by its creator as "the second coming." Photographers are instinctively biased about the merits of their own work, but the best photographers play down their work. Bottom line: too often the image in hand was just average and certainly not a front-page contender. But having requested and gotten six columns of the *Star's* front page, I had to then give up the allotted space. I hated to grovel, but I begged forgiveness. So the lesson I learned was to be very skeptical of some photographers' assertions.

I expanded the intern program and selected young image makers not only from Ohio University, but also the University of Missouri, the University of Texas, and Indiana University. Some of the finest young photojournalists either were on staff or were interns at the *Star*. Joe Vitti, Joe Patronite, Len Layman, Alan Berner, Jan Sonnenmair, and Sarah Leen brought a fantastic mix of styles and

Tucson, AZ 1980—At the *Arizona Daily Star* while working as the young Photo Director. Photo by ©Alan Berner.

Tucson, AZ 1980—I was at a journalism conference while working at the *Arizona Daily Star*.

approaches that collectively raised the appreciation of graphics.

Bill Woestendiek suggested we hire a new art director. After a careful search, Rob Covey was the obvious choice. I found him over-confident, brash, and over-powering . . . even threatening. Yet I sensed his talent. I was torn about hiring him and was leaning against it, when he called me at home and initiated a long, thoughtful conversation. Thus began a wonderful collaborative relationship and friendship.

Rob went on to redesign the *Seattle Times* and *U.S. News & World Report* and he later become Senior Vice President of Content and Design at Discovery Communications and later, the same title at the *National Geographic Society*. Joe Vitti went on to the *Los Angeles Times* and the *Indianapolis*

Star-Tribune. Joe Patronite left for the *Dallas Times Herald*, Len Layman went on to the *San Jose Mercury News*. Alan Berner, my superb deputy, went on to achieve greatness at the *Seattle Times*. Jan Sonnenmair free-lanced for *Time Magazine*. And Sarah Leen went on to intern at *National Geographic*, later becoming a prime contributor, and finally appointed Director of Photography for the magazine.

Bringing together immensely talented photographers where they could each inspire and be inspired, became my guiding, central theme. The synergy, the sharing of talent, and information gleaned from years of thoughtful mentoring—often in subtle ways, yet deeply embedded and profound—was the gift that I had received and could now pass on. Indeed, we stand on the shoulders of giants.

Another Ending—Another Beginning

There is always a moment when the thought of leaving crystallizes in our minds. After remaking the *Star's* photography department and even changing the way photojournalists were perceived at the paper, I began to learn an important lesson. It is easy and fun to make massive changes, but damn hard to consolidate the gains. After raising the status and self-image of the photographers, the constant flow of demeaning, unessential photo-assignments only abated for a while. I routinely rejected assignments that had nothing to do with news and everything to do with massaging egos.

Of course, writers were not asked to make advertisers or the movers and shakers feel important by aiming a camera in their direction. That was the realm of photographers. My refusals to cover events rankled some section editors, and their complaints reached the front office. My support was beginning to flag as complaints mounted. In one case we had covered a fire in a doublewide mobile home, providing visual evidence of the homes' combustibility and inherent fire danger. Within the week, representatives from the mobile home dealers marched into our managing editor's office. Afterwards, we were directed to do a story on the positive aspects of prefab housing.

It was time. . . . After five years, I marched into Woestendiek's office to give two weeks notice that I would be leaving. His first comment was, "Don't do it." His second comment was, "Are you sure?" I watched my deputy, Alan Berner's expression of impending doom. I wanted Alan to immediately take the reigns. I would set out on my own and be a photographer again. One of us was happy.

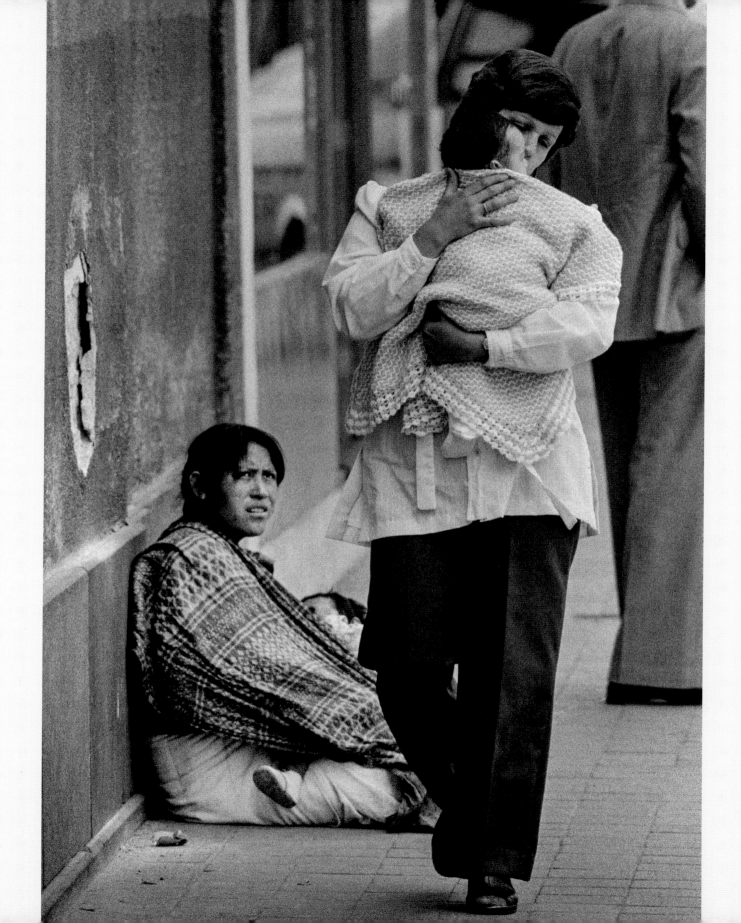

◀ Mothers, Mexico City

With Chicago's fierce competitive photojournalism behind me, the lessons gleaned from the white-hot competition remained. Chuck Scott's hand still guided my career, but now it manifested itself as an internal voice reminding me that with my pictures I was telling a story. "Look for a beginning, a middle, and an end."

My new editor Bill Woestendiek at the *Arizona Daily Star*, in Tucson, Arizona, handed me a plum assignment to document the sudden changes due to Mexico's newfound oil reserves. It was 1978 and together with writer Bill Waters, we set out in a rented Volkswagen to document Mexico and all it complexities. Bill, an ex-Peace Corp Volunteer who spoke fluent Spanish, left his post as editorial page writer to lead the way through Mexico City's streets to the jungles of Chiapas.

As a photojournalist trained to observe intensely, reoccurring themes are noticed and gradually form belief systems. For me, the startling gap between the extreme wealth and abject poverty quickly became apparent. One of the most powerfully concise statements a photojournalist can make is when the simplicity of the moment is instantly clear. And here, a mother's gaze amplifies the juxtaposition between rich and poor.

I sometimes feel like a voyeur watching the human drama from afar, safe in my middle-class life, yet when my feelings and empathy guide my camera the resulting images reflect an honest connection. It's very hard to be dropped into situations where you are the interloper. And, it's easy to feel guilty or to impose your values on your subject. Being the "fly on the wall" is never easy. But you'll never go wrong when you embrace our common humanity.

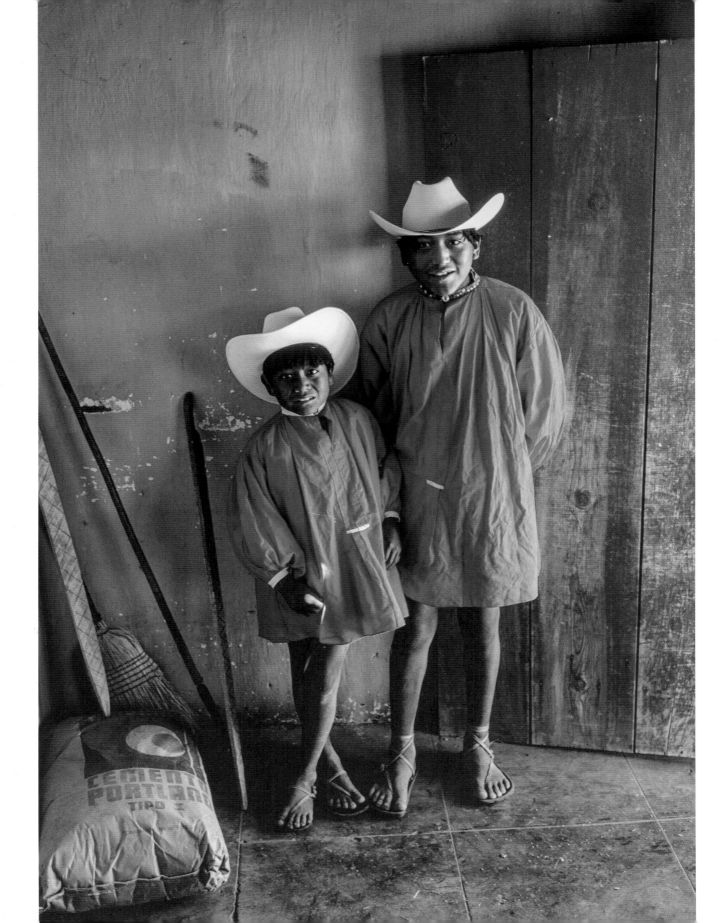

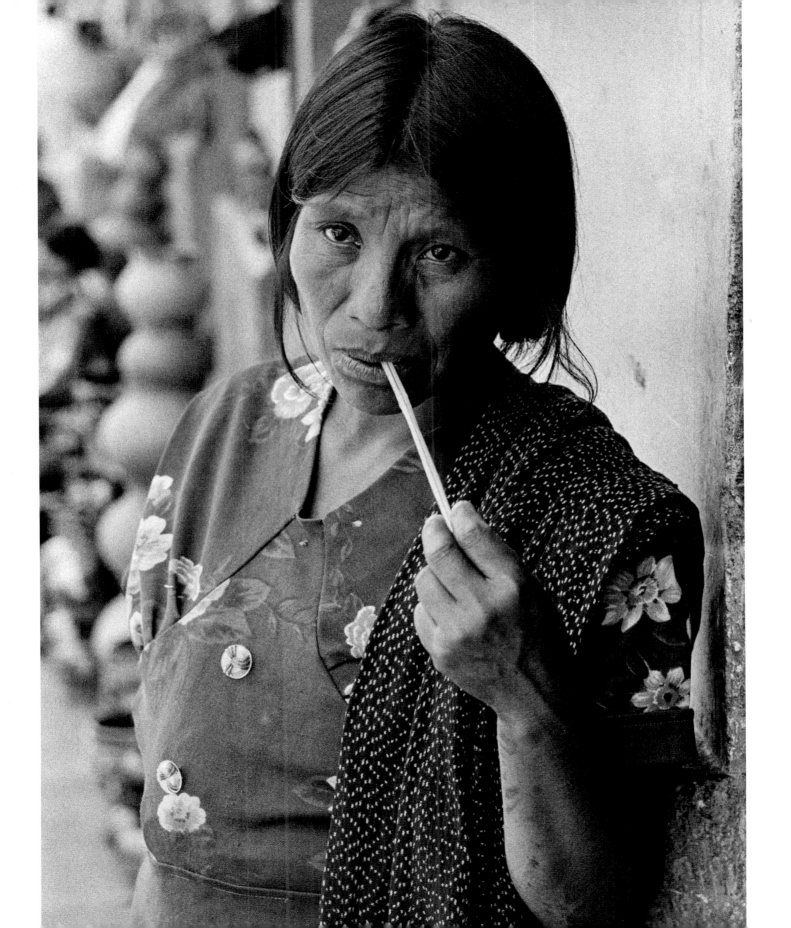

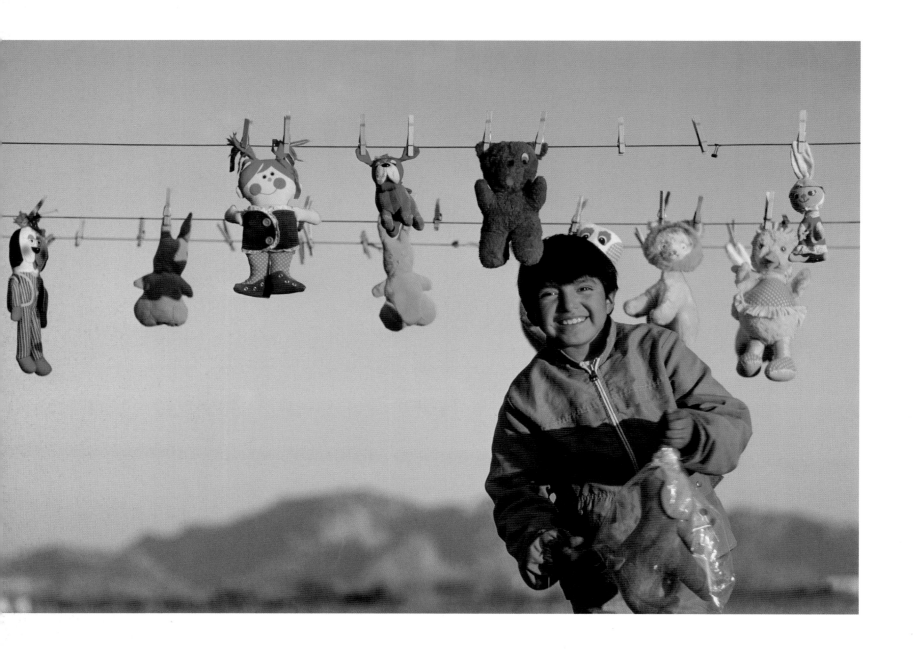

PART 4 **Trust**

CHAPTER 7 Ginger—Follow Your Dream

It was 1985 and I needed direction in my life. I was doing some freelance work for news magazines, but Arizona is not New York and both *U.S. News & World Report* and *Time Magazine* provided only a sporadic income for assignment work. *Arizona Highways Magazine* Managing Editor, Wes Holden, assigned a story to me on the Nature Conservancy's Muleshoe Ranch. Located in the Galiuro Mountains east of Tucson, the ranch was a prime piece of real estate that preserves the unique riparian habitat and features a hot spring. My appointed contact was a silver-haired, incredibly fit woman whose ready smile was deeply etched into her face. It was immediately apparent she had found happiness and solace in remote corners of the world. As a former Mountain Travel guide in Nepal, Ginger Harmon was uniquely suited to manage this remote Nature Conservancy preserve.

Ginger and I became instant friends. Together we hiked the land while she pointed out significant features in the preserve. After the article was completed, we kept in touch, and together hiked into various canyons and climbed in Mexico's Sierra Pinacate. During one of our adventures, and with the correct amount of beer, Ginger wondered aloud why I didn't do something with my life. With a laser-like stare, she asked me what it was I really wanted to do. My answer came in the form of a flood of ideas. But as fast as I uttered that I'd like to do a book on the Sonoran Desert, I explained why I couldn't do it. It turns out Ginger Harmon was not the little hippy lady I had assumed. In fact, before divorcing her husband, she moved in circles that included the Kennedys and her ex-husband, a real estate magnate, even ran for governor of California. She had chosen a different direction for her own life and devoted her time and talents to the preservation of the wilderness.

"What would it take to do a book?" Ginger asked. She gazed at me as the words hung in the air. My response was an immediate, "I don't know." Then I said I supposed $25,000 would be enough to cover travel and film expenses.

"Fine," she said. "I'll write you a check." But she had one caveat: "I need to go along."

My response was, "Sure, sure . . ." but I was filled with disbelief. Her response was swift and to the point, "Dammit, I'm serious!" This simple generous act changed my life.

The hardest thing to overcome is breaking out of a secure, predictable existence and to try something new.

I was now free to work on a worthy project. Free, yet chained by the constant worry of failure. Free, yet worried sick about what my wife would think. Free, but still an insecure fat kid from Chicago who was way out of his element.

The real freedom came from my wife, Margaret, with her support and confidence in my ability.

I asked Chuck Bowden if he would like to write the copy for the book. The more images I produced, the more my love affair with the Sonoran Desert deepened. I lived in my camper. I came to know individual cacti as friends. The desert became a principal mentor for this displaced Chicago kid. Almost by osmosis, my wilderness skills improved. Observing the weather patterns, the movement of the clouds, and the orientation of the sun became part of muscle memory. Rattlesnakes, scorpions, tarantulas, and coyotes became familiar, leaving me a different person, schooled by the land.

Morton and Abrams

Chuck produced an epic body of writing that wrapped my images with the raw feel of the place. I'd always wanted Ed Abbey to write the introduction, but he died before publication. It was, after all, Ed's writing and Phil Hyde's images that first inspired my love of deserts.

With images in hand, I assembled a proposed layout and presented them to Sierra Club Books. Their rejection came quickly and shook my confidence.

However, within weeks, Bob Morton, special projects editor at Harry N. Abrams, New York, agreed to publish. Bob shepherded us through the New York publishing scene, and in 1992 *The Sonoran Desert*, a book I'm still proud of, dropped off the press.

Abrams committed to two more books: *Stone Canyons of the Colorado Plateau*, which was published in 1996, and *Desert: The Mojave and Death Valley*, published in 1999. Chuck's Abbey-esque writing in *Stone Canyons* called for the creation of a "Secret National Park. Let's build a park and not invite anyone."

We were following a tried and true environmentalist's tactic, initiated by David Bower, to produce the Sierra Club's powerful format series that documented an area while calling for its protection. It turns out our timing was good. Former Arizona Governor Bruce Babbitt, now was Secretary of the Interior, and Harold M. Ickes, son of the Secretary of the Interior in the Franklin D. Roosevelt administration, was President Clinton's Deputy Chief of Staff. The elder Ickes, Harold L. Ickes, was the original Escalante National Park proponent. Their backgrounds perfectly fitted our desire for our book to help fuel the Utah Wilderness Alliance's push for more land preservation.

You just never know what will resonate. But the *Stone Canyons of the Colorado Plateau's* cover image of the Coyote Buttes so moved legendary Abrams Books publisher Paul Gottlieb, that he pushed the cover through with no title copy. Babbitt gave President Clinton a copy of the book, with Chuck's searing words and an introduction by Robert Redford.

▶ Saguaro in Bloom

My *Sonoran Desert* book was a project of love. With the generous seed money from Ginger Harmon, I set about devising a plan. I wanted to establish a list of must-see places that embodied and defined the Sonoran Desert. Because my Tucson home was in the Sonoran Desert, I already had knowledge of the land. However, I wanted to pour over maps and naturalist's guides and map out the essential aspects that needed to be documented.

Every definition to the Sonoran Desert describes the forests of giant columnar cacti as the defining plant community. Saguaro cacti occur nowhere else and therefore have become the singular symbol of the region. In fact the saguaro cactus can be seen in marketing campaigns in both the Chihuahuan and Mojave Deserts; two places where they do not exist. But their iconic shape has come to define any and all deserts.

Telling the story of the Sonoran Desert made saguaro cacti an essential element to any book on this arborescent desert. I approached photographing saguaros knowing they were already elevated to cliché status by the sheer numbers of saguaro cactus photographs. Yet their survival skills warrant an elevated status. They shade themselves with their spines and corrugated trunks and they store vast amounts of moisture. Saguaros propagate successfully in the harsh desert by flowering and dropping their seeds over long periods, improving chances of germination during the isolated summer "monsoon" storms.

One month before blossom season, I began scouring the desert near Tucson for any saguaros with limbs descending. A week's work netted about half dozen cacti. Next, I wanted the proper orientation to the sunrise, when the night-blooming flowers were still fully open. I eliminated all but two where the composition seemed most promising.

I finally settled on one scene I thought would work. Armed with my three-foot stepladder, I began my visits to my chosen saguaro. My assumption was that saguaro flowers burst forth massively, covering the tips of their limbs. The cactus had other ideas. I discovered only one solitary flower on a given night. Then, perhaps three flowers the following night while the first one shriveled and died. This pattern repeated itself over another week until finally nine flowers greeted the dawn in my final composition. I had my image.

It remains one of my signature images, because though saguaro cactus images have become cliché, this image tells the story of survival.

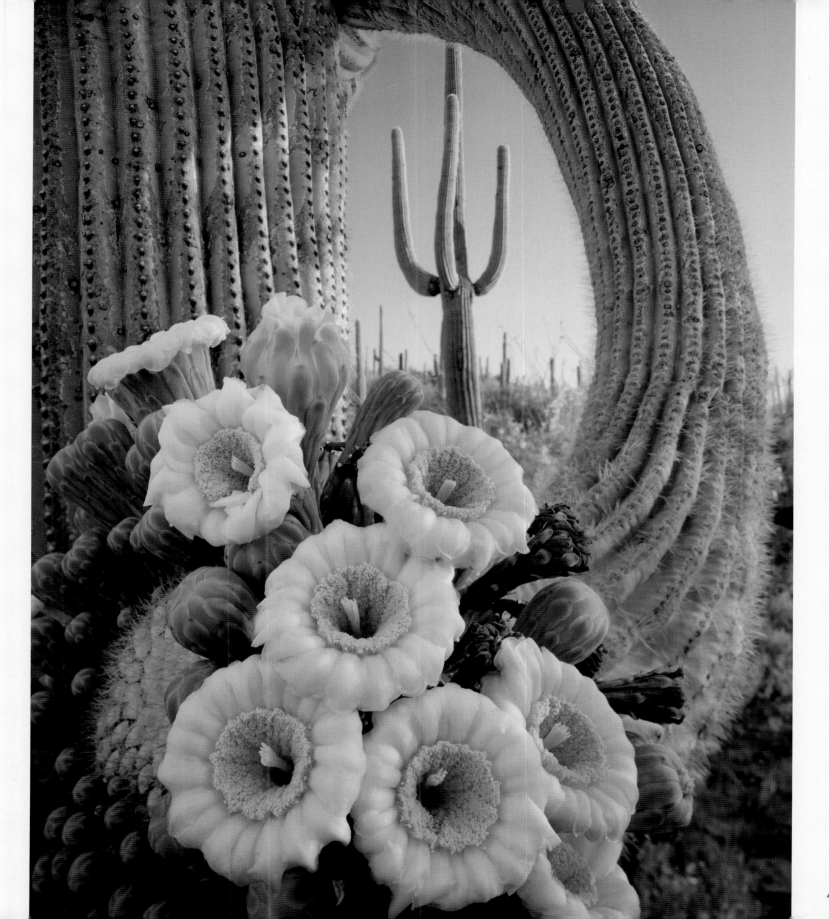

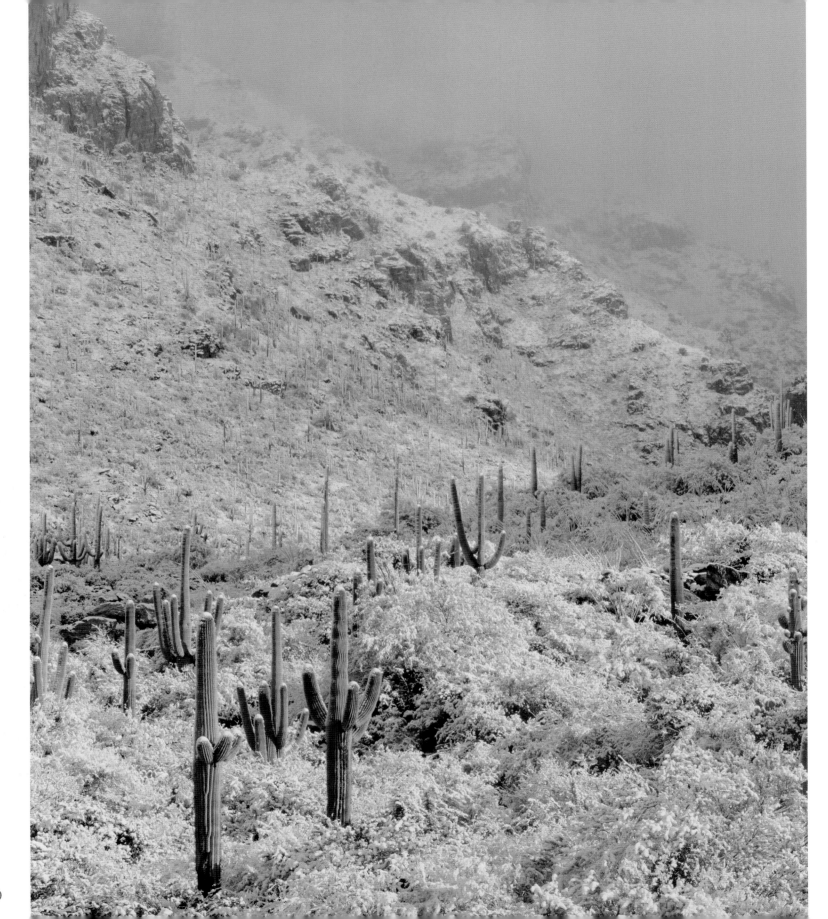

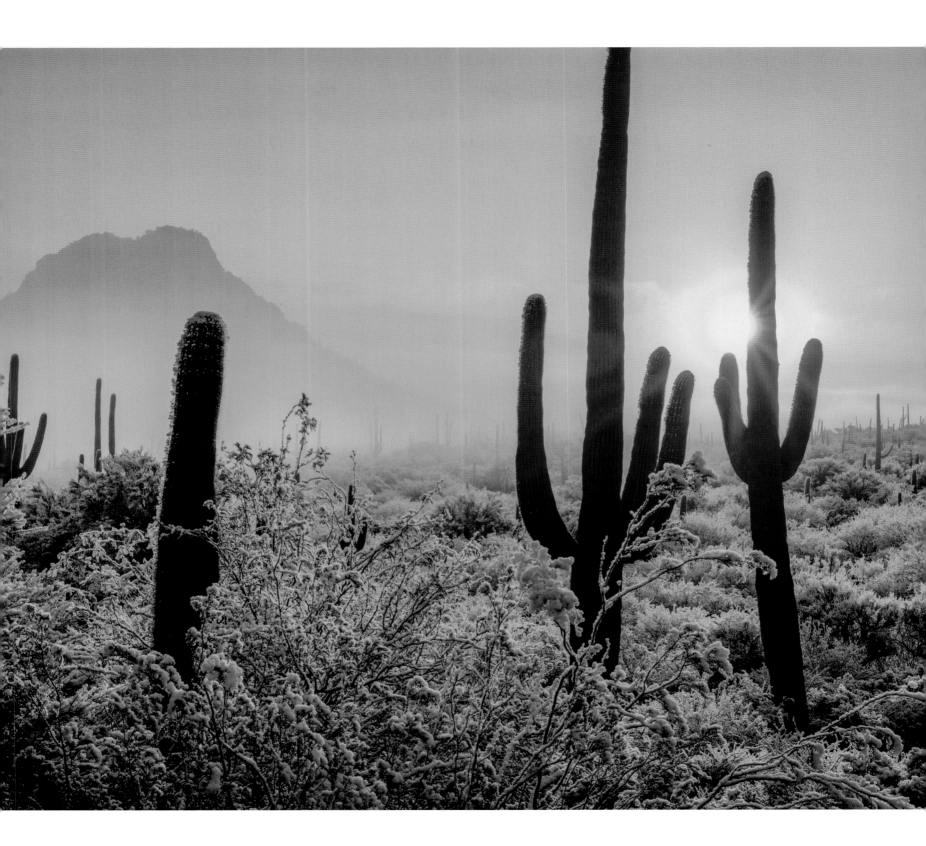

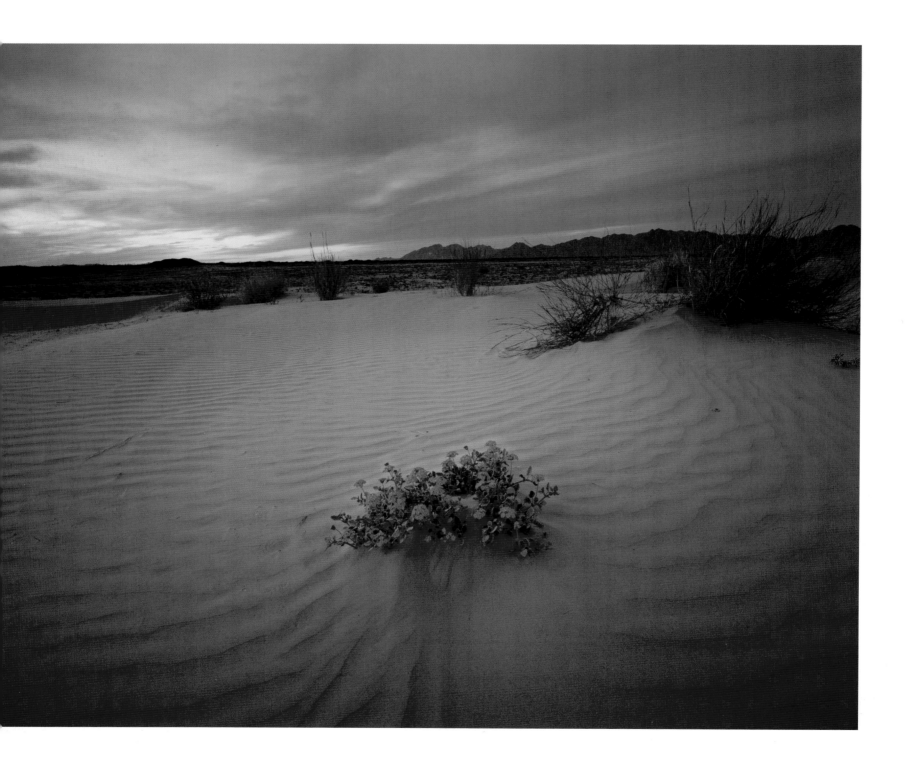

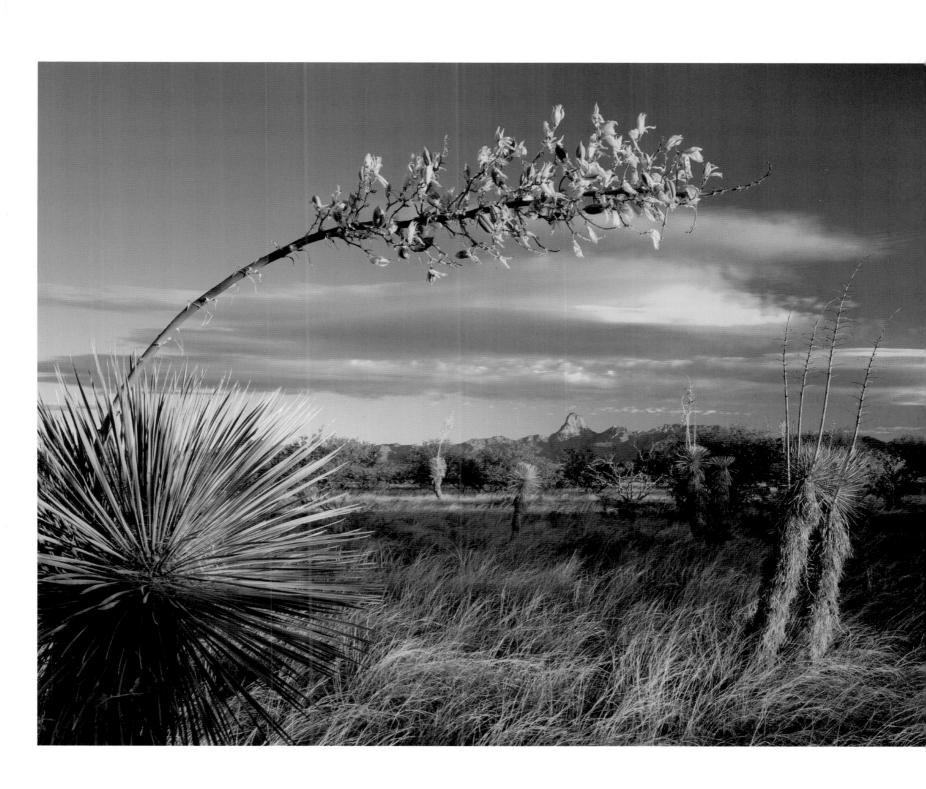

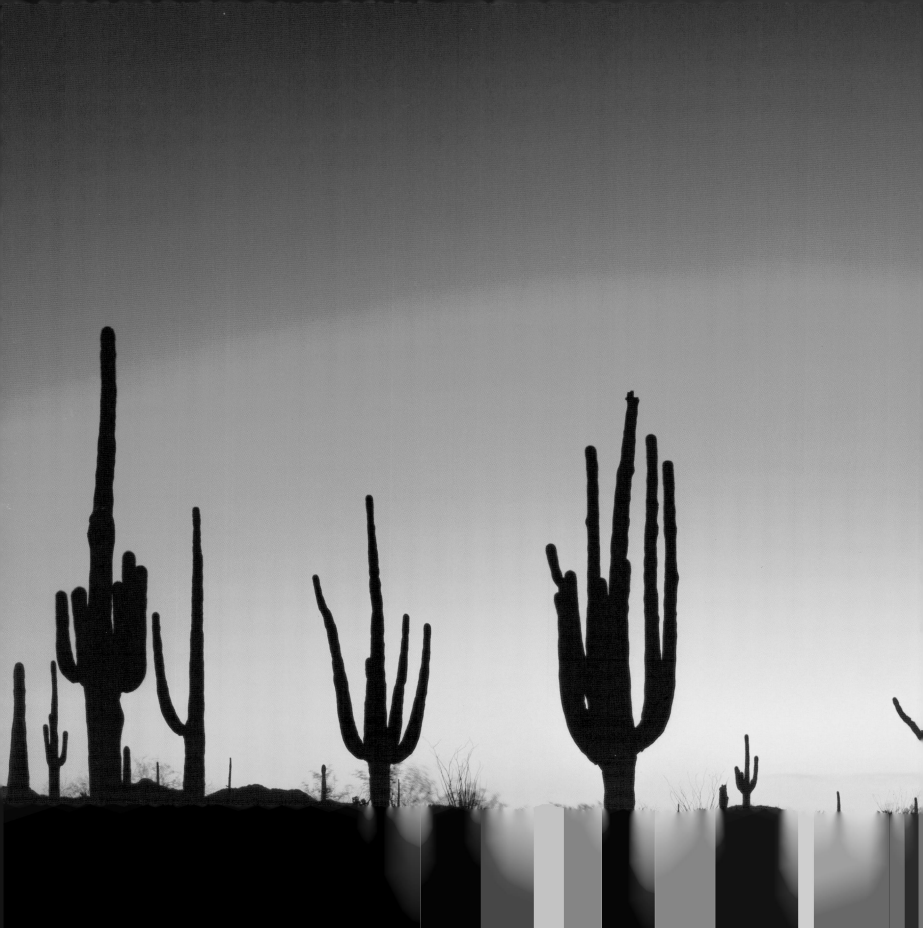

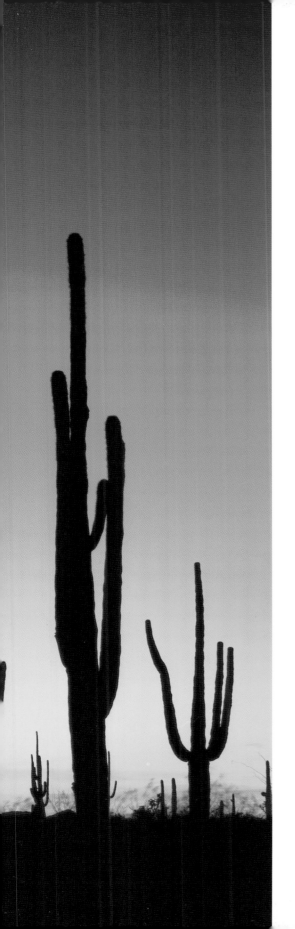

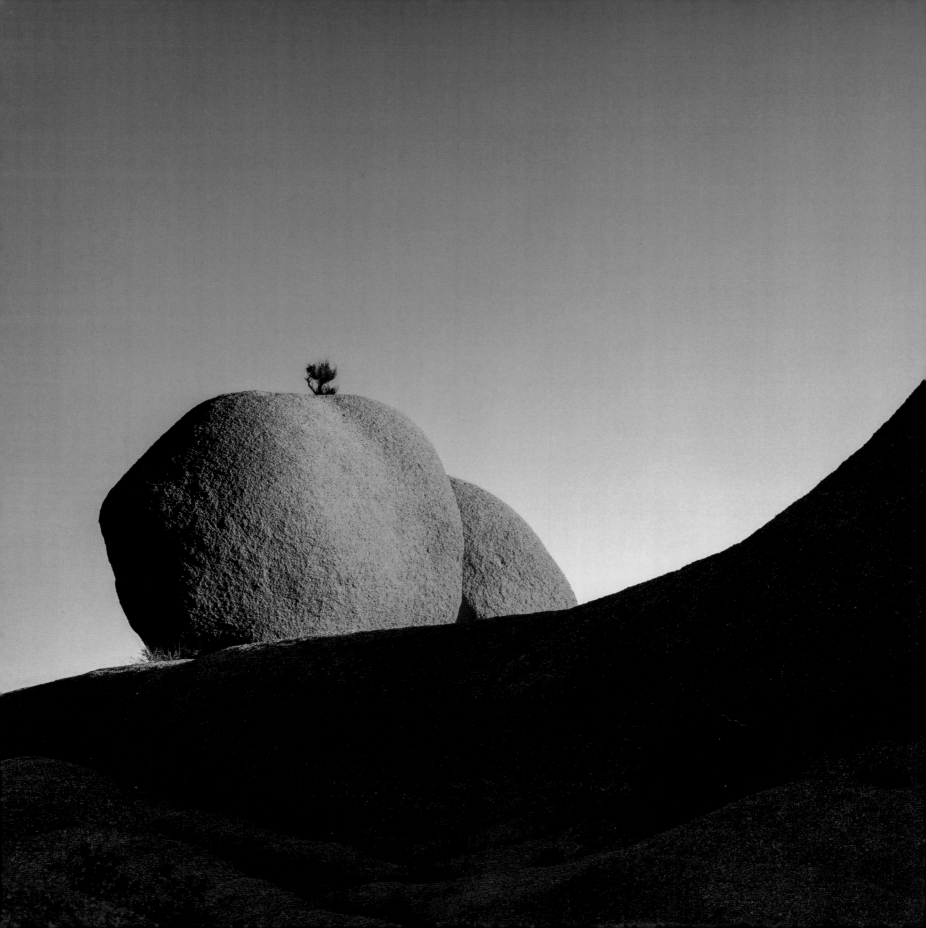

◀ Joshua Tree Boulders

My self-initiated *Sonoran Desert* book was the impetus to explore the far reaches of the Sonoran Desert, which meant paying particular attention to regions where the Sonoran and Mojave Deserts meet and overlap.

Walking is my method of immersing myself into my subject. There's just no such thing a "drive-by shooting" in landscape photography. In other words, you need to put in the time on the ground. So it was that I criss-crossed the boulder-strewn Joshua Tree National Park (then National Monument).

The land is a highly complex visual mish-mash. I found myself trying and failing to find a simple "clean" composition that would illustrate the feeling of being in a world of over-sized marbles. I walked several miles in different parts of the park at different times of the day. After several days, I had made a few images I liked, but nothing that really made my heart go pit-a-pat.

As I neared my camp, I happened to look up from the dry wash I was following and there it was. Like many of my favorite images it was just there, and it appeared to jump into my camera. The straightforward simplicity and clean line demanded a purist's no-gimmicks approach. Yet while exposing film, the rosy light of dawn proved elusive. I hedged my bet and kept photographing.

Back in Tucson, with a mug of coffee and a stack of recently processed transparencies, I could see an image that "almost" made it. A great angle and great composition, but the light was anemic.

A week later I found myself trudging back down the same trail with a different lens at the ready and the promise of a crystal clear dawn. My heart skipped a beat while the light's intensity painted the boulders crimson.

I knew it was a wrap.

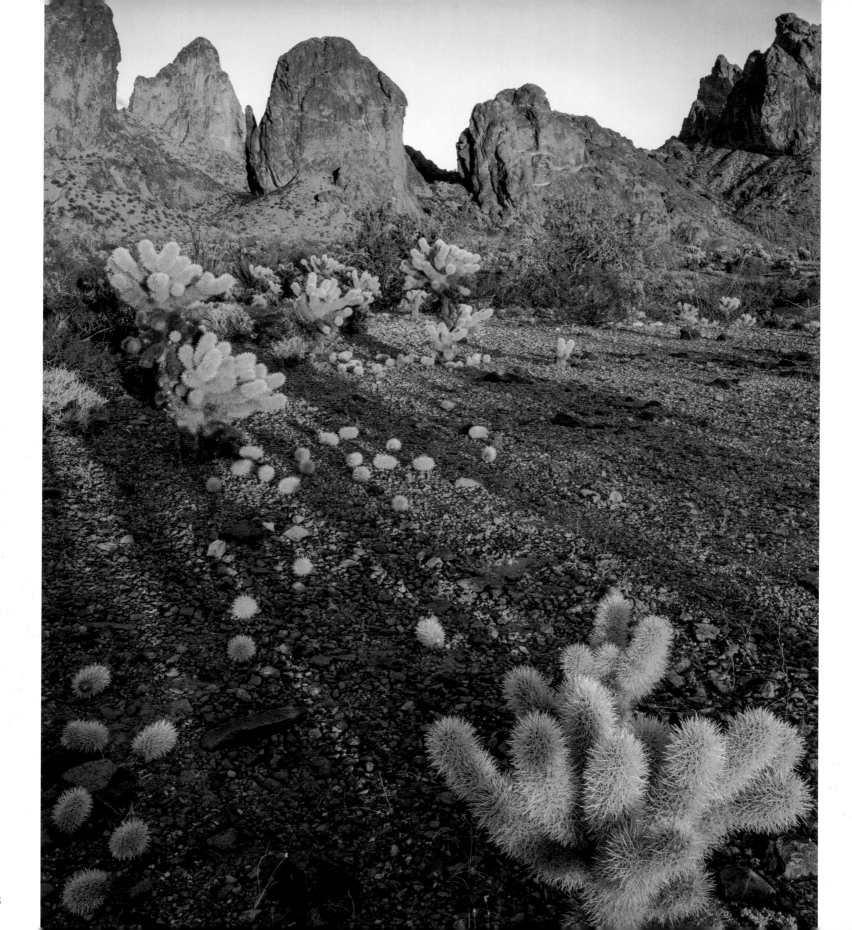

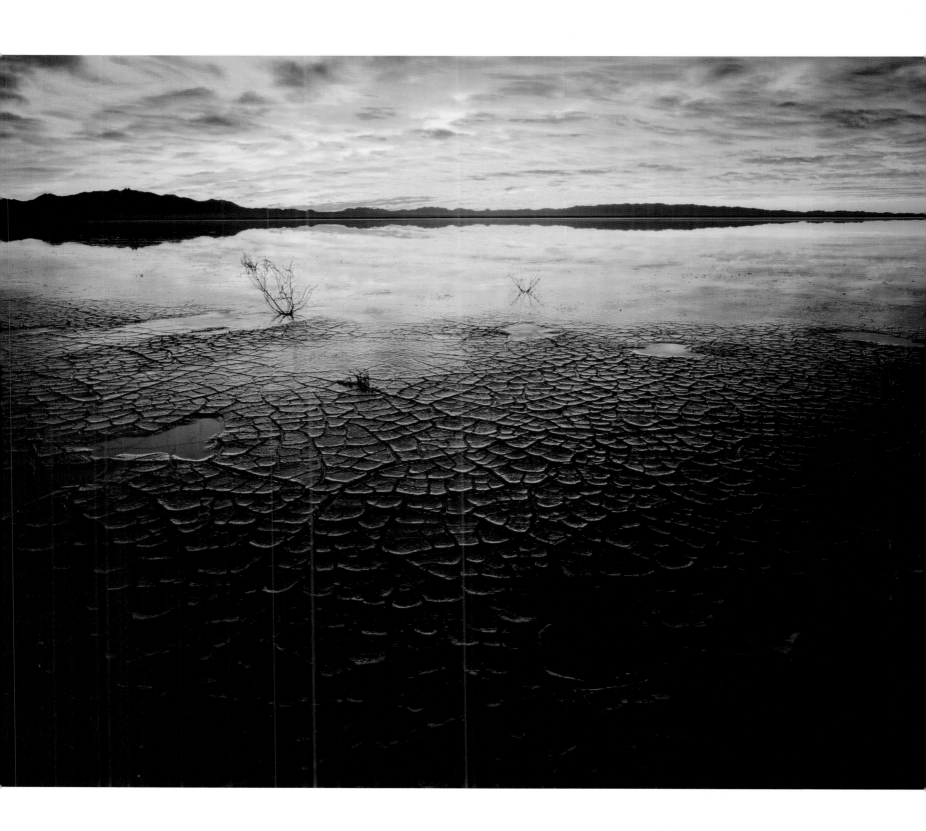

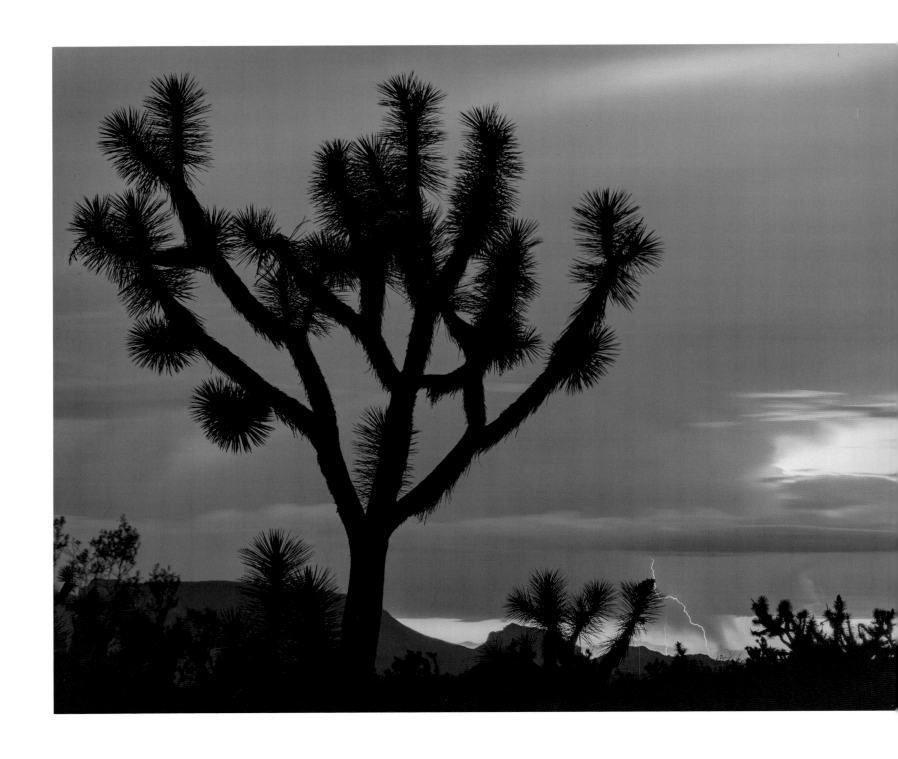

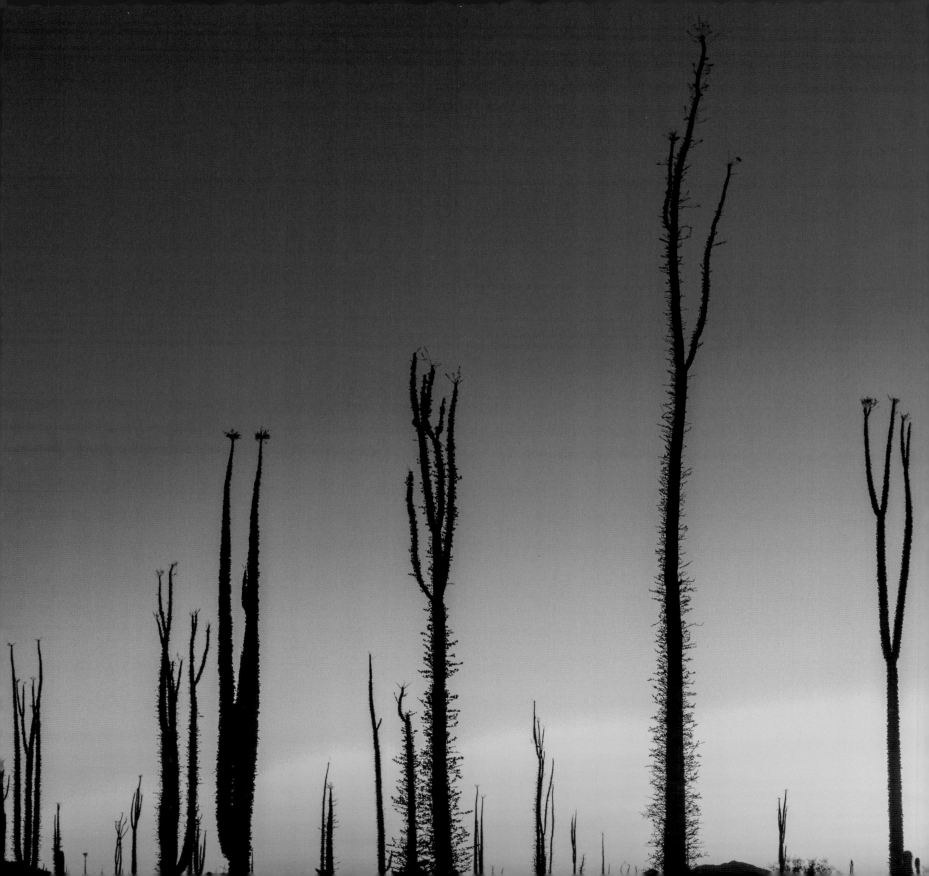

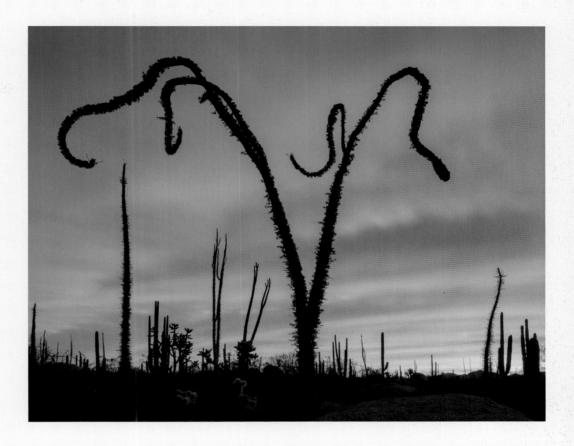

◀ **Boojum Trees**

My quest for Sonoran Desert images led me deep into Baja, Mexico. Another "marker" plant that defines this part of the Sonoran is the strange Boojum tree (though not really a tree).

Phil Hyde's amazing book *Drylands* exposed me to the wonders of Baja. His fleshy close-ups and spiny designs intensified my desire to explore the central desert regions of Baja Norte.

My first camp amid the strange silhouettes that looked like inverted carrots rising from the desert floor was a life-changing experience. With intermittent fog banks and the marvelous transition of crepuscular light, it was mesmerizing. The clean lines and bazar shapes drew me in like no other subjects. It was as if I had been assigned to document another planet.

A week flew by and I photographed too many situations to count. Yet this image's utter simplicity remains my favorite. The lesson I learned was that when situations are so inherently complete in their own design just honor the moment. Sometime you simply can't improve on nature.

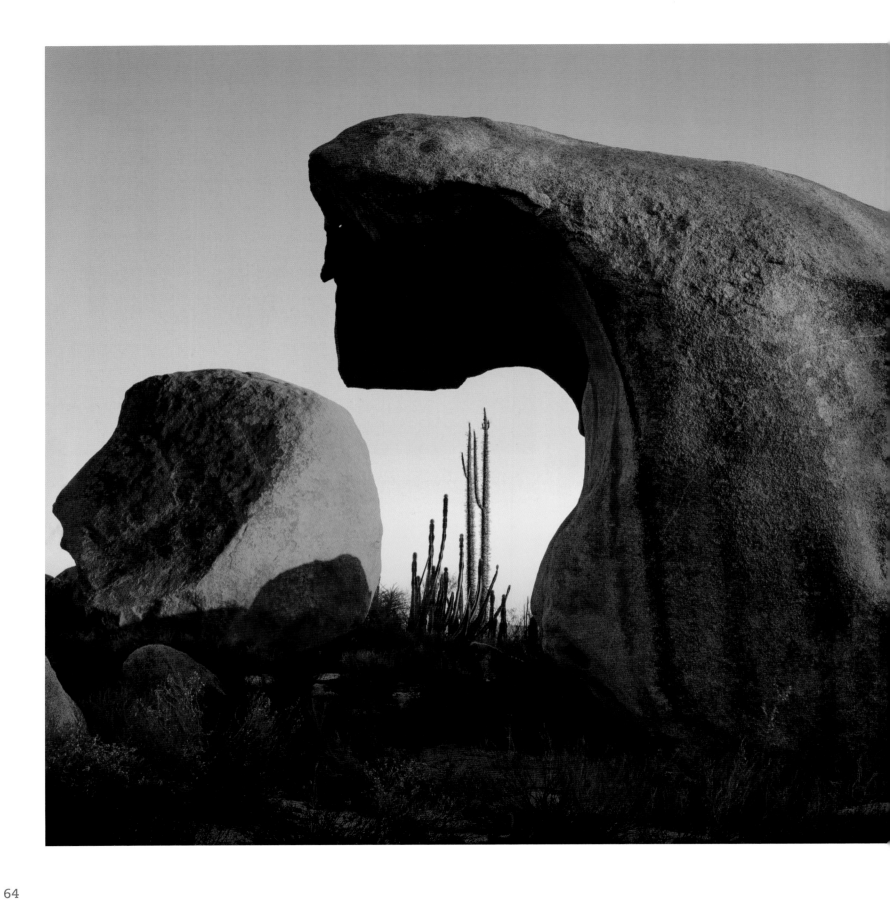

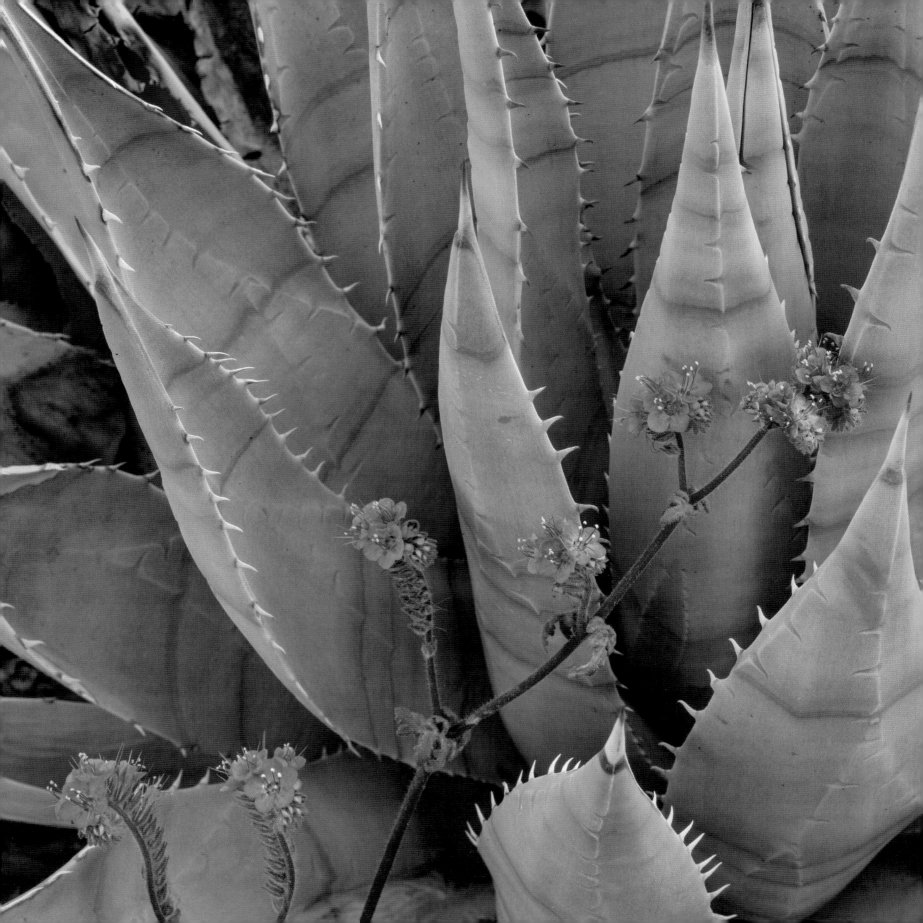

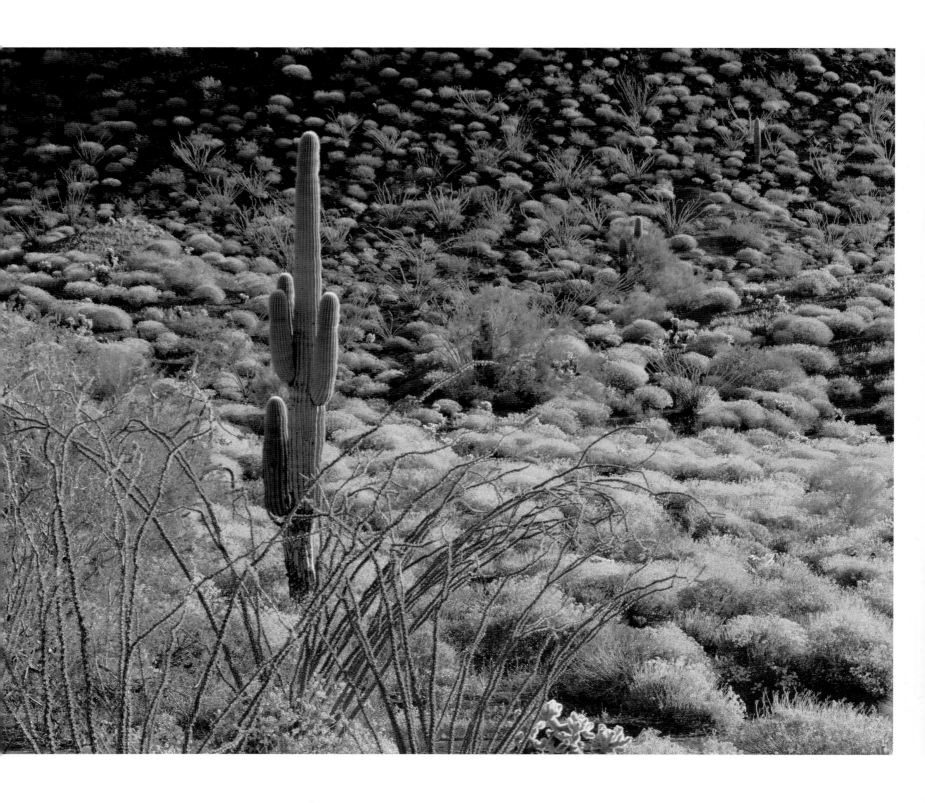

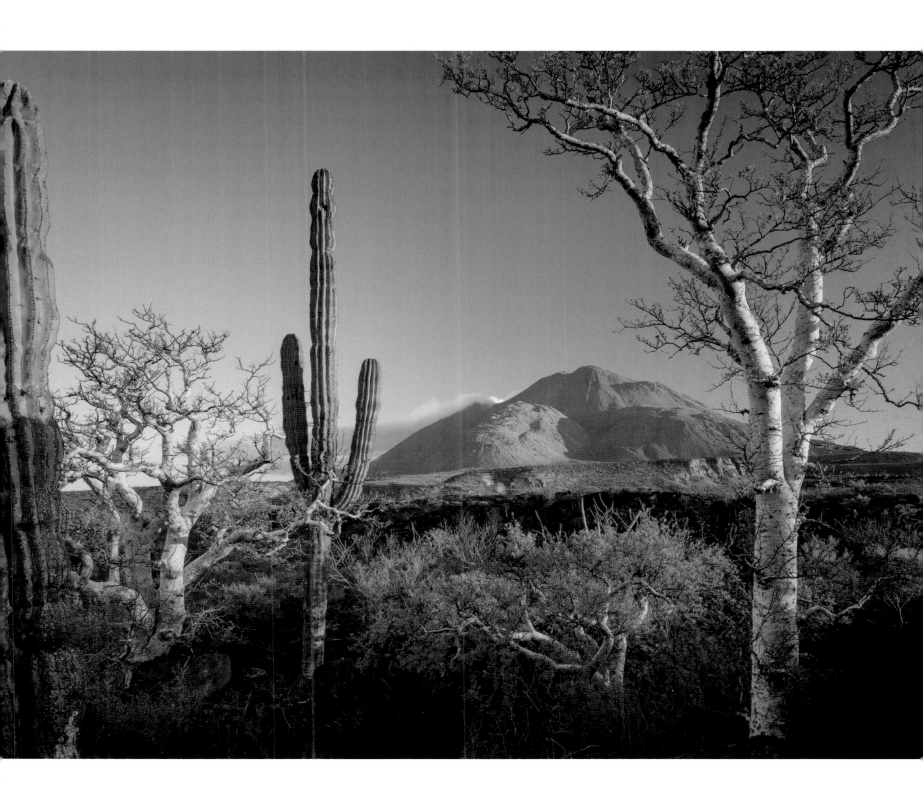

▶ Agave

On a remote dirt track near San Quintin, Baja Norte, Mexico, my little Toyota was limping homeward minus its third gear. Ginger Harmon held the map as we plotted our route. Her generosity in support of my *Sonoran Desert* book allowed me to concentrate on far-flung edges of the wondrous desert.

Even the best intentions and most ardent love of a place can falter after miles of a 4-40 road. That's a road upon which you can either blast along at 40 mph to plane over the washboard ruts, or creep along at 4 mph while trying hard to keep the truck from rattling apart.

It was one of those trips when my spirits flagged, even when fortified with a beer or two.

Yet on the hillside ahead, almost like a rescue beacon, colorful agave plants studded the desert foothills. Better yet, they were in various stages of turning color due to the extreme heat in the region.

As a journalist, an absolute must in telling the desert's story are images that graphically illustrate the unforgiving harshness of the land. Much as a tree's leaves change color in the autumn in the northern ecosystems, desert plants undergo incredible changes in color as well.

As usual, I hiked amid the plants until I located an agave that was glowing in the afternoon light and whose "blades" displayed colors from lime green to yellow to orange.

I wanted to visually compress the scene to emphasize the contrasting colors while stacking the jagged serrated edges of the plants against each other. I selected a 400mm lens and composed an image. I felt I was walking on a trail blazed by Philip Hyde.

I think about moments when passing bits of advice reemerge years later in the work we create. I realize how fortunate I am.

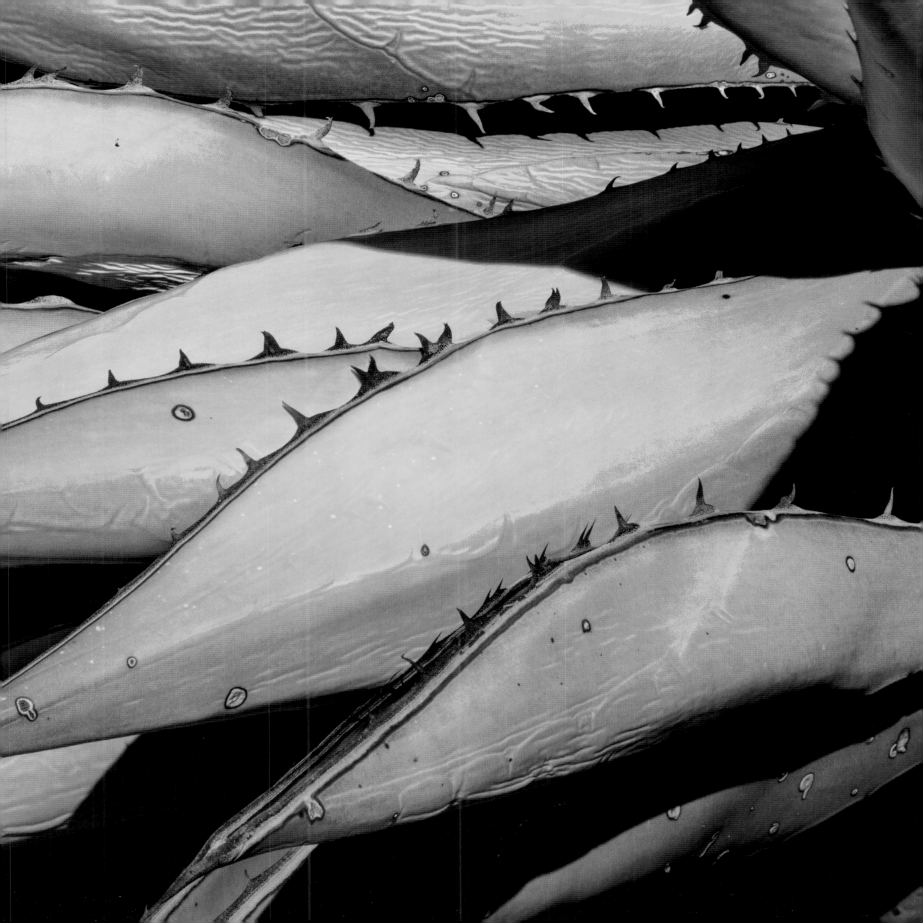

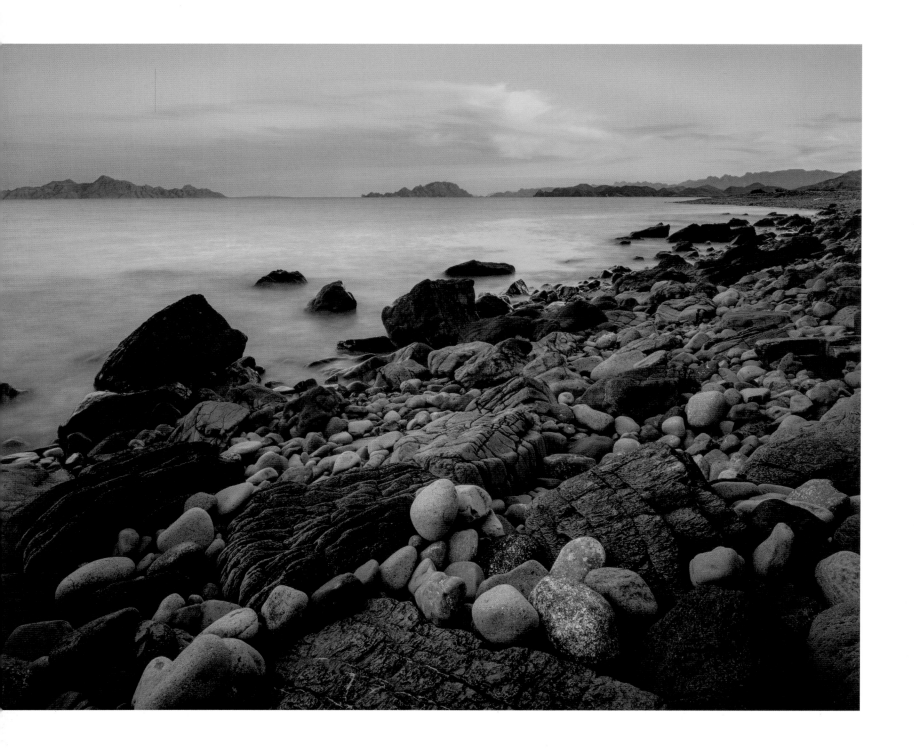

PART 5 **Finding the Path**

CHAPTER 8 Phil Hyde—Quiet Eloquence

I first became aware of Philip Hyde's photographs in the spring of 1975, while I was living in Chicago and deeply committed to photojournalism. I had stumbled upon an article in *Backpacker* magazine profiling a California landscape photographer whose work was making a difference in conservation efforts in the West. As I looked at his work, I had muttered to myself, "I want to be like Philip Hyde." I hungered for that sort of commitment.

Perhaps I was burned out on photojournalism. In spite of the inherent drama of images documenting the human struggle, I had begun to notice a recurring sameness. For me, both subject matter and technique were becoming cliché. Photojournalistic contest winners frequently resembled past winners. However, visual reporting on the environment was nonexistent—probably because the slow, subtle changes to our environment lack the appeal of the human condition.

I began to feel that the health of the planet was the most important issue of our time. With Adams's and Hyde's works as my guide, my direction shifted in an important way. I came to see the rate of destruction of wild places as a forecast of our extinction. I also felt that images of wild places need not portray the presence of humans.

I reasoned that I could still be a photojournalist while using a large-format camera to communicate the sense of place, using its unique ability to provide unparalleled clarity and detail. I wanted images to give viewers the true taste of the land.

With my secure job as Photo Editor behind me, I left the *Arizona Daily Star* with the romantic idea of becoming a wilderness guide and freelance photographer. I solidified my commitment to large-format film and began photographing with a beautiful cherrywood Wista 4×5 field camera.

I studied images by other photographers and eventually noticed styles and techniques put into practice in publications like Sierra Club and Audubon calendars. In short order the works of Larry Ulrich, Willard Clay, and Jeff Gnass joined David Muench and Philip Hyde as people to watch. Each had a particular way of photographing the land. Their images were similar, yet subtly different. I pored over their images to learn from their vision. Each of these photographers lived an enviable vagabond's life, following the life of the land, recording flowers, storms, and textures that make wild places so special. Living and feeling the land became visceral and essential.

I bought a camper and joined the cavalcade of a select few who actually eked out a living marketing their images. Of course, it was inevitable that my travels would intersect their travels. Fantastic desert floral displays were like beacons drawing dusty camping rigs with leather-skinned artists to "secret" places. I became friends with Larry and Donna Ulrich, Willard Clay, Jeff Gnass, Jeff Foott, Pat O'Hara, John Shaw, George Lepp, Jerry Jacka, and Bob and Suzanne Clementz.

These were heady days when we felt camaraderie while still competing to get our images published. I became like a sponge and listened to any stray tips. Larry's expertise and solid advice led me to begin using an Arca-Swiss camera that employed the greater movement potential of a monorail view camera. The images I began making with that camera were of a wholly different quality.

One of my flower-seeking trips led me to Organ Pipe Cactus National Monument, where Park Ranger Caroline Wilson asked if I wanted to meet Philip Hyde. "Of course!" I said.

Far from the competitive breed of top-tier landscape photographers, Phil had a quiet grace and understated humor. He was a great listener. Here was a man who didn't need to brag or posture. Phil was a legend. And his advocacy for the land, combined with a more subtle approach to making images, made him special.

Phil and I hit it off and we sampled Mexican food together with his wife, Ardus. I learned much from Phil in terms of using smaller, technically superior process lenses, and from watching his economic style bring his images to life. He resisted using the bright colors of Fuji films, preferring the subtle tonal range of Ektachrome. He knew what he liked.

Our travels together expanded to trips into the "buried range" engulfed by "star dunes" in the Mexico's Sierra del Rosario. Phil's mastery of packing his equipment was apparent in his tiny Datsun, where interlocking boxes were fitted like puzzle pieces to form a bed. Everything had its

place. This was something I noted. Minutes after setting camp, Ardus had the uncanny ability to produce healthy, gourmet meals from a collection of canned goods and fresh vegetables.

Our affinity for Baja's Sonoran Desert took us south down the remote gulf coast toward a series of increasingly steep hills know as the "Terrible Three." Our route was a gravel path dissecting the steep coastal hills. We used the lowest gear and four-wheel drive to negotiate the most precarious sections. Any doubts about why it was called the "Terrible Three" quickly vanished as we crept upward past arroyos strewn with smashed Volkswagen vans forming a virtual auto graveyard. Bienvenidos a Baja!

While on one trip together in Baja, Phil shook his head as he watched me erect a nylon tent to create diffused light and shield desert flowers from the wind. His approach was purer and devoid of overpowering the landscape with more equipment. He had a deep sense of "the voice of the land" and wanted his work to be more about the place than about himself. He taught by example about the "voice" of an image. He chose to whisper at a time when many were shouting. That's not to say his images lacked impact, but he had a sense of pace that allowed him to offer "a sense of place."

I was in my 50s and was in good physical shape, and Phil was perhaps twenty years older than me. We camped amid giant granite boulders that define the landscape of Catavina in Baja's El Desierto Central. Boojum trees—looking like giant carrots inverted into the desert landscape—created a magical forest landscape. Climbing to the top of a huge boulder was essential to get an overview of the entire bizarre world. I scrambled to the summit and after making several images I headed down to where Phil was just beginning to climb. It really was quite steep, so I offered my hand to pull Phil up a difficult section. I'll never forget the expression on his face that said, "I've been doing this since before you were born." He shot past me.

I loved to share images with Phil. His advice was like gold. Before publishing my *Sonoran Desert* book with Abrams, I had journeyed to the Sierra Club in San Francisco to see if they'd publish the book. To this end, I assembled storyboards showing my idea of a potential layout. They looked at my proposal and quickly informed me it wasn't something they wanted to do. I was devastated.

With San Francisco in my rear-view mirror, I headed to Phil's home in Taylorsville, California. All the self-doubt came pounding into my head as I gained altitude. I felt pretty beat up.

Phil's home, called Rough Rock, had a familiar Virginia creeper vine ascending near the front door. Phil's ready smile and elegant demeanor was evident as I poured my heart out, telling him about the shabby treatment I'd received at the hands of the Sierra Club's book editors. Phil had an amazing ability to raise his voice several octaves when upset. He startled me with a shrill, "THOSE IDIOTS!" It no longer mattered what the Sierra Club thought. The master had spoken. Phil liked my work. I had arrived.

Phil's style with understated color realism taught me that the language of photography, like music, could be played at many different volumes. The tranquility of certain images demanded attention without screaming. Phil's communication occurs as a powerful whisper.

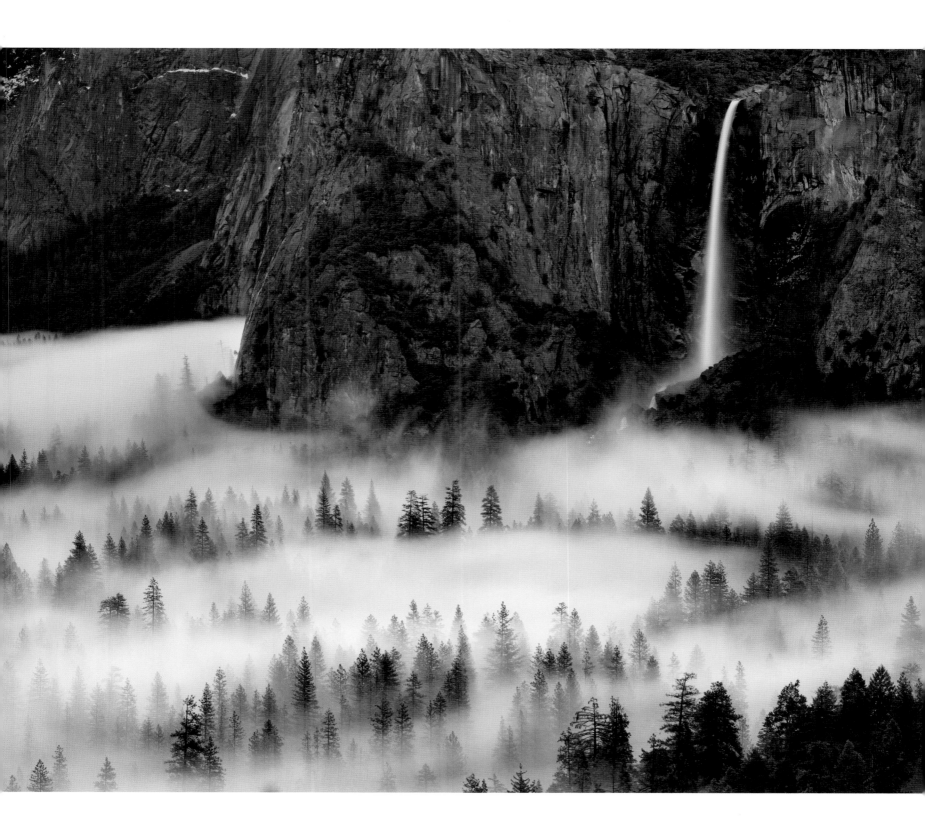

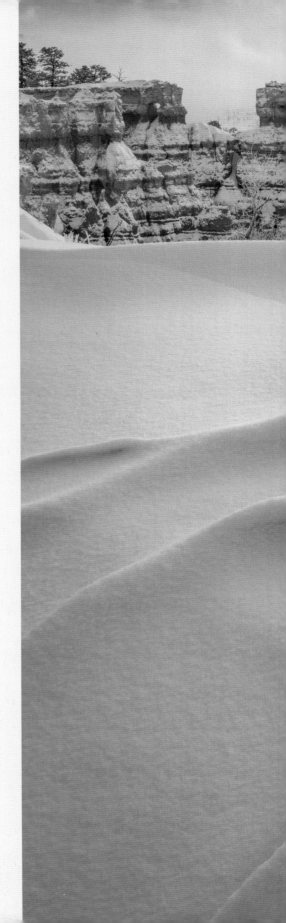

▶ Bryce Canyon

Many of our national parks are overrun with tourists in the summer months, yet the bitter cold winter months can still supply heavy doses of magic, and with few visitors. Solitude is that precious commodity that helps me produce my best work. Plodding along in the predawn light affords me the contemplative moments that germinate creativity.

This day, a world of reds and blues was hushed under the weight of new snow along the Bryce Canyon rim. The rising sun's promise was literally cooking the moisture and rising into a screen of fog.

One of my favorite subjects was happening before my eyes. Layer upon layer from the foreground to the background was crammed with excitement and design. Radiating lines of a limber pine grabbed my eye as the full drama of the canyon light unfolded.

I thought, this is happening *now*, and thoughts about the leisurely pace of landscape photography were forgotten, as the need to photograph quickly demanded action. I threw my pack down and in a fluid practiced motion, selected a lens brightly labeled as 80mm (80mm Schneider Super-Symmar) and slammed it onto my waiting Arca-Swiss F-Field camera. In a practiced sequence of events, I opened the shutter, opened the aperture, attached a focusing cloth, checked focus with a loupe, adjusted focus near and far by tilting the back, made slight changes in the composition while watching the corners in the foreground, closed the shutter, stopped down the lens to f/45, metered the light, checked that all movements were locked, and then loaded and exposed film as quickly as possible (allowing for camera vibration to stop). I silently counted the several second exposure times.

The key is possessing muscle memory that rapidly connects one's vision to the mechanical process of image making, which would otherwise be both tedious and slow.

The entire sequence takes about thee minutes.

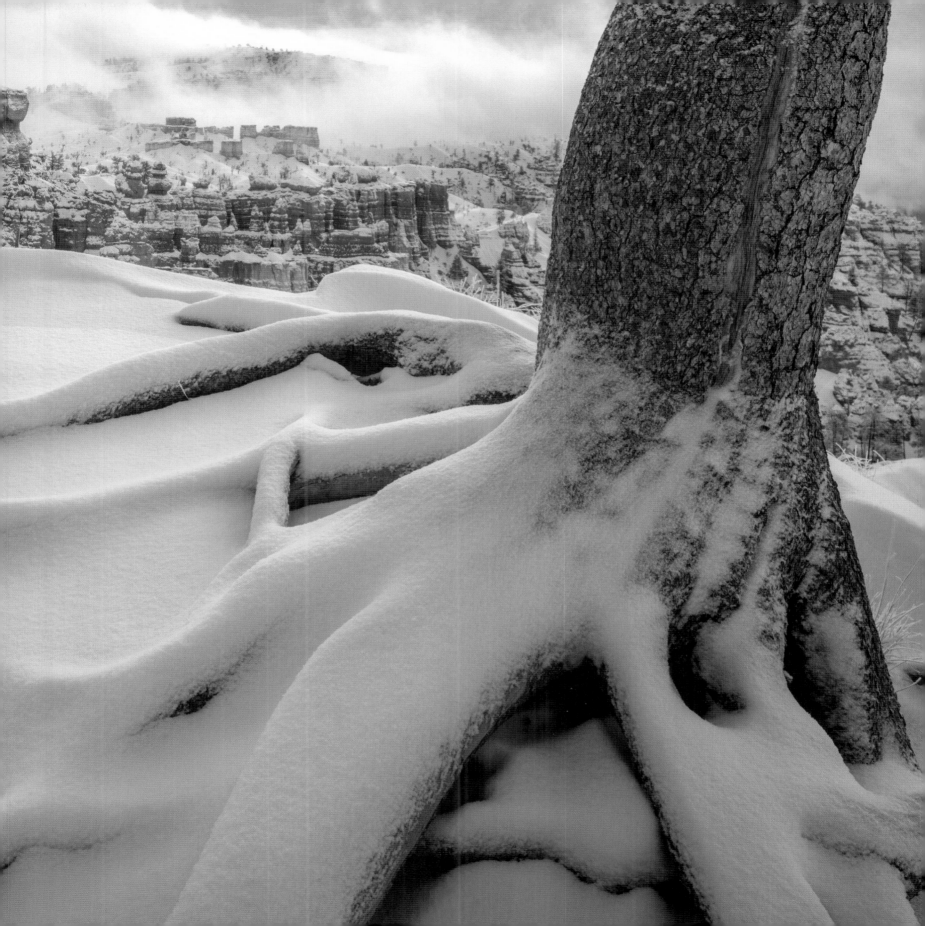

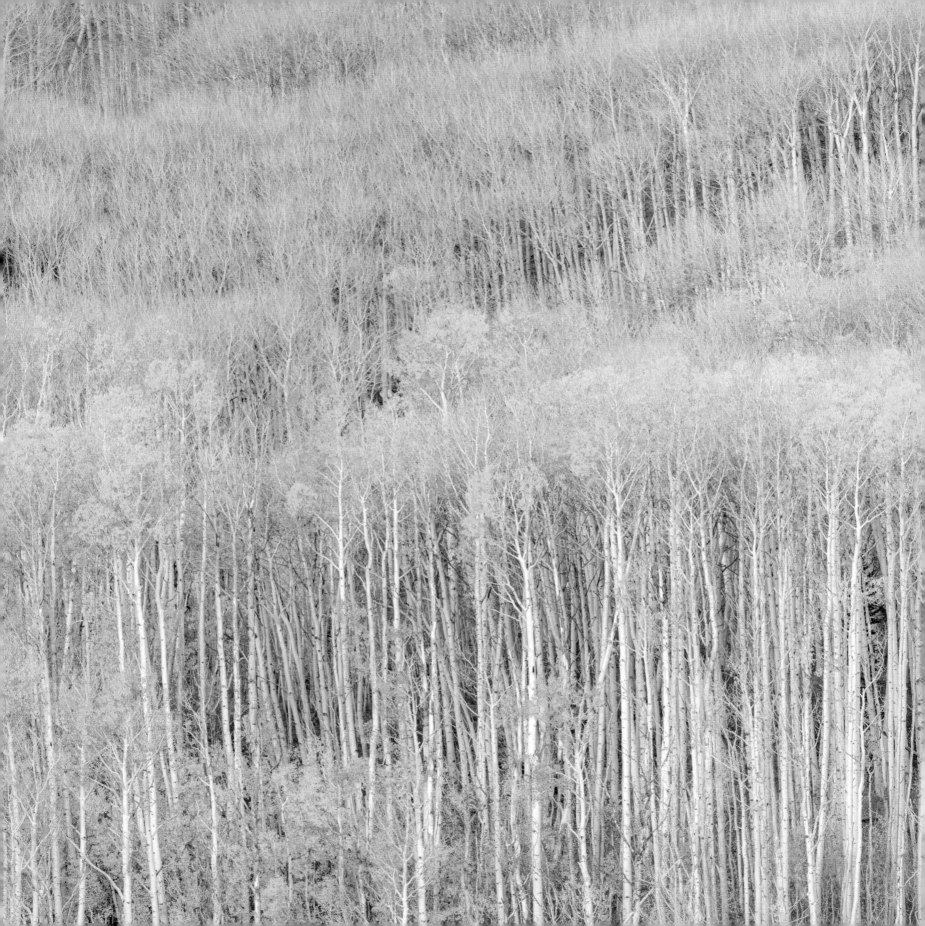

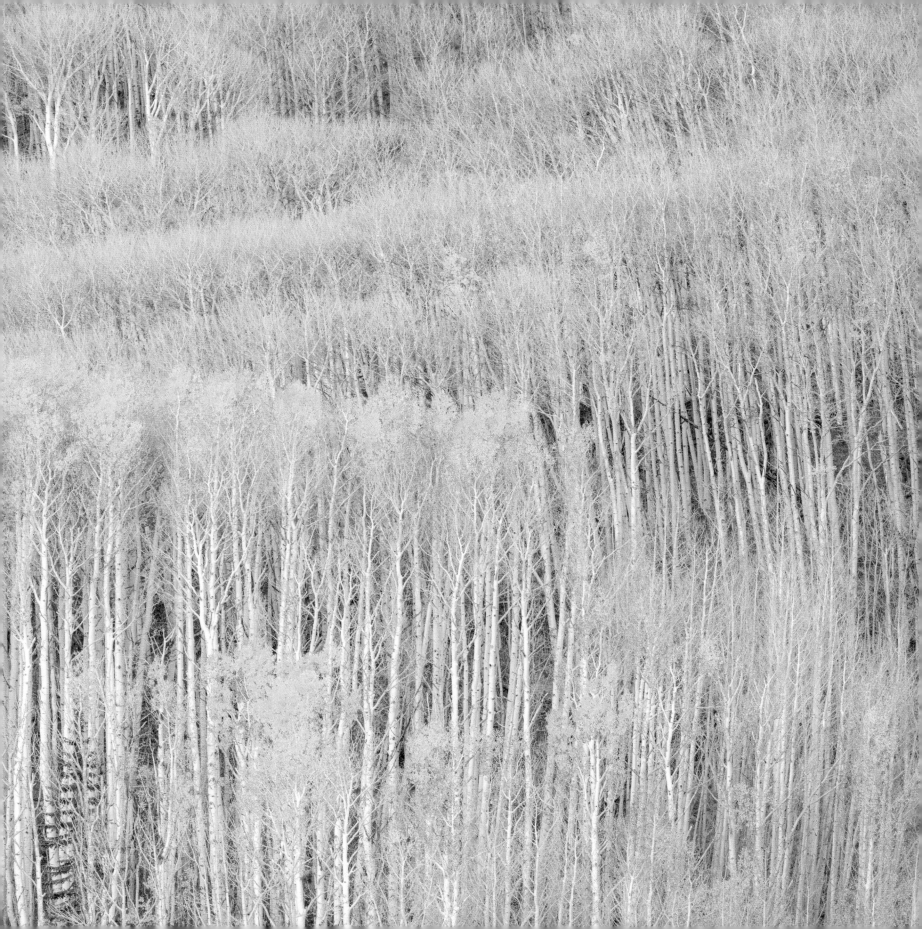

◀ Aspens of Boulder Mountain

Image making has changed dramatically in the past decade. First film got better, then digital arrived, then digital got better, then the software got much better.

For thirty years I have made images with the wondrous 4×5 large-format view camera that Arca-Swiss created for my left-handed preference. There was no finer camera in my life. It was more than a camera . . . it was a passport to a lifestyle. I could slip into my focusing-cloth retreat to practice contemplative Zen photography.

Yet the very size of the format made really long telephoto lenses nearly impossible without a parade of tripods supporting a very unwieldy machine. So, the whole time I worked with large-format cameras, I found myself longing for the range of lenses that I used as a photojournalist. I wanted the ability to stack foreground against background, compressing design elements with a flat two-dimensional look.

When digital arrived, I was suddenly able to use a full compliment of lenses that Nikon made, including extreme telephoto optics. Yet in the beginning, the digital sensors rendered only about six megapixels.

Enter Nikon's D800 and D810 series cameras. They churned out 36 megapixels of incredible data. So, at last, I was able to create high-res images that could utilize the growing array of telephoto lenses I had acquired. By using a leveling head from Really Right Stuff with my 500mm Nikkor lens I could photograph in the vertical orientation, panning across my subject, and then stitch them together using either Adobe Lightroom or Photoshop CC to produce files that equaled my large-format work.

So I pointed my 500mm tonnage of optical glass at the dense stands of aspen. My intention was to stack layer upon layer, creating a wall of aspen trunks. The trunks shimmered in the cool predawn light. The remnant yellow aspen leaves were doing something I rarely see. They were not moving! And there wasn't even a whisper of wind. Employing live view on my camera's monitor, I lined up my composition. I opened the lens wide and focused, before setting my exposure aperture. I took a photo of my hand to mark the sequence and then I started my series of six vertical images that, when stitched together, would become a 650 megabyte file.

The perspective gained with telephoto panoramas is wonderfully horizontal, allowing a view that compresses subjects, which in this case were at least a quarter-mile apart.

I have printed this image at 60 inches wide and the results are stunning. My wonderful Arca-Swiss gathers dust in my closet, yet I'll never sell that masterpiece . . . and I still have film frozen and ready.

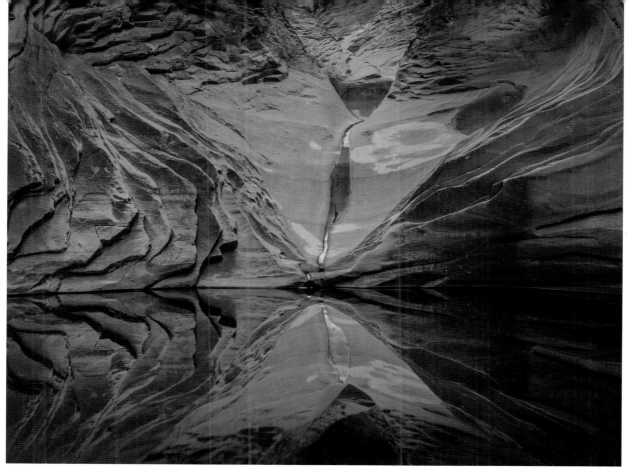

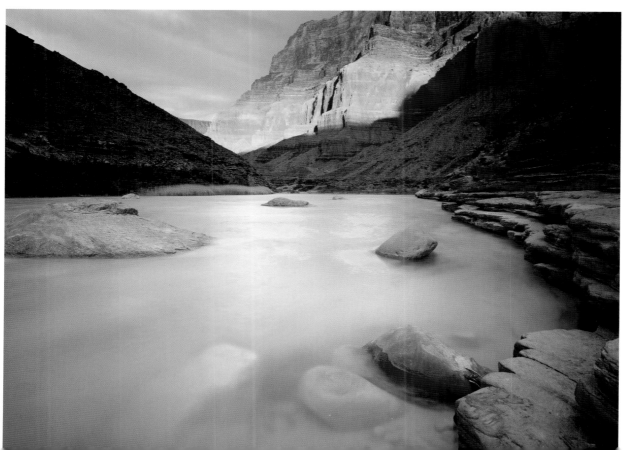

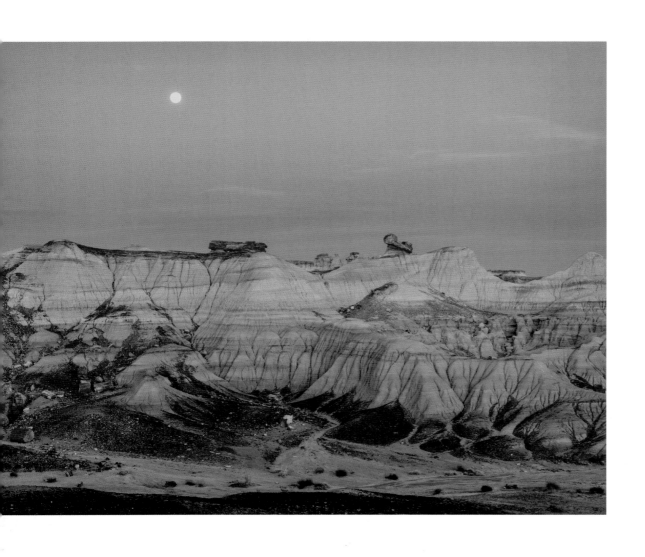

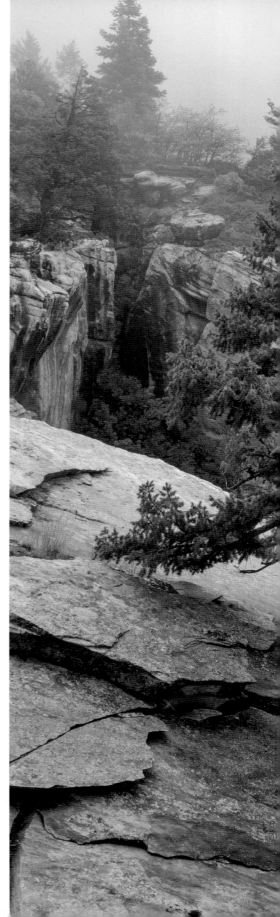

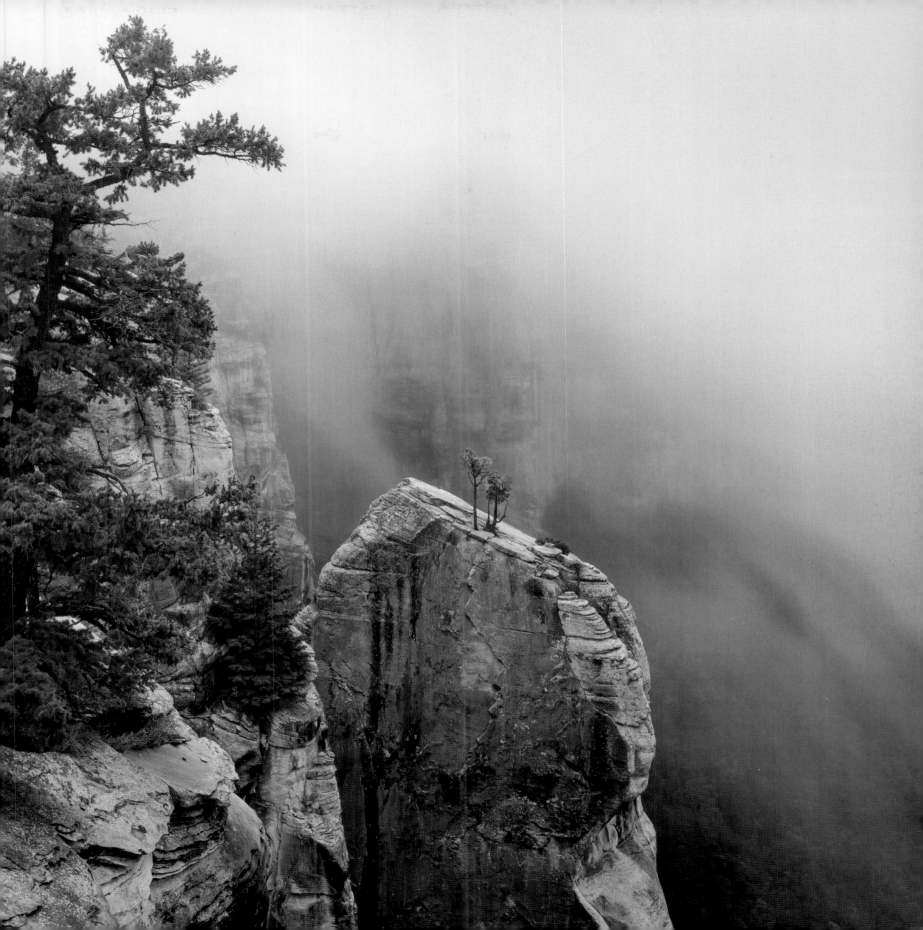

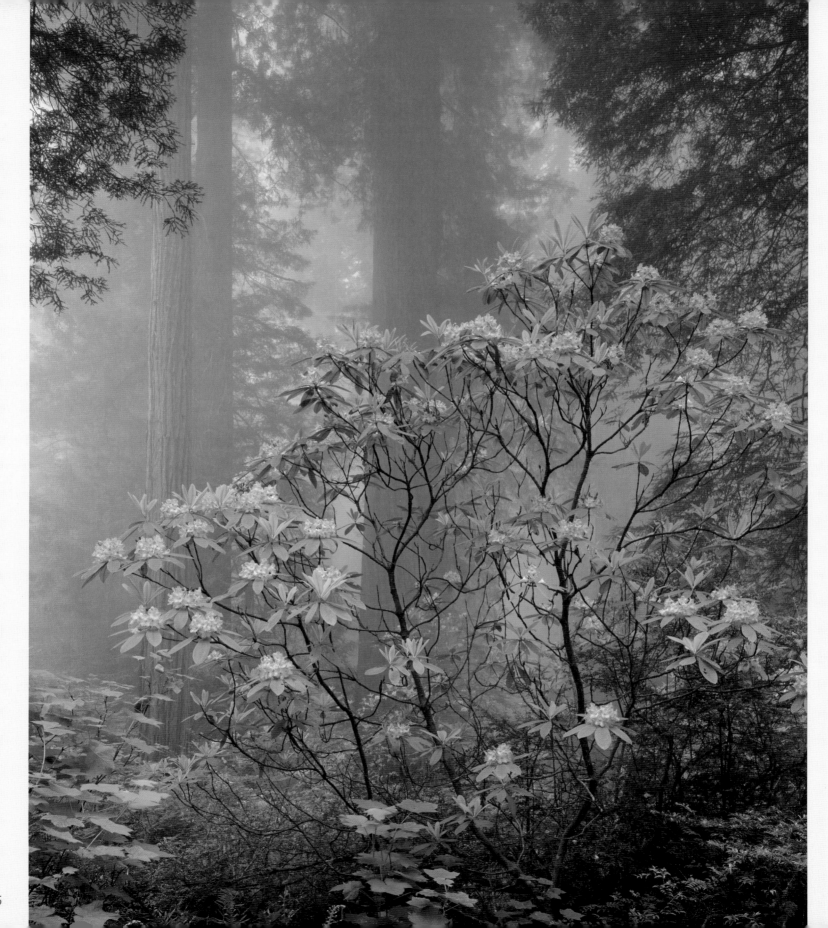

◀ Rhododendron in Redwoods

The harsh light of the desert was a distant memory. The wide expanses with an endless sky over sparsely vegetated landscape demanded an equally expansive approach. The land dictated a wide-angle lens approach. Yet that wide vista approach seemed out of place as I walked the Redwood National Park trails of California.

The soft wet light was also a soothing contrast to the brilliance of the Sonoran Desert. Here, the colors were cool. And redwoods screened out the light's intensity with dense canopies dimmed further by coastal fog. In the deep shadows, patches of intense color originated from the rhododendrons flowering near the forest floor.

My vision was to place the pink flowers against the wall of towering giants. I needed a normal to slightly-long focus lens to create that juxtaposition of the central elements. In every situation there are specific problems to overcome. Here, I needed to use a lens with limited depth of field at a large enough aperture to work in the dark forest, and with long periods with no wind to permit 20-second exposures.

On top of that, I was painfully aware that colors shift dramatically during very long exposures. So, a color correction filter was needed to compensate.

I love challenges.

I used a 180mm APO Schneider Symmar lens to produce dazzlingly sharp images, sheltered the lens from the light drizzle, and waited for that wonderful time when the incoming coastal fog reached equilibrium with the warmer inland air. At that point, with my composition locked in position, I waited as the fog diffused the background redwood trees enough to provide a clean separation of the delicate sinuous rhododendron trunk.

As I made the exposures, I was a mix of compulsive nervousness and detached observer savoring the moment. Decades of great photographers added layer upon layer of landmark work that has filtered through my eyes showing me the way. Phil Hyde's book *The Last Redwoods*, published in 1963 by the Sierra Club, actually is the reason this magnificent place has been preserved. He is the real hero and sometimes I can feel his gentle nudging.

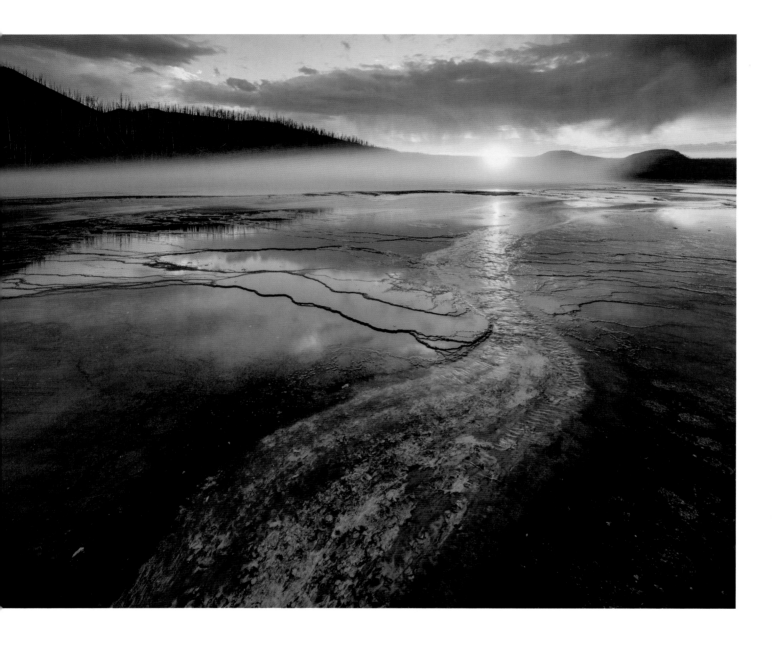

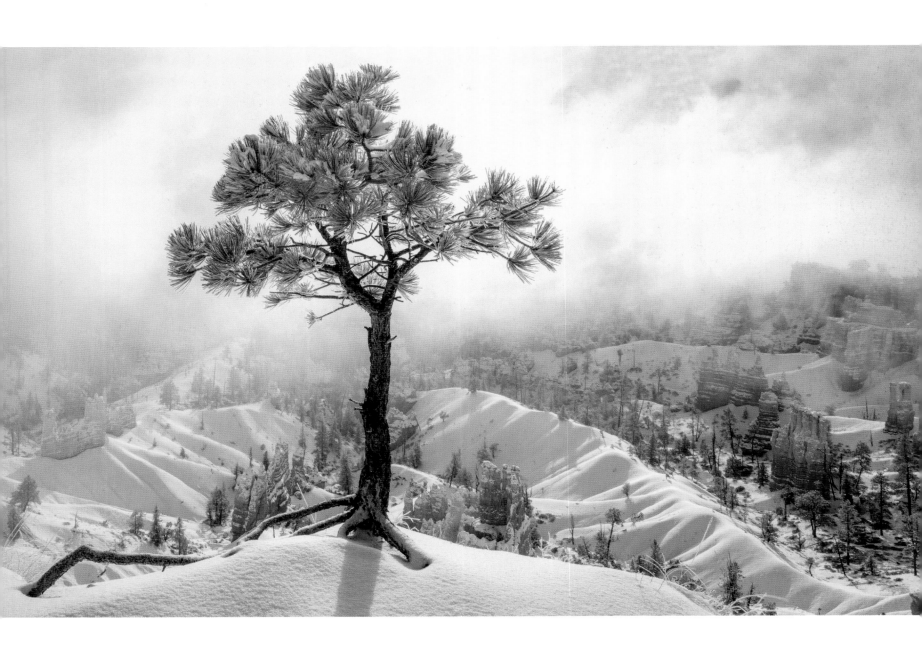

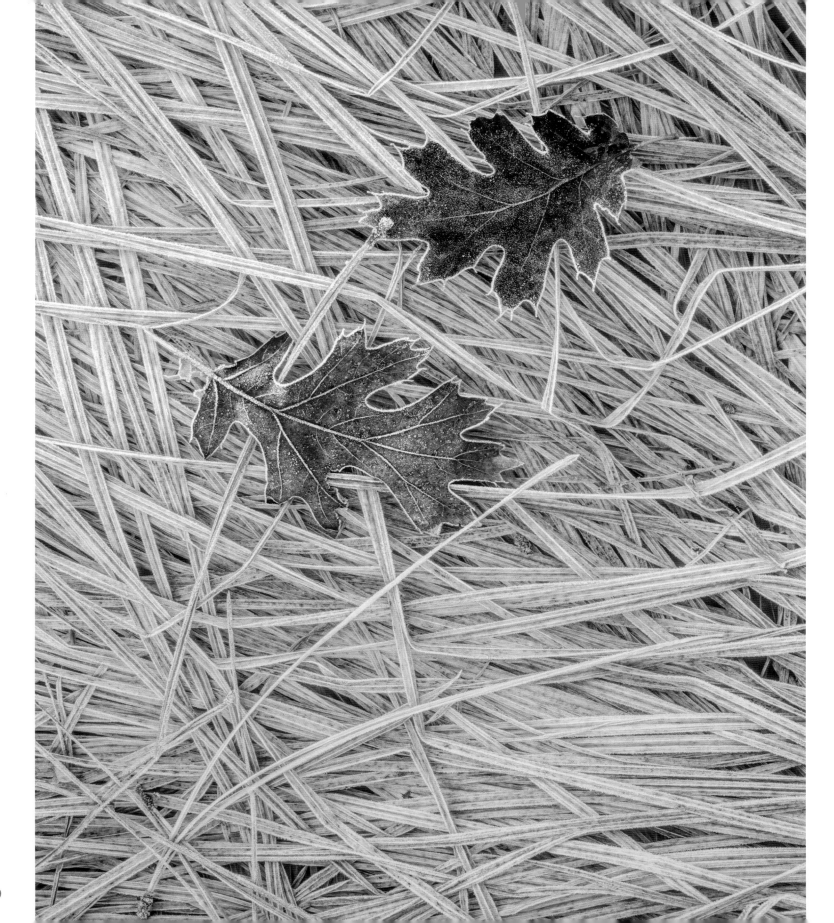

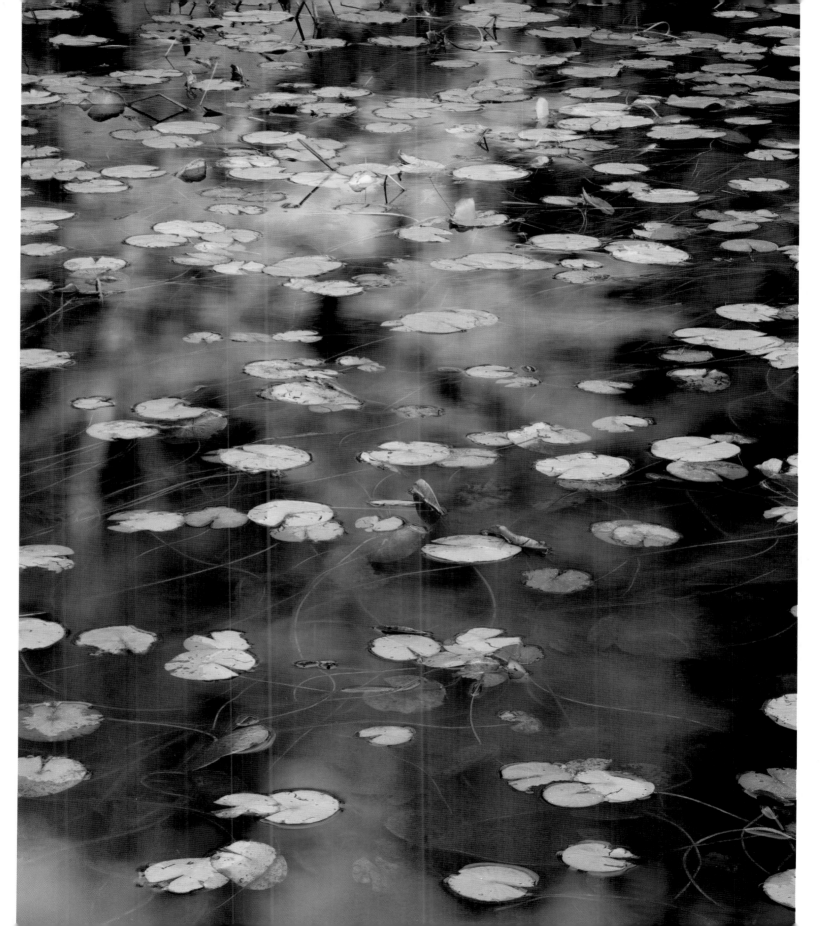

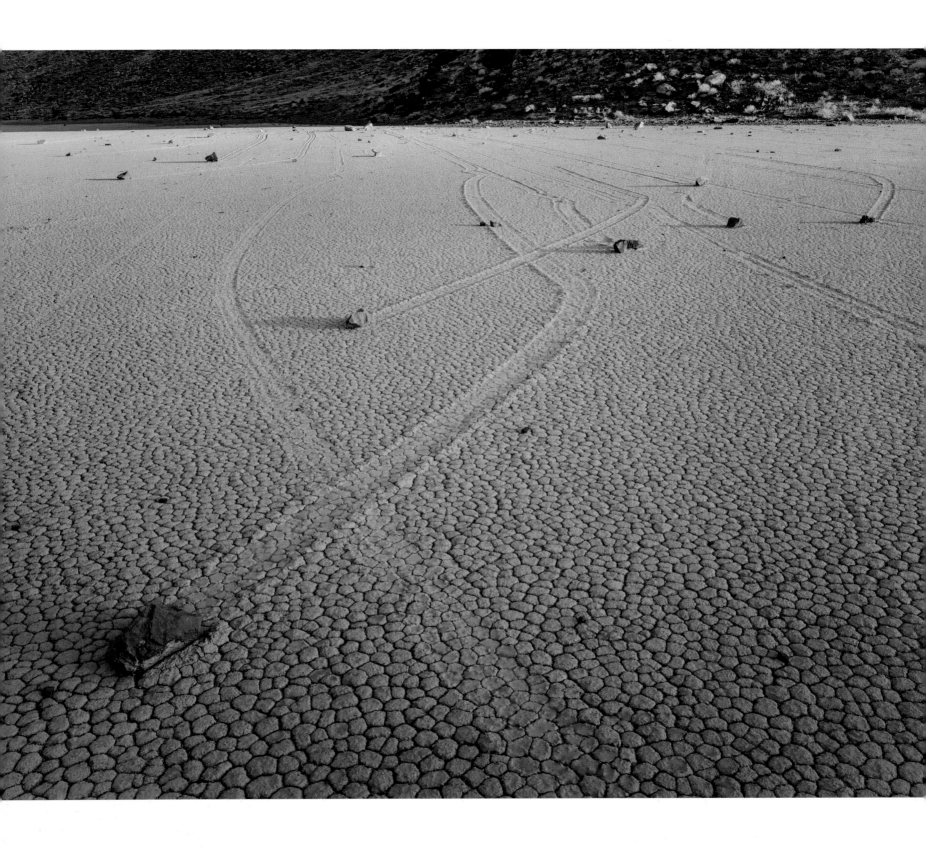

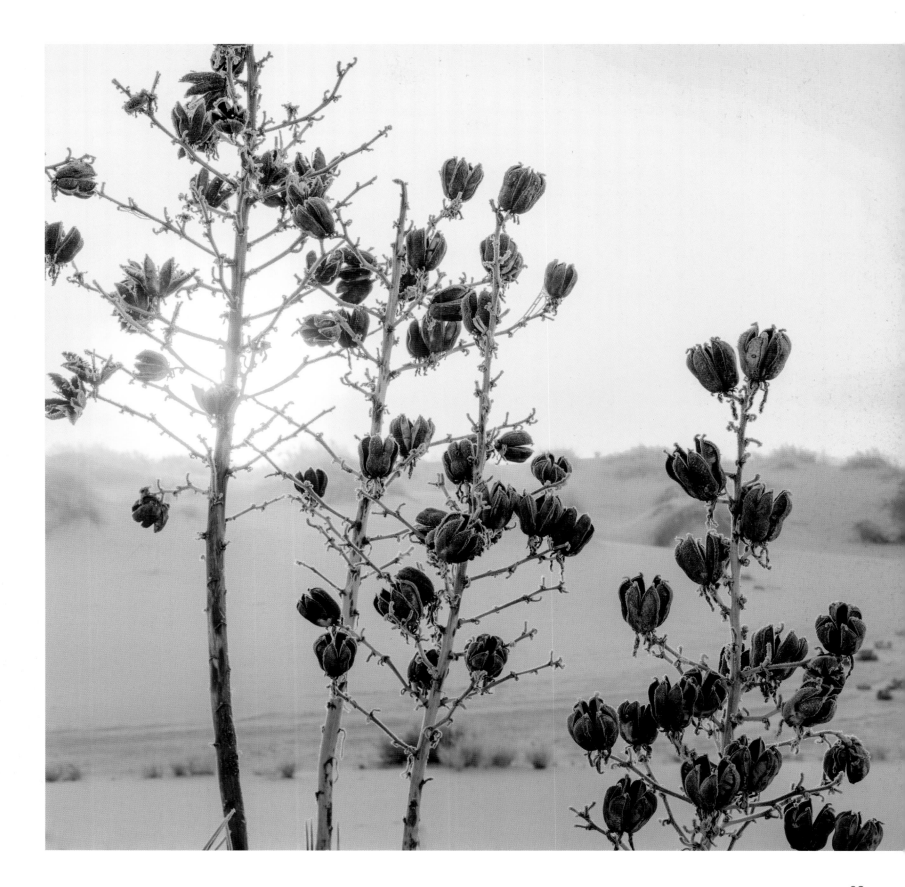

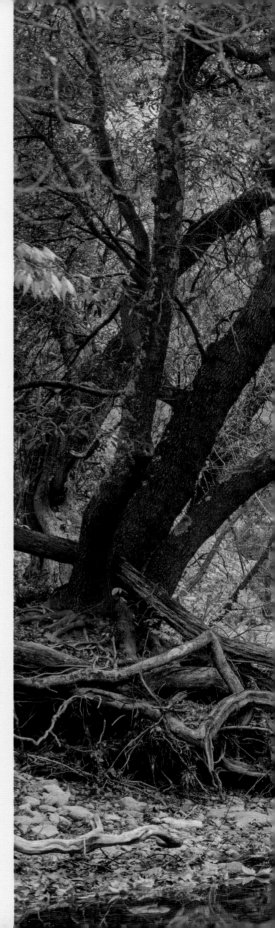

▶ Sycamores

My assignment was to record the remote wilderness canyon east of Tucson, in the Galiuro Mountains. It was autumn in the desert and this canyon was known to be an upside-down environment: The high mountain ridges were nearly devoid of large trees, yet in the riparian canyon bottomland all manner of trees flourished.

The short walk from my four-wheel drive truck's last safe parking spot turned out to be not so short. At times like that I wished I wasn't so optimistic about distances.

When I began to descend into the canyon along a steep grade that was the remains of a long forgotten jeep road, I saw why the traffic here was light. Below my route were the scattered, rusted remains of trucks that didn't make it back.

After silently congratulating myself for discretion, I trudged deeper into the canyon.

Thoughts of trucks, bad roads, and the weight of my pack vanished as a world apart appeared in front of me. Arching lush canopies of ancient

sycamore trees with their white bark shining amid their autumn foliage spoke to me instantly.

I dropped my pack and circled the scene, locating reflection pools that complemented and enhanced the effect of pastel color in the softest possible light. I recalled Phil Hyde's preference for Ektachrome, while most landscape photographers were using Fujichrome's vibrant palette. I did, however employ Fujifilm's superior emulsion because I had come to appreciate its qualities of preserving contrast in softly lit scenes.

This was a scene with no need to deceive the viewer with wide-angle effects or wild camera angles. This was a subtly soft pastel scene so painterly that it literally composed itself. I just had to show up for work.

I employed a lens that Phil favored: a tiny 240mm Fujinon "process lens" that was both light weight and very sharp. Together with my light-weight cherrywood Wista camera, hiking deeper into the wilderness became possible.

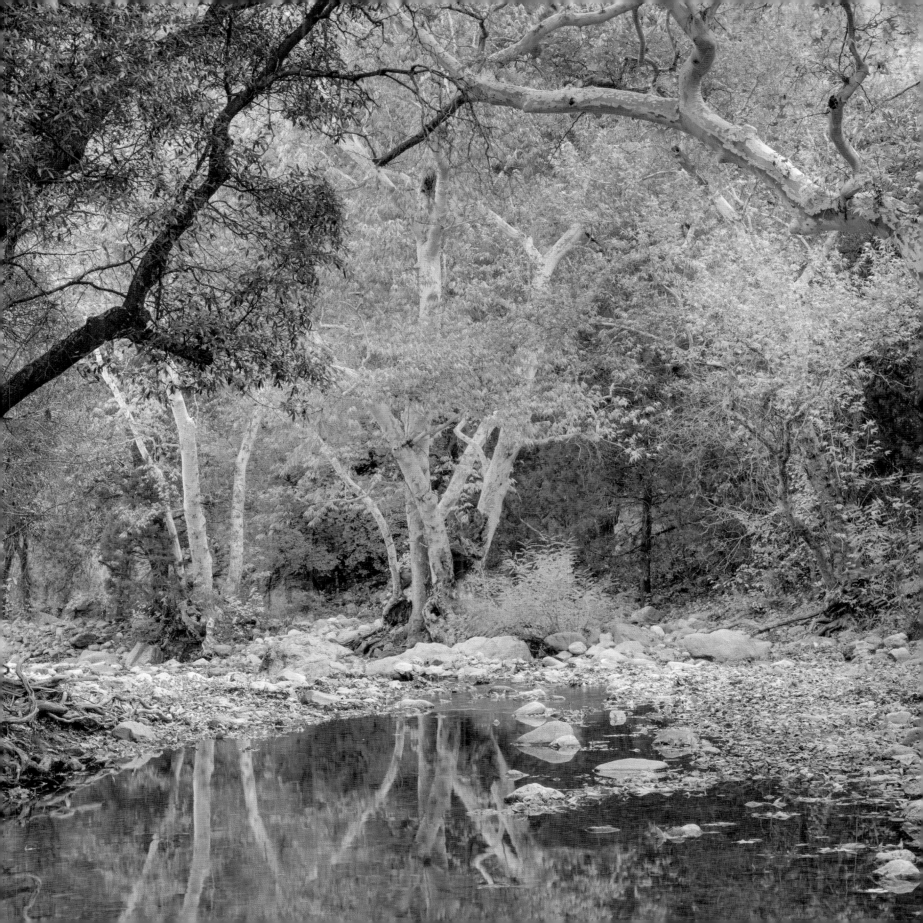

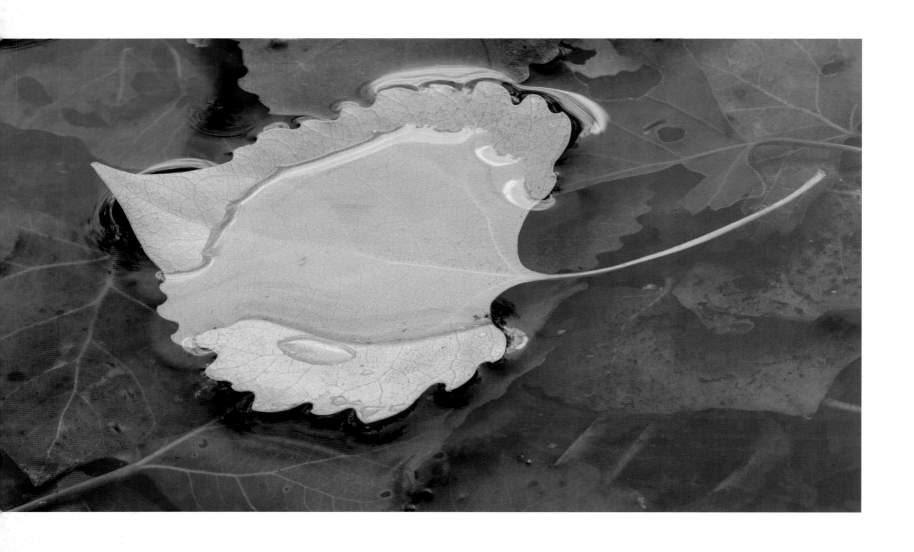

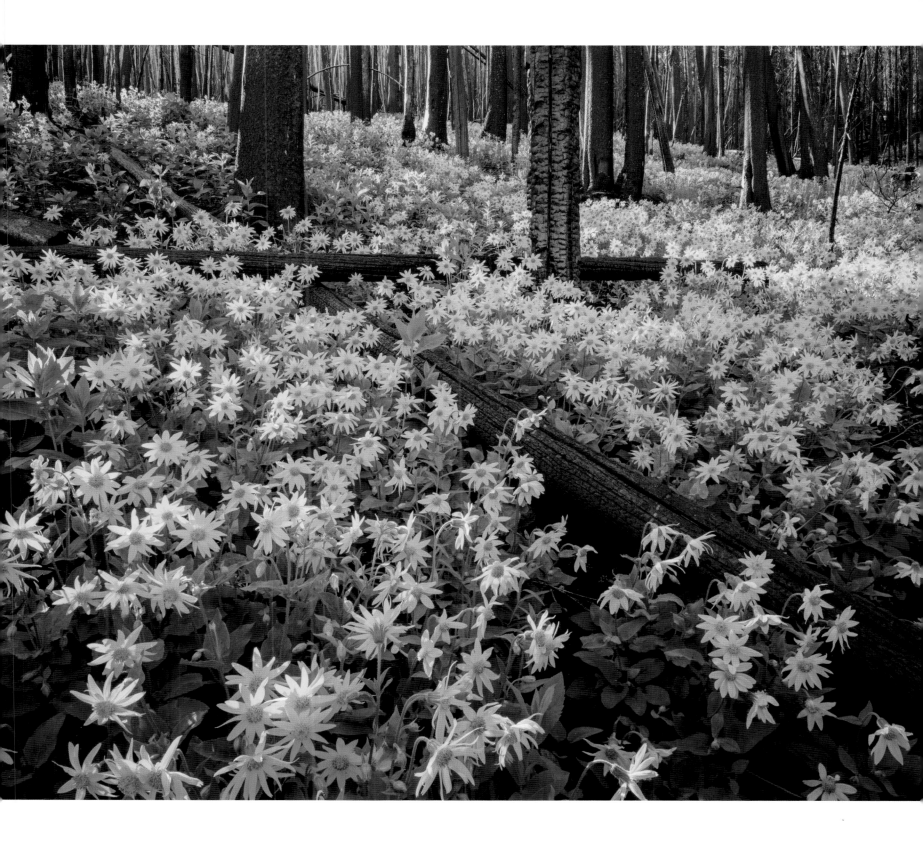

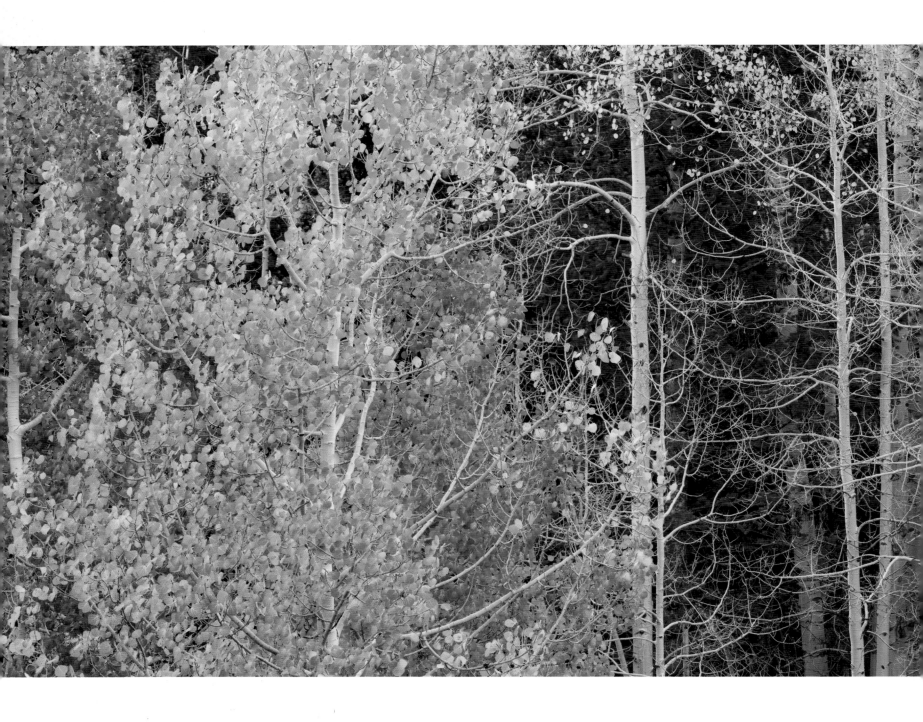

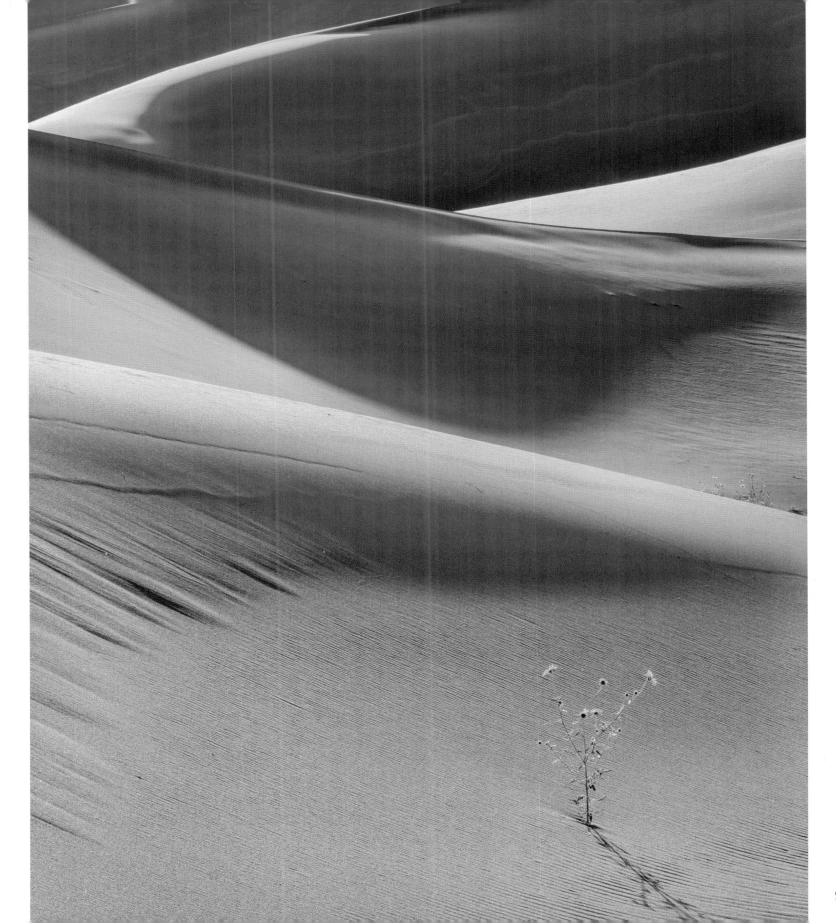

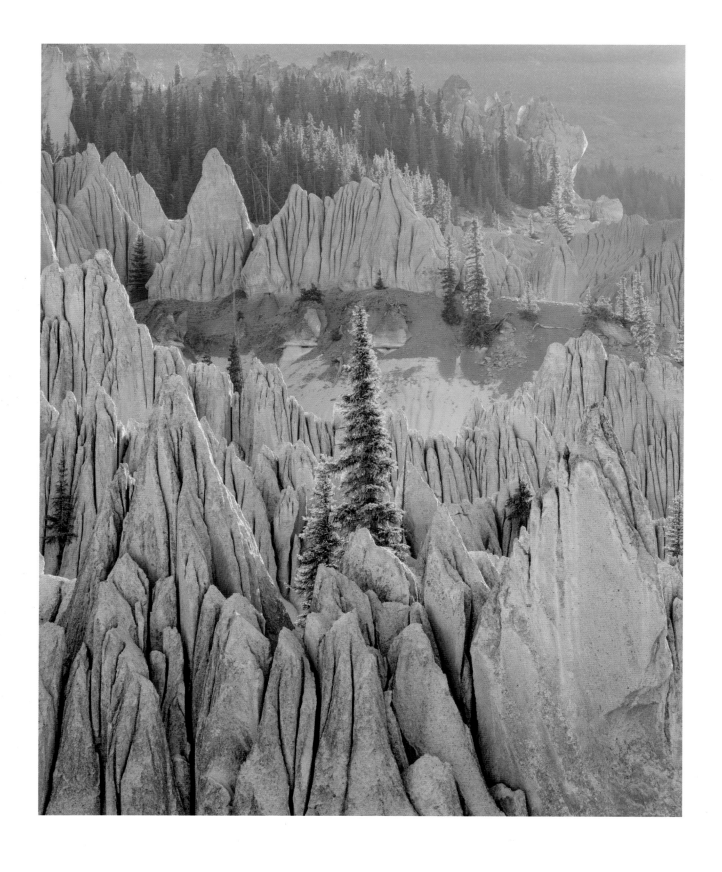
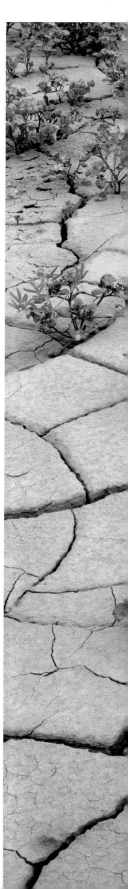

CHAPTER 9 Bowden—One Person Can Make a Difference

It was 1981 and I had an idea (apparently ahead of my time) of leading wilderness trips while teaching photography in the field. Southwestern Wilderness Travel was born. I remember leading amateur photographers through Paria Canyon's 36 miles of boulder-strewn wading, quicksand, and brilliant sandstone walls dissecting the Colorado Plateau. It was heaven. Carrying a double pack (a client suffered a leg injury and couldn't carry the load), or wriggling from my bivi-sack in a rainstorm that had transformed our camp into a muddy pit, seemed wonderful. Shouldering my pack, with horizontal rain pelting my face, I couldn't stop smiling; knowing the worst day in Paria was better than the best day at any newspaper.

Sea Change

Economics, however, interrupted my love affair with my wilderness photography business, which was barely braking even. I had purchased a used van and expenses were mounting, while income remained elusive. In desperation, I devised a plan in which I'd promote my unique business venture to *Arizona Highways* magazine.

I headed North to Phoenix to meet Wesley Holden, Managing Editor of the magazine. He listened politely to my pitch. He sat back and stared at me while making a counter offer. He liked my images, but he asked if I could photograph with large format cameras. My beginnings in photography were with a Speed Graphic, so I said, "Sure." But, I had no clue how to really use a large format camera. I just knew it was big. I bought a well-used large format Crown Graphic press camera. Wes suggested I head to Ramsey Canyon, where a young writer was doing a story on the Nature Conservancy and their preserve in the Huachuca Mountains.

Two things happened: First, I began a life-long relationship with the premier landscape magazine, and second, I met Chuck Bowden, a gangly writer with an uncanny resemblance to Fess Parker, the actor who portrayed the Davey Crockett character of my youth.

Chuck and I circled each other like two dogs assessing their allotted territory near a fire hydrant. Much chest pounding and posturing was designed to let the other know how extremely fortunate he was to be in the company of such a skilled professional. What began as a match, turned out to be the beginning of a life-altering friendship. Together we produced many articles and seven books.

Chuck

Meeting Chuck Bowden was one of those once in a lifetime encounters, where the raw talent is nakedly visible . . . all the time. There was no pause button with Chuck. His mind was quick and the depth of his eclectic reading was evident as he lectured more like a preacher than a journalist. There was urgency in his messages. "You need to know this!" He was also the best reporter I ever worked with. His keen observation skills made him the only journalist I ever really listened to. When Chuck said something would make an image, I'd take notice. Conversely, when I had a particularly strong image that needed more space, Chuck was quick to cut the story.

Chuck's bona fides were solidified for me while we were hiking in a remote piece of desert real estate know as Tinajas Altas. We were working on a story of this harsh area's history of killing off generations of people from early prospectors to present-day Mexicans racing toward a better life. Chuck lagged behind and I backtracked a hundred yards to discover Chuck bent over with pen and pad in hand, carefully examining a tire. A TIRE. He was interviewing a tire! My incredulous reaction turned to admiration as I watched him scribble the tire's name: "Lifesaver Radial."

Our relationship was a series of journeys. We hiked the footsteps of John Lee through Paria Canyon. We followed the Texas Argonaut's August route to the gold fields from Yuma to Palm Springs. We bicycled from the Grand Canyon to Mexico, explored Mexico's Sierra Pinacate, climbed Mexico's Pico de Orizaba, and skied across the Grand Canyon.

The trust we developed amid moments of survival and joy bolstered our partnership. We trudged across the hottest, exposed part of the Colorado Desert (a portion of the Sonoran Desert in Southern California), to recreate the Texans' trips during the forty-niners gold rush. We wanted to travel as they did and feel what they felt. The Texans had reasoned that after desert monsoon storms, water catchment tinajas would be filled with water. Their route

1987—Chuck Bowden

veered south and into the harshest desert to avoid Indian predation.

Our reenactment of the Texans' trip was simple and also followed the tried and true methodology of illegal immigrants racing North on foot. We each carried four gallons of water and hiked "flat out" (4 miles per hour) through the night. We needed to cover forty shade-free miles before the death sentence of 115-degree days.

We set the metronome in our heads and carrying a ready one-gallon jug, we drank and walked as fast as possible. A numbness came over us while we were force-marching with no end in sight. The only sound was the crunching of boot to sand. A mild hallucination was interrupted by the sound a very loud cricket. Jolted back, our eyes widened as we noticed our marching boots were propelling a very pissed off sidewinder in a series of disrespectful punts. The snake was not amused. Too tired to care, we continued the trek.

Chuck's thighs did not like the pace or the heat. They were becoming hamburger. We limped into Glamis, California, the self-proclaimed Sand-Toy Capitol of the World. Imagine a cross between the movies *Thunder Dome* and *Deliverance*. At a local shop we found hats with penises

erect from the crown and boob hats with similar strategic classless displays. But Chuck was undeterred. He was on a mission. He needed nylon running shorts to stop the pain. We scanned the aisles of porno headgear and still came up empty. Finally a leathery faced woman emerged from the shadows long enough to direct my desperate friend to the only running shorts in Glamis. Chuck's smile froze as she presented a pair of hot pink shorts with "Dune Doll" emblazoned on the rump. They were a perfect fit.

Ever the practical hiker, a nonchalant Chuck sauntered off in shocking pink as we crossed the Imperial Dunes. Dune Doll indeed . . .

We followed the same protocol by hiking into the nighttime coolness and being treated to the soft bed of sand. We were reeling in Palm Springs and moving with less pain when a mirage appeared on the horizon. A bar! Not just any bar, but a "biker bar."

The standard array of Harleys surrounded the joint as we trudged onward. The dimly lit bar featured not only drinks, but mason jars full of hard-boiled eggs Chuck described as being from the Fillmore presidency. The eggs weren't the only hard-boiled residents of the bar. Stern, unsmiling faces glared from the darker corners. Great. After we gave a brief explanation of our trek, they became incredulous allies.

I produced my Leica and invited the largest biker named "Brew" to step outside. Really . . . no danger, these were great guys. Brew did have a 38 strapped to his hip along with a foot-long bowie knife, but he wanted his picture taken, and who was I to refuse? Out of the corner of my eye, I noticed Chuck slowly edging away with a couple of the other bikers looking his way. Now, Chuck was never, I repeat never, afraid, but at that moment I saw genuine concern in his eyes. I made several portraits before giving in to Chuck's urging to leave. Only then did I remember that Chuck's buttocks were a virtual neon sign in pink, proclaiming him: "DUNE DOLL."

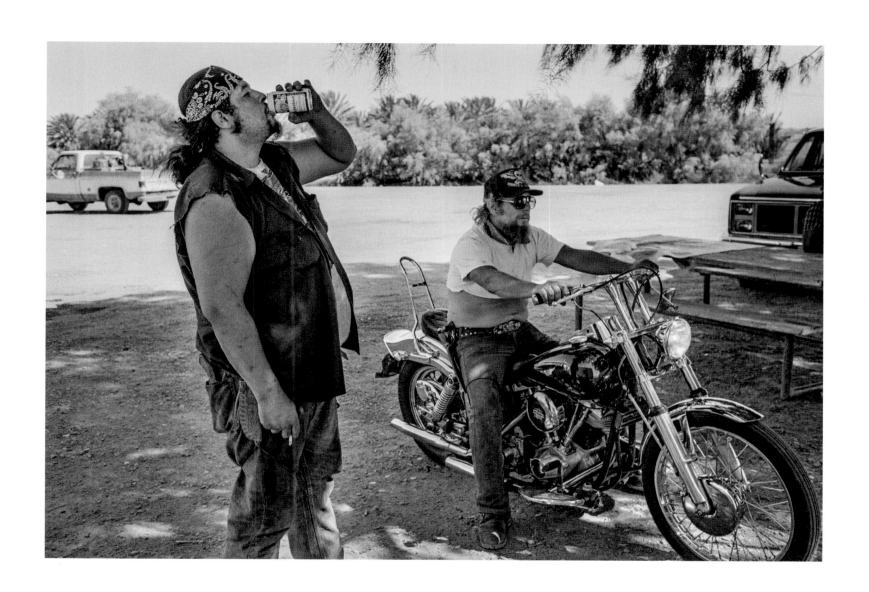

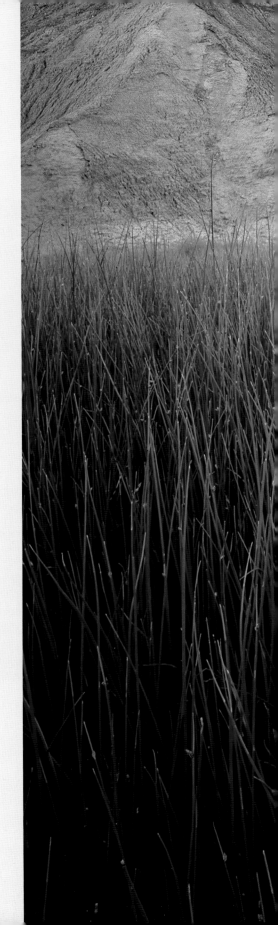

▶ Indian Paintbrushes

Days spent roaming the high desert canyon country of Utah—that began as food for my soul—finally morphed into my book *Stone Canyons of the Colorado Plateau*. The same visual story-telling technique I learned as a Chicago photojournalist compelled me to seek ways to illustrate the fragility of the land as well as the reasons to treasure it.

So, as I rumbled down four-wheel-drive roads in the backcountry north of Capitol Reef National Park, my eyes became accustomed to the red and yellow striated sandstone landscape. But when I crested a hill leading into an arroyo bottomland that was suddenly electric green, I was instantly struck by the uniqueness of the lush green sedges and the flowering Indian paintbrushes that were surrounded by pure arid desolation.

For me, this was one of those teachable moments that I could share using my images. Illustrating the ecosystem with its unexpected anomalies of sheer beauty is something that drives my photography. Recording and sharing images of the wildness with urban dwellers has become my passion. The very fact that places are allowed to remain protected hangs on decisions made in urban areas and our nation's capitol.

I feel a certain responsibility to record the wilderness with both honesty and a sense of wonder. The very fact that I am awe-inspired as I witness beauty in the landscape makes communicating that feeling to others easy for me. I follow my feelings as I carefully compose images in the ground glass of my view camera.

I intuitively seek a design in the scene, as I did with this image. I looked for spacing between the Indian paintbrush flowers and the emerald green garden of sedges. My eyes traced the borders of the ground glass image as I repositioned the camera ever so slightly so each plant was spaced with no overlap.

My leisurely pace turned into a race with rising sun. My camera pointed due east would soon be engulfed in bright morning light flaring into the lens. To make matters worse, the same moisture that had given me a visual banquet, also harbored an endless supply of biting flies. Of course, I was wearing shorts. I danced to and fro—focusing, swatting, loading film, swatting—and finally, I grabbed my camera with lens still mounted and quickly retreated into my truck.

The serene beauty and my sense of wonder had been abruptly confronted by the reality of the wildness. That's wilderness.

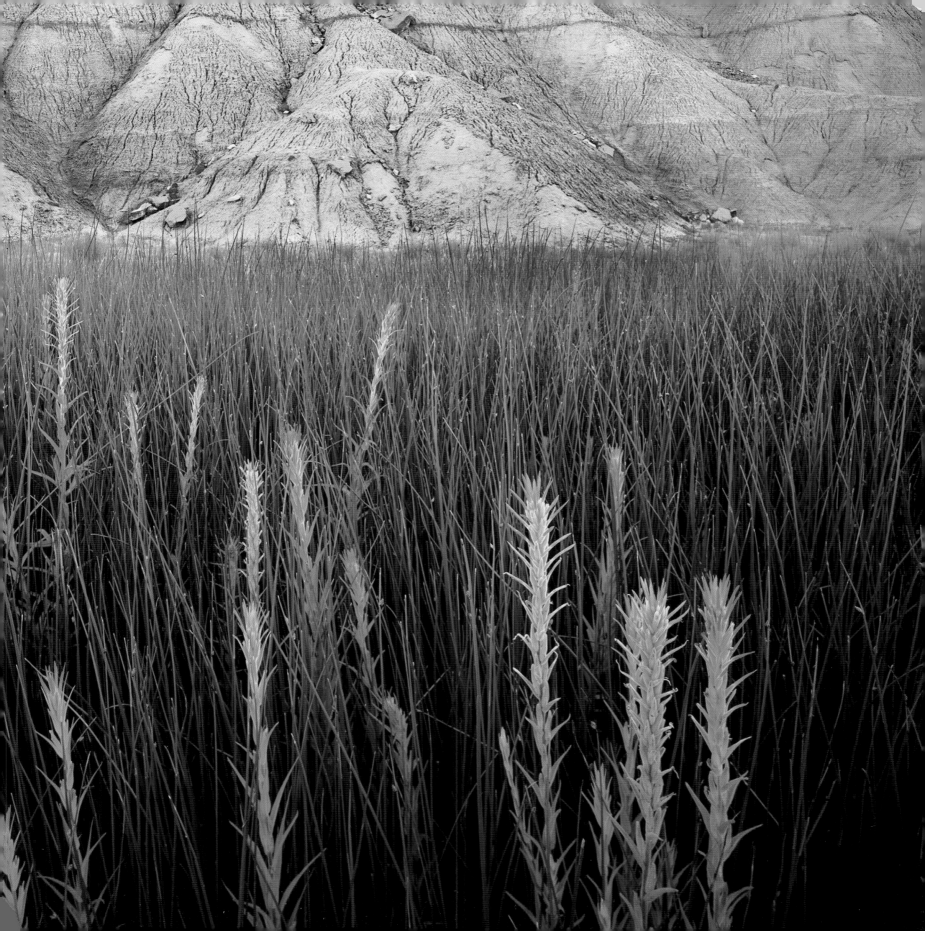

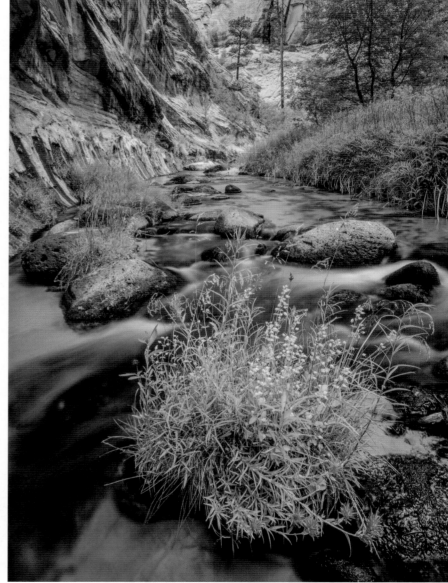

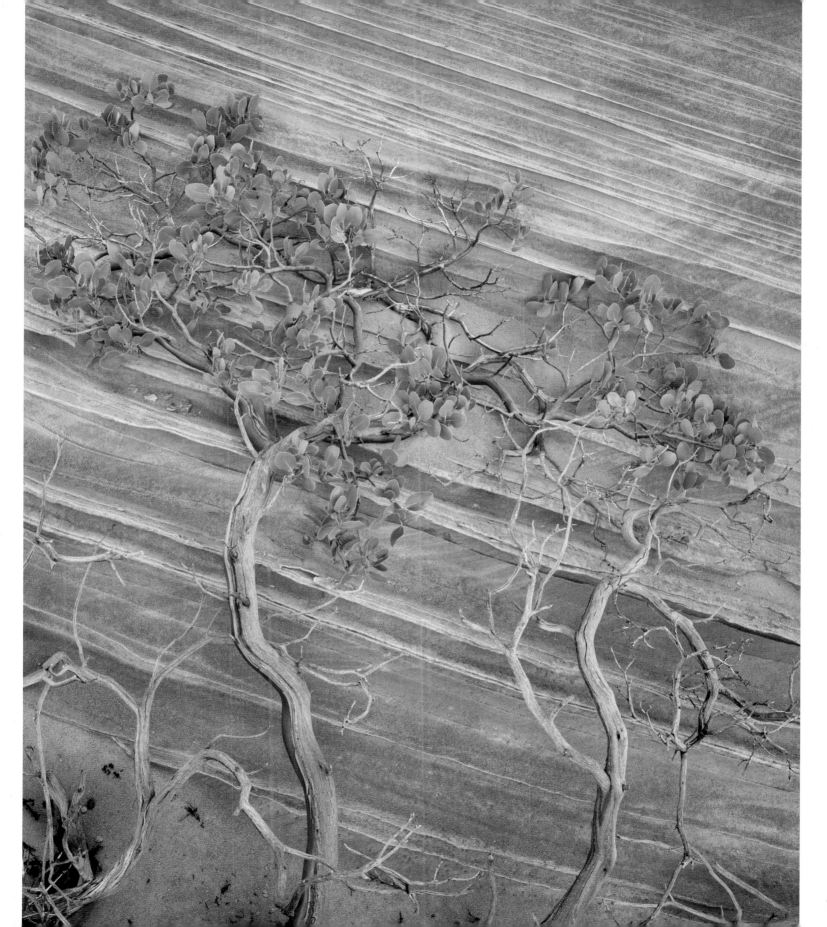

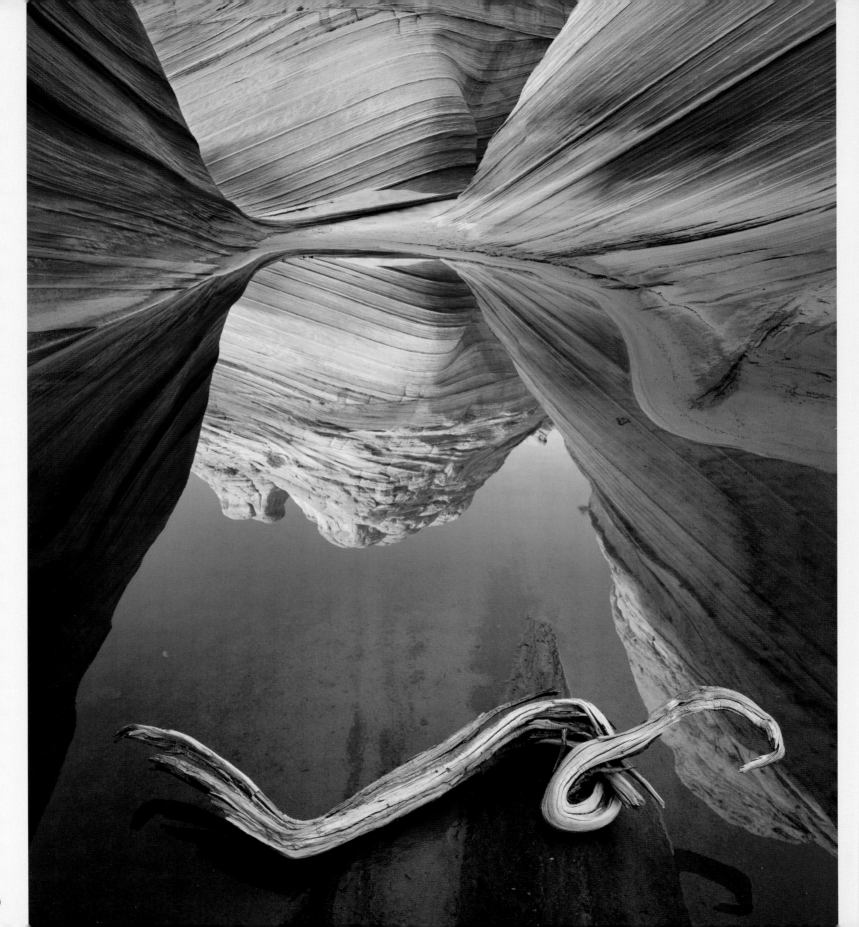

◀ Stone Canyon

April 1992 found me deep in the canyon country of the Colorado Plateau. I had given myself an assignment to immerse myself in slick rock country. The idea of doing a book on the dramatic sandstone landscapes laid bare by eons of water and wind hadn't fully formed in my mind. After I had accumulated enough images, my plan was to coerce my buddy and writer Chuck Bowden into doing a book calling for preservation of this sacred place.

In the late 1980s I had the good fortune to meet the legendary fine art photographer Frederick Sommer. He showed me some of his current projects and viewed some of my images. He dazzled me with his knowledge of large-format photography and he began to expound on the importance of corners. That simple statement became locked in my brain.

As I journeyed into the petrified sand dune formations, I had the weight of the my backpack, with my 4×5 view camera and its accessories, pressing into my back, but the joy of just being in such immeasurable beauty lightened my step. After several attempts, I finally located the legendary spot never named and only whispered among Colorado River Boatmen. It was the nexus of multi-colored sandstone with sculpted pools at the base of stone pyramids.

The little water dammed in pockets between the sandstone was literally being blasted by fierce winds funneled through the natural venturi. I made a halfhearted attempt at photography, but the wind ripped at my camera and smashed it into the stone. Weeks later I returned with the same results minus the broken camera.

Months later, I was having dinner and a few beers with my publisher friend Ken Sanders in Salt Lake City. Once we said our goodbyes, the visualization of the sandstone wilderness burned as brightly as ever. I drove through the night arriving around midnight at the trailhead, and grabbed a few hours sleep before retracing the three miles to the spot some have called the "Center of the Earth."

Persistence won out as I summited the ridge leading to the watery pool. I stared at a perfect reflection, with no wind this time, and saw the curled sun-bleached root. My heart was pounding as I realized I was racing against the sunrise. I draped the focusing cloth over my head and felt the calm of the ageless way of seeing an inverted image projected on the ground glass inches from nose. My technique is now part of me and the camera is an extension. My mind is free to listen to the masters. I heeded Fred Sommer and composed, paying special attention to the corners. After careful consideration, I did the unforgivable thing and slid the curled root six inches to the right to complete the image. That moment has endured and this image has been named one of the 40 most important conservation images of all time. It became the cover of my book *Stone Canyons* and it contributed to the preservation of the land when Bill Clinton created the Grand Staircase-Escalante National Monument and later the Vermilion Cliff National Monument. Fred would be proud of the corners.

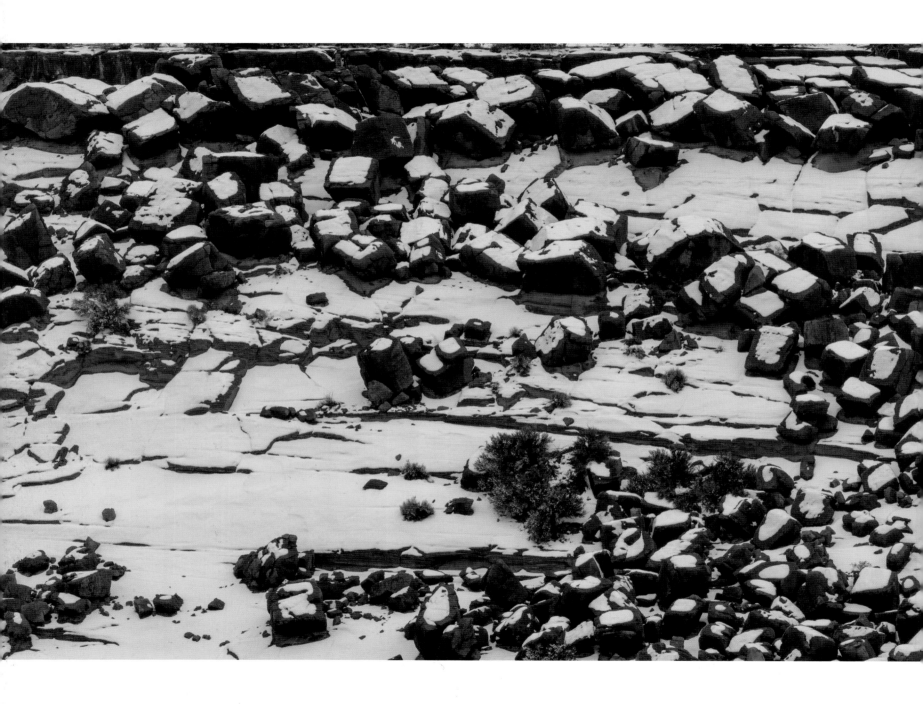

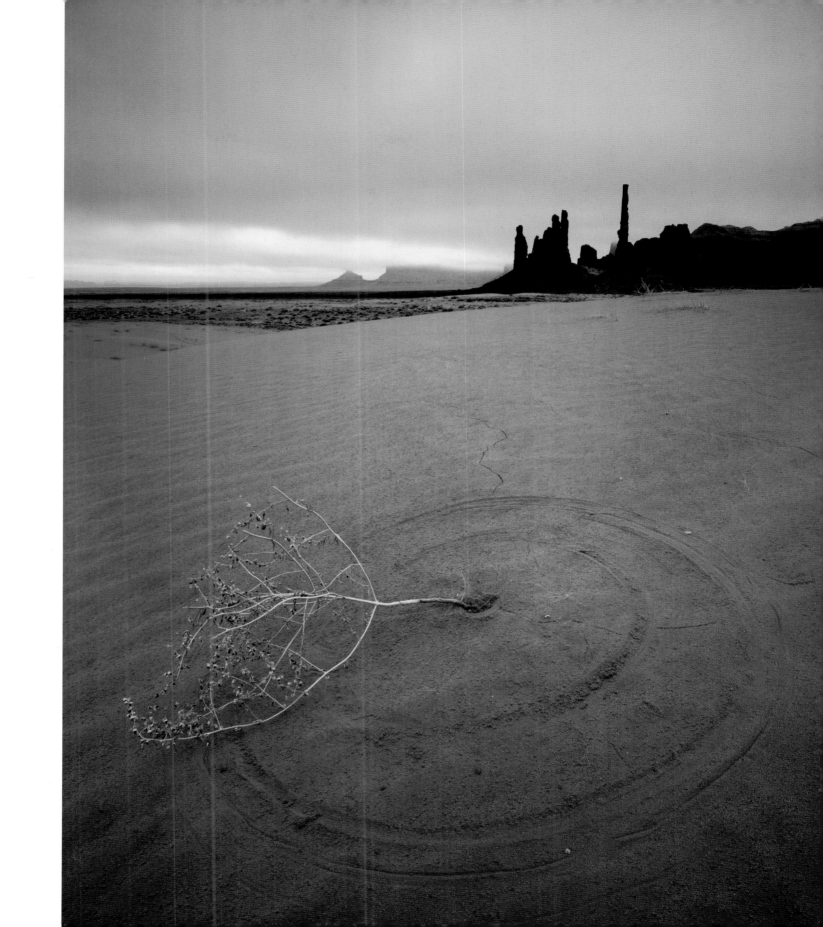

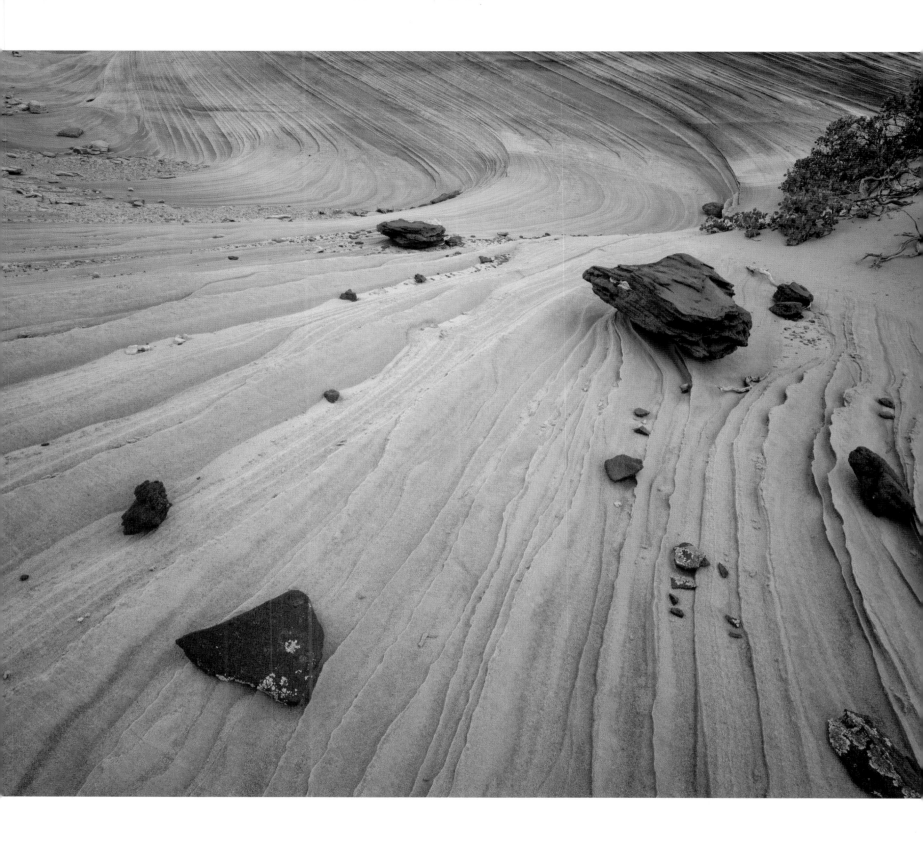

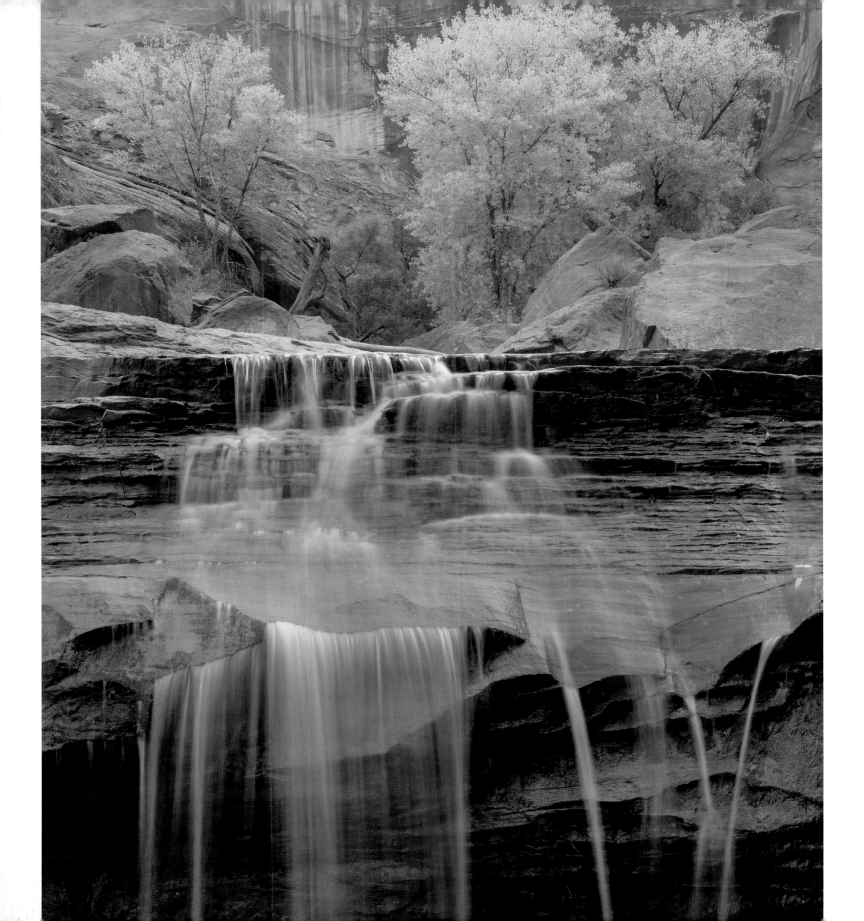

117

▶ Water Shamrocks

I learned early on that one could create compositions using a view camera in much the same way that both Ansel Adams and my friend Philip Hyde had perfected. Phil's technique was geared for backcountry work. He chose "process lenses"— small lenses that could resolve amazing details with superb color correction.

Writer Doug Kreutz and I were following a canyon drainage that ran perpendicular to the Arizona-Mexican border. The canyon was in fact (as we later learned) a prime corridor for people and drug smuggling into the U.S. We felt safe because we were backpacking and therefore not near the major dirt roads smugglers preferred. Both Doug and I felt we needed to immerse ourselves into the Tumacacori Highlands wilderness in the Atascosa Mountains to provide a sense of place for our audience. Lying on the ground and listening to the noises of the night deepens one's connection to the land. Even if I can't find a subject to photograph, the experience would add texture and context to our story.

On good days, however, images appeared as I labored under my pack heavy with camera gear and camping gear. The process so familiar to me involves laying my pack on the ground and walking around my intended subject—making decisions on which lens, which filter, and assessing the light before it actually happens. With large-format view camera photography one needs to anticipate conditions and commit to a photograph, because the camera's ability to react quickly is severely hampered by endless settings needed before film is exposed. Yet there always seems to be a race against the sun: I'm trying to shoot either moments before sunrise or after sunset, and in either case the optimum light is ephemeral.

Water shamrocks were unknown to me prior to this trip. Their shamrock shapes, one-and-a-half inches in diameter, covered water in the pooled up portions of the Peck Canyon drainage. But the pool was in a tiny grotto with steep walls encircling it. The only possible way to photograph the pool was to wedge my delicate frame into a space so tight that I was pinned behind the camera and tripod unable to see the lens settings or reach the film packets.

I did what any intelligent photographer would do: I whined loudly until Doug agreed to make the lens adjustments and feed film to my rocky perch.

I love this image for both the work it entailed and the technique unique to view-camera photography. I was able to maintain sharp focus across the surface of the water by tilting the plane of focus. I then could expose the film at a wide-open aperture allowing the warmly lit canyon walls in the background to become splotches of reds and yellows against the blue sky reflection.

Many photographers adopt the attitude that an image is great because of the required effort. My days as a photojournalist taught me that no matter the work that went into creating images, they rise or fall on there own merit. Still, I feel blessed when both effort and the end result conspire to create an image that endures.

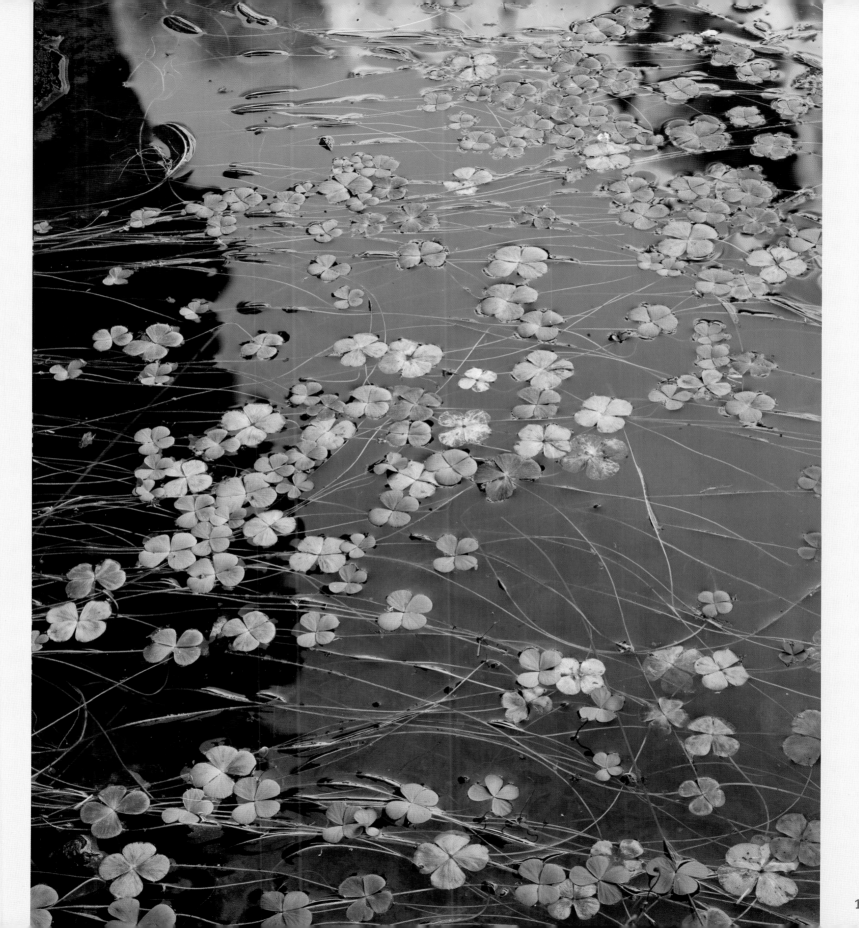

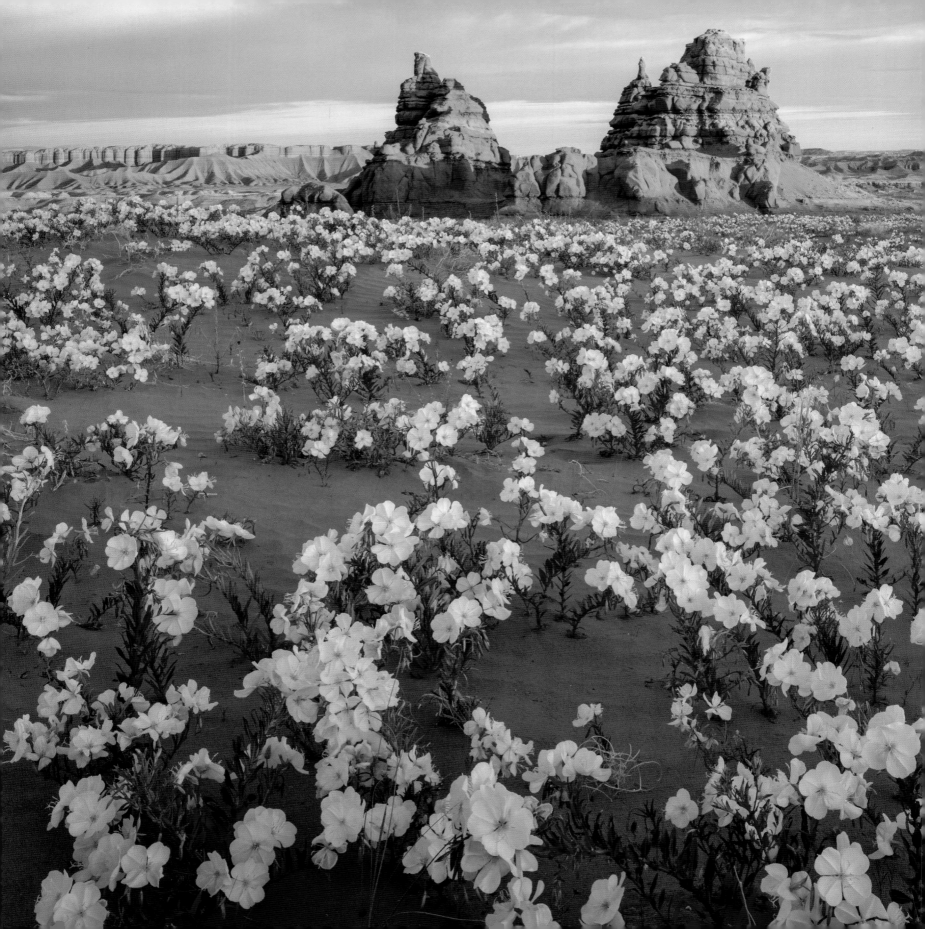

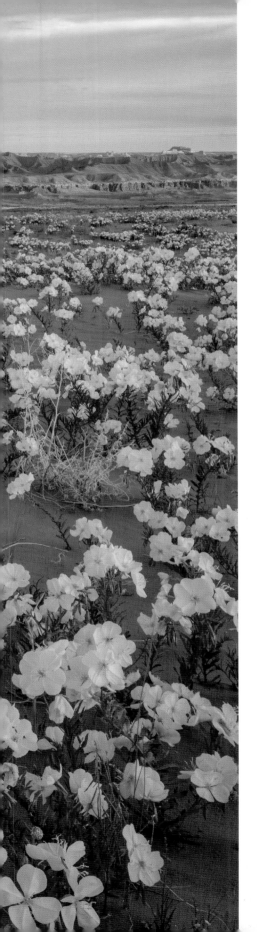
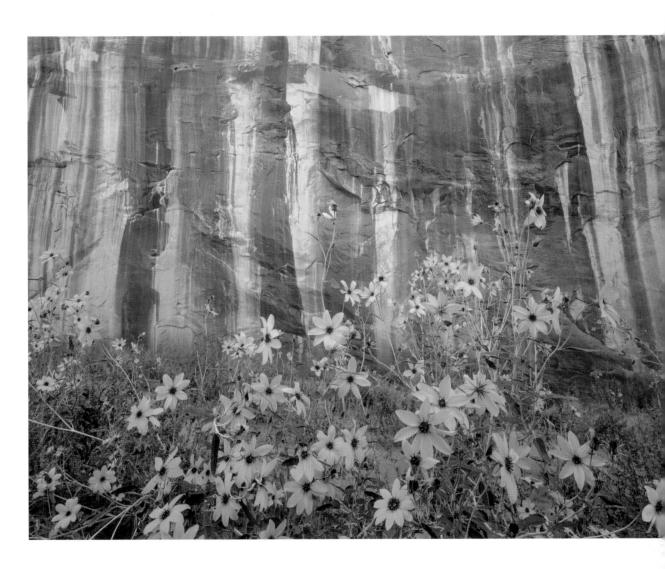

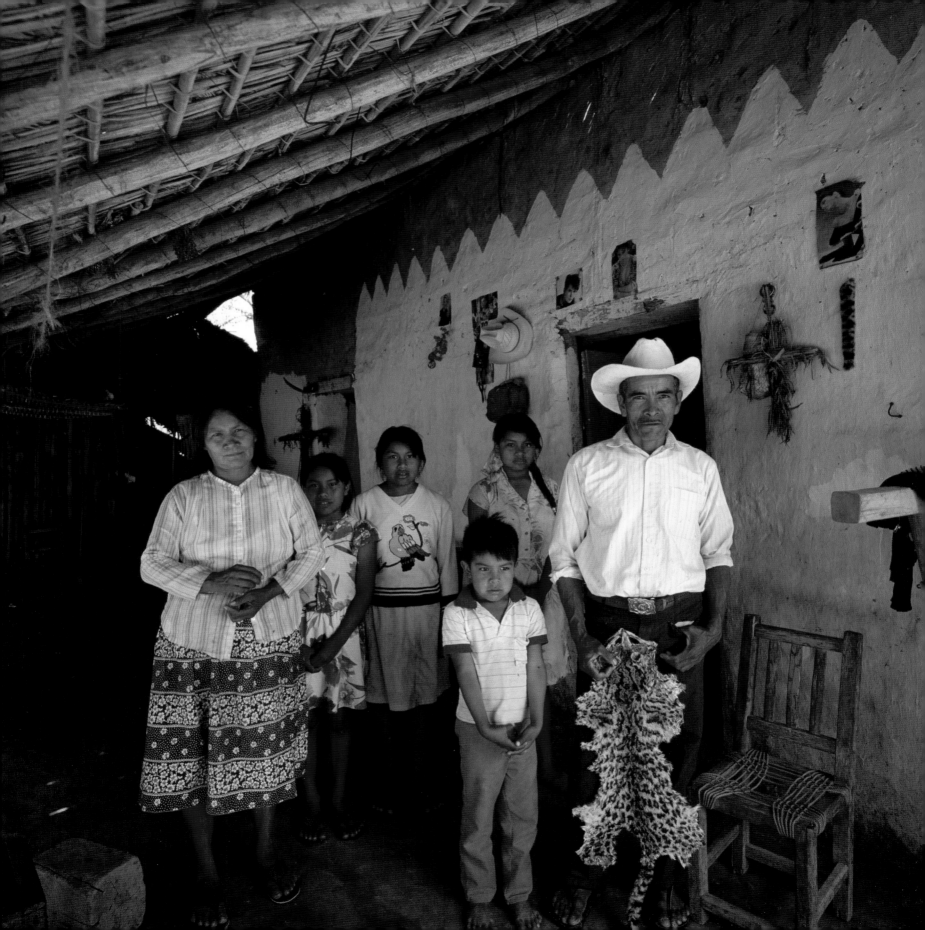

◀ Ocelot Pelt

Chuck Bowden listened to scientists at the Desert Laboratory as they complained about the spread of buffelgrass (an exotic species native to Africa) as a food source for cattle in Sonora, Mexico. As with many of our joint projects, we made a verbal agreement to produce a book. We followed paths laid down by writers like Abbey and Stegner and by photographers Adams and Hyde. It never dawned on either of us that we had no publisher, no game plan, and no money to cover expenses. We simply wanted to do it.

Chuck had moved to Alamos, Sonora to experience the place and to become part of it.

I would commute to document certain seasons based on Chuck's advice.

As we better understood the perceived problem, we could see vast tracts of native vegetation being replaced by large expanses of buffelgrass, which flourishes and expands its territory when burned. Native species are consumed by fire and replaced by dense grasslands and the ecosystem is forever changed.

We found that people living a subsistence farming lifestyle were also becoming an endangered species.

My truck traversed deep into the Rio Cuchujaqui canyon country, inching over beach-ball-sized stones, when I spied a rancho and its mestizo family watching our snail-paced progress. I had taken my friend, photographer Jeff Foott, along to show him the landscapes I was documenting. It had been a very long day of bone-jarring travel and we both had visions of a cold beer back in Alamos.

I eyed the man and his family and noticed glamor magazine photos tacked to the wall and an ocelot pelt in his hands. I looked at Jeff and knew he wanted this day to end soon, so I offered to head back to town. Jeff's response was a strong protest, telling me get my ass in gear and get that photograph. I picked up my Hasselblad Super-Wide and informed the rancher that I didn't want to buy the pelt, but would like to photograph him and his family. I love the body language and expressions.

Later, during an environmental group presentation, I was questioned about taking the photograph. Some were appalled by the feline pelt the man held in his hands.

I explained that to us it's an endangered species but to him it was something eating his chickens . . .

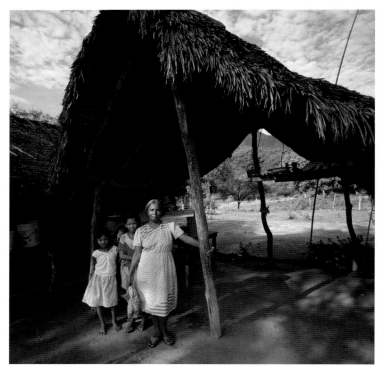
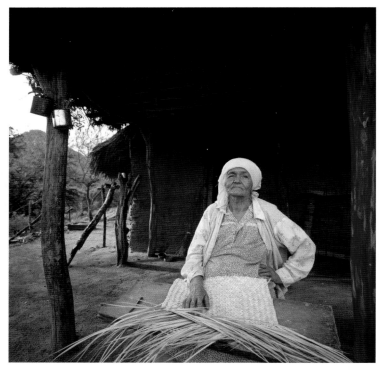
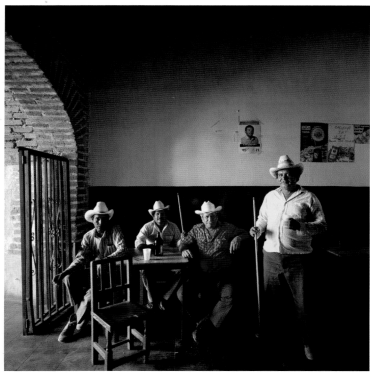
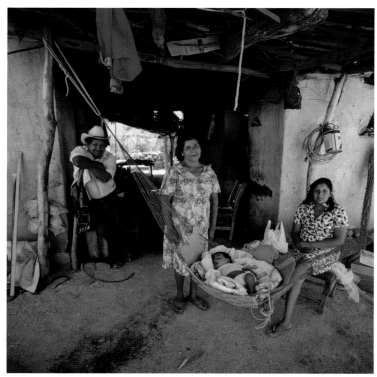

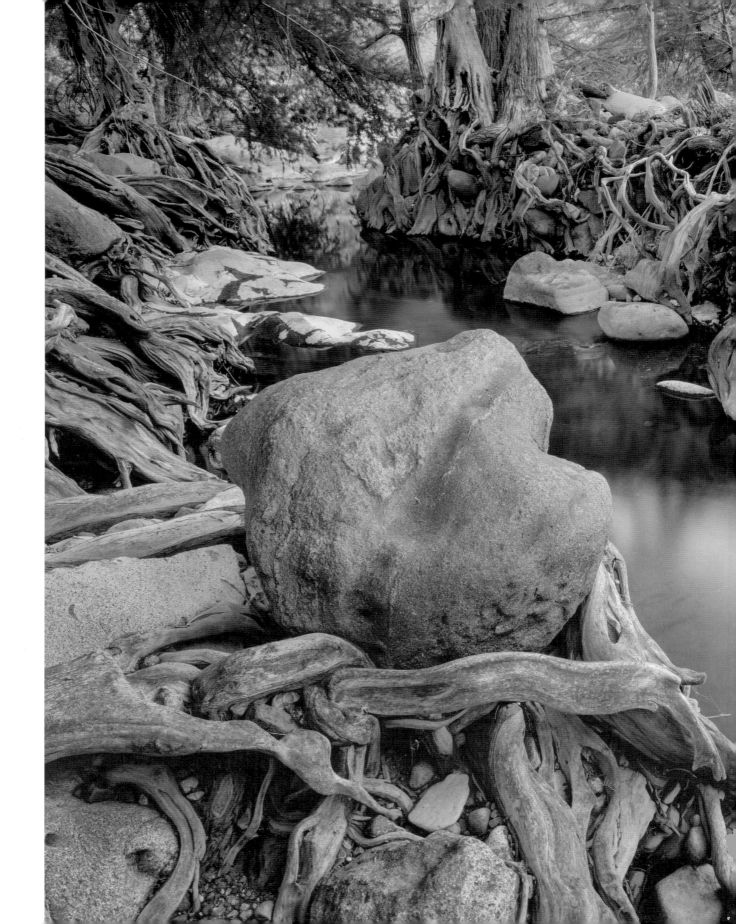

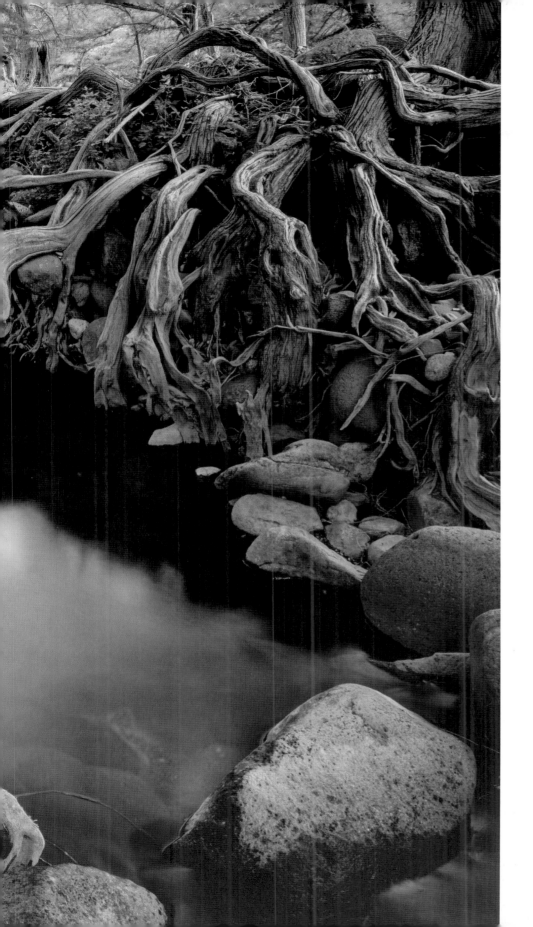

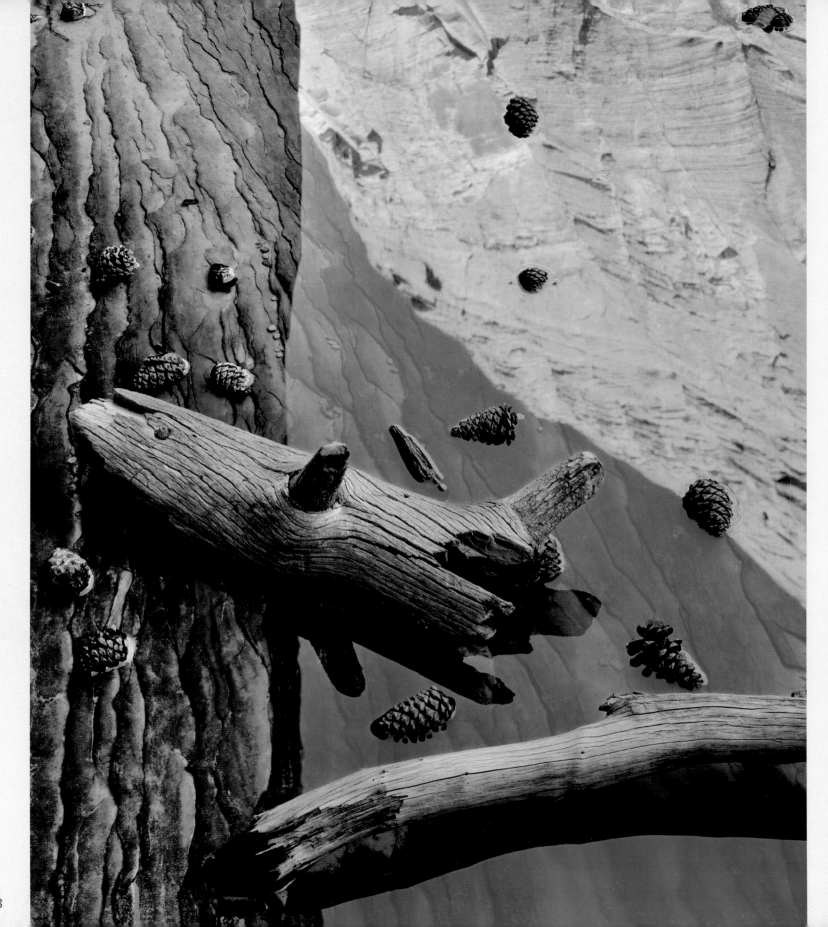

◀ Death Hollow

While working the canyons of Escalante, I adopted a method to ensure a rescue in the event I was injured deep in a sandstone wilderness. Each time I prepared to explore, I would review the topographical maps on a table inside Escalante Outfitters. Barry and Celeste Bernards (the proprietors) would offer suggestions and make special notice of my planned itinerary. Celeste also held down the job as a sheriff's deputy for Escalante and she was charged to conduct rescues in the canyons.

I descended into the canyons only after telling Celeste when I planned to return. The rule was if I said I'd be out on Wednesday and I didn't show up, she was to wait two more days before initiating a search and rescue. As a photographer, I was already typecast as a bit flakey. They knew of my lapses in time when enthralled with dazzling canyon light.

As with many canyons in the Escalante Canyon complex, Death Hollow is a watery hike with many stream crossings and an occasional swim to make headway up the canyon.

It's a surreal world of reflections and floating debris. The streams bear pinecones from the high mountains and driftwood sanded smooth by flash floods.

I regularly found myself stopping and waiting for the water to settle and for the reflections to return. Each step I made was ruining the fleeting compositions at my feet. The rhythm of start . . . stop . . . wait became my method for seeing image potential.

On this day, the intense sapphire-blue reflection of the sky contrasted with the golden canyon walls. Gradually, I came to a complete stop as I watched the ripples subside leaving a mirror-finish water surface with smooth grey logs that seemed to be floating in a blue sky.

I crept to shore, stashed my pack, and grabbed the bare essentials for the image coming together in my mind's eye. All I needed was one camera, a tripod, a lens, and several film holders in my pockets.

The design in the reflection came to life under my focusing cloth. My friend Jay Dusard liked to say that we photographers are imposing a rectangular frame on our subjects . . . deciding what is in the frame and what's left out.

My frame featured corners anchored by pine cones floating at the upper corners while a triangular blue-sky reflection created a dynamic shape sandwiched between canyon wall reflections.

Funny how a fifty-pound pack seems lighter on the return with exposed film.

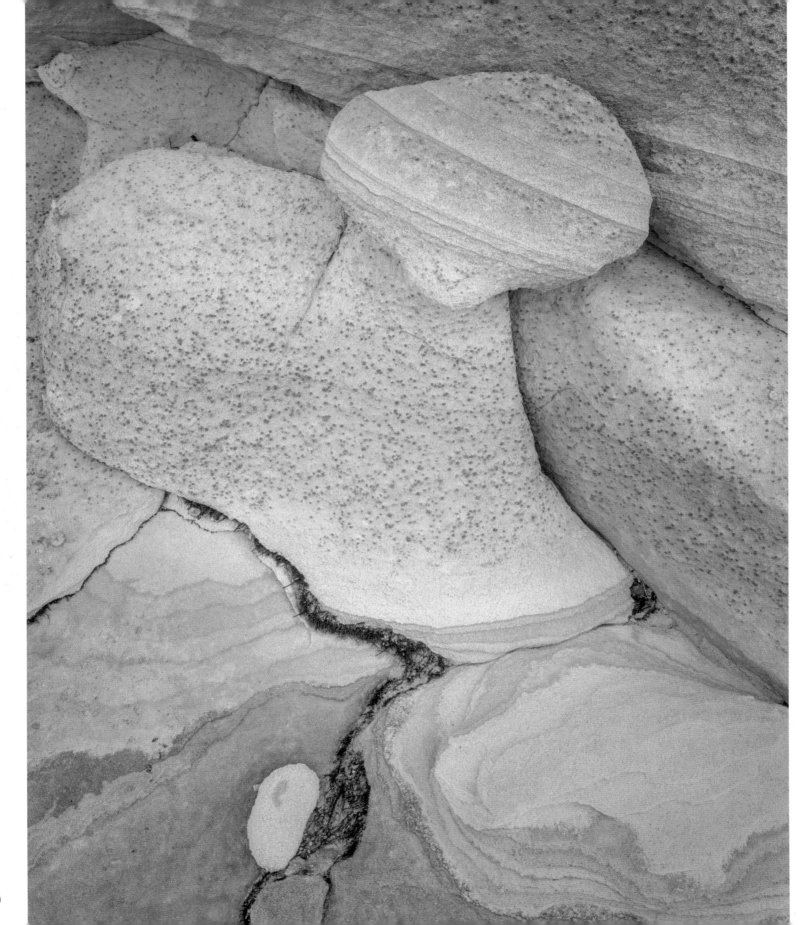

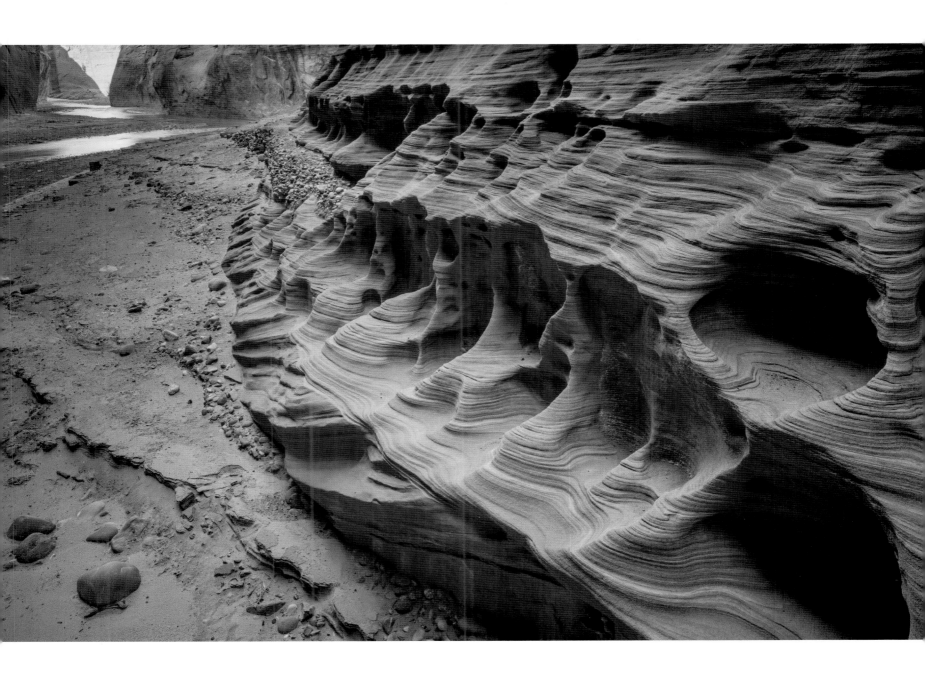

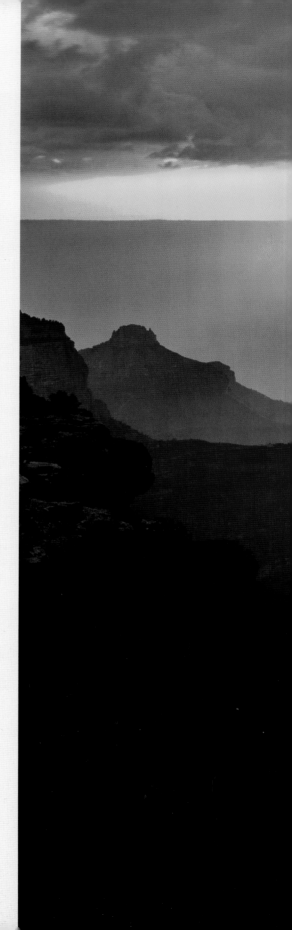

▶ Cape Royal

The North Rim of the Grand Canyon is where I go to recharge. I have a long history with this magical place. I have reached the point in my life when the place is secondary to solitude. The older I get, the more I'm apt to abandon the crowds at iconic spots and search out places where I can be completely alone.

Yet there are still places where weather can turn great scenery into the sublime. I am drawn to the time of year when the air is filled with electricity and when gunmetal storm clouds allow only fleeting glances of sunset light to knife into the canyon labyrinth below. The problem is that both light and storms rarely cooperate.

The best one can hope for is to learn about weather patterns and show up for work.

In my decades-long career, I can count on one hand those enduring moments in which the Canyon granted me moments when I felt transcendent. Images like this are the result of equal parts danger, beauty, and luck. As a photographer, I am merely there to record . . . and hope I don't screw up!

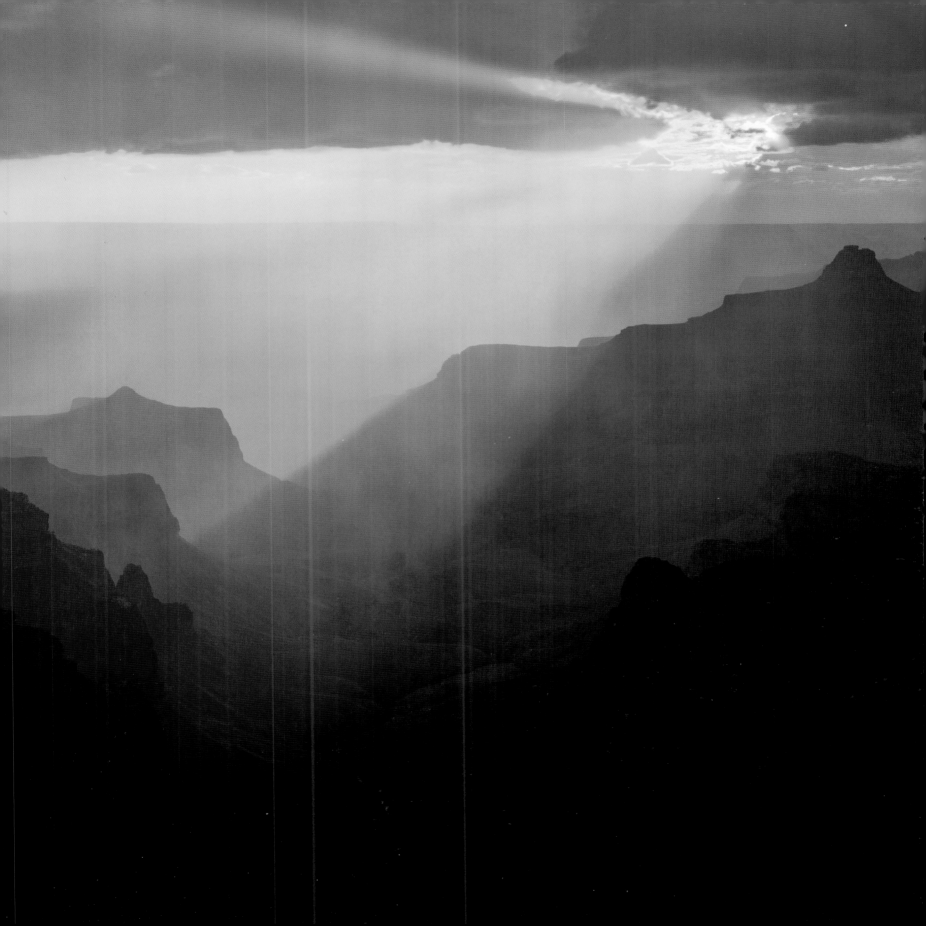

CHAPTER 10 Patricio—Thinking Big

In October 1993, both Frans Lanting and I each won nine Roger Tory Peterson Awards for our published images. The presentation ceremony was held in upstate New York. Frans and photographers from throughout the United States emerged from their normally solitary lifestyles to celebrate fine photography. Unfortunately, I wasn't able to attend.

The gathering was a transformative experience that led Frans and several other attendees to form a new photographic group that would leverage common goals and interests for education and furthering professional standards. So it was that The North American Nature Photography Association (NANPA) was born. Frans called me immediately upon his return home and excitedly suggested I pass the word to the close-knit landscape photography community to gauge support. Everyone loved the idea.

I was asked to participate in a panel discussion during the initial NANPA summit conference. Fellow panelists were to be Art Wolfe and Bill Silliker, Jr. The organizers wanted someone from Mexico to be represented as well. I had just seen some incredible images from Mexico's Pinacate Protected Area taken by a Mexican photographer, of desert pronghorns in full gallop with their shadows creating a surreal petroglyph-like image. Bowden and I knew the

image well from our time working on the *Sonoran Desert* book. Although I didn't know the photographer personally, I strongly suggested that he represent Mexico on the panel. With the convention beginning in a few weeks, I got a call asking if the Mexican panelist I had championed could speak English. Not knowing, I suggested a translator should be made available and I headed to San Diego.

My experience by that time included rather extensive travel to Mexico. So, when it was suggested that someone from our group meet Patricio Robles Gil, our representative from Mexico, I quickly volunteered. We all have our preconceptions. I entered the immense hall thinking that all I had to do was to find the short swarthy complexioned guy and say, "Hola." As I weaved in and out of clusters of people, I began to wonder if Patricio had decided not to come. Suddenly, a handsome, tall, blue-eyed man with thinning hair approached me. His sweater was tied around his neck in European style, and a beautiful woman was with him. He greeted me in deep baritone Spanish accented English. A firm handshake of friendship spoke providentially of our future together. Mucho gusto indeed.

Patricio is a classically trained artist. He paints, he sculpts, and he photographs. He also grew up hunting and knows how to stalk animals. But the years of following his

father on hunting trips didn't fit into his increasing wilderness ethic. He still hunted . . . but with a camera instead of a gun. His knowledge of animal behavior and his phenomenal appetite for everything from deep ecology to E. O. Wilson's books on ants sealed his fate. He wanted to devote his life to the preservation of wild places. He explained to me that the Spanish language didn't even have a word for wilderness. His mission was to change that.

My images were getting published in the *Sierra Club* (magazine and calendars), *Audubon* (magazine and calendars), *Arizona Highways* magazine, and *National Geographic Traveler*, and I felt my work was beginning to help make a difference. Patricio thought I was doing the right thing, but he had larger plans. Why not get sponsorships from big corporations, and produce serious coffee table books with powerful messages? He enlisted Cemex, the multinational cement giant, to underwrite a series of books that he hoped would change Mexico's concept of wild land. By focusing on preserving wild places and celebrating the flora and fauna as a richness to cherish and not merely consume, he sought to change the attitudes of Mexico's powerful elite with his images.

Patricio asked me how much I'd charge to join his project "El Mundo Aparte," which was to document Baja California. When I came up with a bare bones, no frills figure that his tight budget could afford, he laughed at me. "Come on Jack, don't think so small," and he quadrupled the amount. He went on to tell me that little books and little projects were doomed. He wanted an outsized statement that would reach the halls of power in Mexico.

True to his word, Patricio produced a series of books featuring powerful images displayed with sensitivity and elegance. More and more photographers from the U.S. were eager to submit their images to Patricio's projects, but some were fearful of Mexico's reputation for less than forthright business dealings. I carefully reassured the virtual "who's who" of nature photographers, and his stunning books proliferated. Our friendship grew from simple respect to deep affection, fueled by common passions and tequila.

One night while camped on the U.S. side of the Rio Grande, I returned well after sunset to find my smiling friend making a giant pot of spaghetti. Next to the cook table was a line of tequila shot glasses. Patricio greeted me with, "My friend, it's time for your lesson in tequila." The glasses had various tints from dark amber to crystal clear. Commencing my lesson, I simply said, "Gracias, professor."

Patricio's passion, imagination, and pursuit of excellence are unparalleled. I'll always remember listening to opera blasting from my truck speakers, bathed in the perfume of a record desert bloom, my heart singing while Patricio and I paid homage to the Sonoran Desert spring.

Based on the success of Patricio's book, *El Mundo Aparte*, on the Mexican states comprising the Baja peninsula, he secured funding to proceed with an even more ambitious plan to document the wild places in the state of Tamaulipas. To this end, I found myself hiking solo down canyons never before seen by a gringo, let along somebody carrying a 4×5 view camera. I had this remarkable feeling of what it must have been like to be Ansel Adams, traversing pure untrammeled wilderness. For me, it was a privilege and an honor to receive this gift of trust, to share Patricio's homeland.

Patricio knew my Spanish was passable . . . well, *tolerable*. Nonetheless, he insisted I bring along another Mexican photographer to both assist me and make his own images. Jesus Lopez is a non-stop comedian, fond of jokes at this gringo's expense. He taught me the fine points of cursing in Spanish and I provided a coffee press and biscotti made by my wife, Margaret. Together we roamed freely in remote areas of Nueva Leon, San Luis Potosi, Veracruz, and Tamaulipas. We explored the Chihuahuan desert as well as the Sierra Oriental.

One moonless night found us driving about 50 miles from the nearest town and descending a narrow track strewn with fallen rocks as we headed toward the distant lights of Miquihuana. We were deep in joyful banter after an exhausting day of photographing giant Agave montana (or Mountain Agave) high in the sierra. Suddenly, powerful

beams of blinding light blasted us. My mind flashed on all the movies where someone is executed in a remote corner of the planet . . . like where I was. . . . But Jesus, ever jocular, assured me everything would be fine. I didn't feel fine.

We inched forward into the light. I kept telling myself to be cool as I began to notice large men with even larger guns waiting ahead. With the windows open, a man in military fatigues leaned in and asked, "Donde va?" My compadre Jesus quickly launched into a brief history of our travels, told about our destination, and added that the gringo was a famous *National Geographic* photographer. We had stumbled into a drug intervention checkpoint of the Policia Rural. Suddenly, the hard faced officers were laughing, as Jesus continued in animated Spanish, no doubt making jokes at my expense. Soon we were all laughing. I laughed too . . . but mine was a nervous laugh.

We finally make it back to town and shook the dust off our clothes. For the next week, each time we encountered the Policia, they would offer suggestions of where plants were flowering in the sierra or the best vistas. Jesus, the miracle-man, had made them our "best friends."

In 2007, Patricio gave an impassioned plea to a gathering of the top nature photographers from all over the world. The group was gathering in Palm Springs, California, for the NANPA annual summit, and added a breakout meeting of the newly formed International League of Conservation Photographers. He put into words what many of us were feeling about environmental degradation, and he challenged us to donate our talents to causes larger than ourselves.

Patricio proposed that top professional photographers with various specialties join an expedition for a weeklong concentrated documentation of El Triunfo cloud forest in the Mexican state of Chiapas. He wanted to shine a light on both deforestation and the economic benefits of maintaining a forest canopy so essential for successful shade-grown coffee production. His classic approach of showing both destruction and positive economic benefits became the model for all future Rapid Assessment Visual Expeditions, or RAVEs.

Each year the International League of Conservation Photographers' RAVEs produced bodies of work that were helping scientists and non-governmental organizations by providing the highest-quality visuals to help save endangered species and places. This was meaningful, important work that actually effected change. Of course, this was exactly what I wanted to do with my life. Phil Hyde's model of a life devoted to conservation burned fiercely in my heart, and Patricio provided the organizational means—along with Cristina Mittermeier, the charismatic iLCP director—to make a difference.

Patricio set in motion my involvement in a series of important iLCP photographic expeditions that produced images in association with some of the best photographers in the world. In every case, a degree of success was achieved. The simple act of showcasing threats to pristine environments was enough to effect change.

We documented a threatened mangrove-lined beach named Balandra near LaPaz, Baja Sur, Mexico, and our efforts were able to stop a Club Med development that would have destroyed the area.

Inspired by Krista Schlyer, we documented the U.S.–Mexican borderlands for the entire length of the fenced frontier to focus attention on how dividing a continent with a border fence affected species migration.

To help the local groups Amigos de Sian Ka'an and Conservation International, we highlighted the effects of full throttle tourist development, which caused the Yucatan's water crisis and affected the underground rivers.

We traveled to Chile to join the Sin Represas movement to stop giant hydroelectric dam projects. The images we created aided local environmentalists, and the dam construction was halted.

Inspired by a plea from Canadian photographer Ian McAllister, we journeyed north to British Columbia to join efforts to stop tar-sand oil pipelines from despoiling the temperate rain forest and craggy coastline.

The Baja Peninsula remained Patricio's passion. Potential deep water ports, oil tankers in the Gulf of

California, and gill-net fishing were all threatening the biodiversity of an area he calls "the watery Serengeti." The tiniest dolphin, the Vaquita, is teetering on extinction with about 60 remaining at the time of writing. Blue whale populations are plummeting worldwide, yet the California population, especially in the Sea of Cortez, is doing well. However, their long-term health is dependent on krill for a food supply, and that is in question as the sea warms. Patricio is an environmentalist first and photographer second.

So it was I found myself scanning the horizon from the bridge of a ship in the Sea of Cortez. Around us, dolphins were playing in our boat's wake. The play of light on the glassy morning sea turned this old desert rat into a mariner.

I began to sing, "Yo no soy marinero . . . soy capitan, soy capitan." Eyes sharpened with strong coffee watched the crimson sunrise as dolphins turned the calm sea into bedlam. I felt blessed just to be there. I want the world to feel what I was feeling. The Loreto Bay National Marine Park in the Gulf of California is protected, and the images made by Patricio and those of his immensely talented nephew, Jaime Rojo, have brought increased awareness to "El Golfo."

Patricio helped enlarge my world view. His passion and talent taught me by example that great things can happen for those who dare to dream big. His force of will makes anything seem possible.

▶ Barrel Cactus

I was working on the Tamualipas book for that state's government, to document biologically diversity. One of those privileged moments found Jesus Lopez and I deep in the Chihuahuan Desert. Towering yucca plants and red-spined barrel cacti defined the place.

I was experiencing visual overload as we hiked ever deeper into the desert. Gradually, the practiced process of selecting a scene began. Once I located the dense cluster of barrel cacti, I envisioned a stair-step line of bulbous plants leading the eye into the frame from a dense cluster in my foreground. I aligned the camera to include the giant yuccas in the background, creating another layer of the towering giants on the horizon. Employing a wide-angle lens and tilting the camera's back to change the plane of focus brought the tiniest detail sharply into focus.

Though I may be photographing the land, my thoughts are always rooted in documentary photojournalism—to provide information and tell a story. I wanted people to have a sense of the Chihuahuan Desert. By providing near-macro detail showing the plant structure in the foreground and establishing the context in the background, I lead the viewer on a journey into my composition . . . to feel what I felt at the scene. The resolution of large-format film photography provides so much information that one can almost feel the sharp points of the spines.

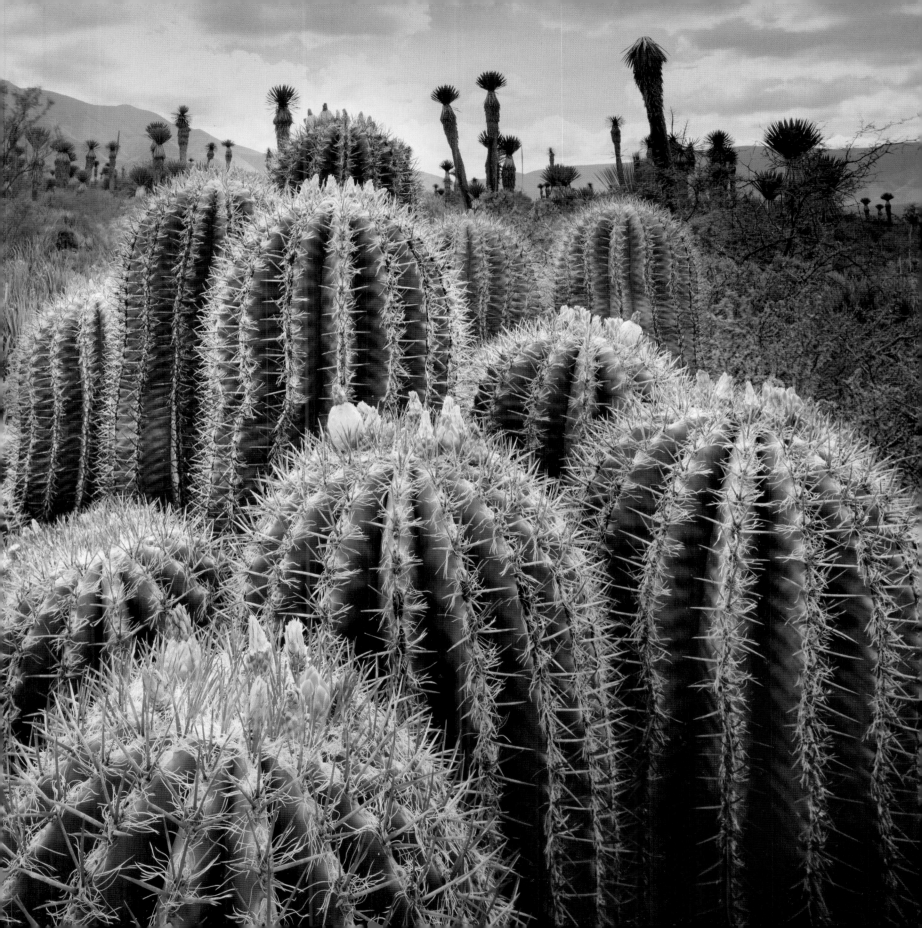

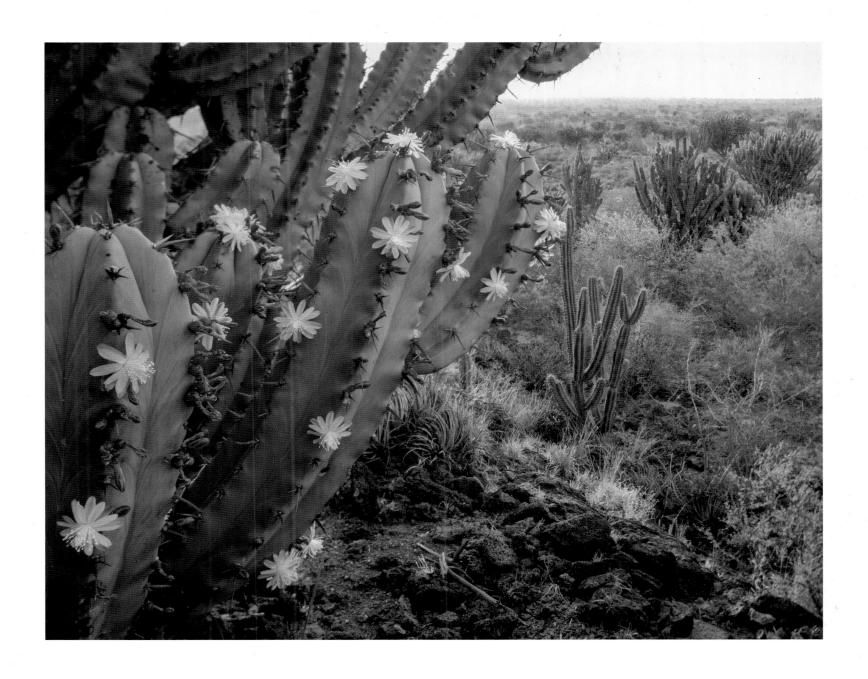

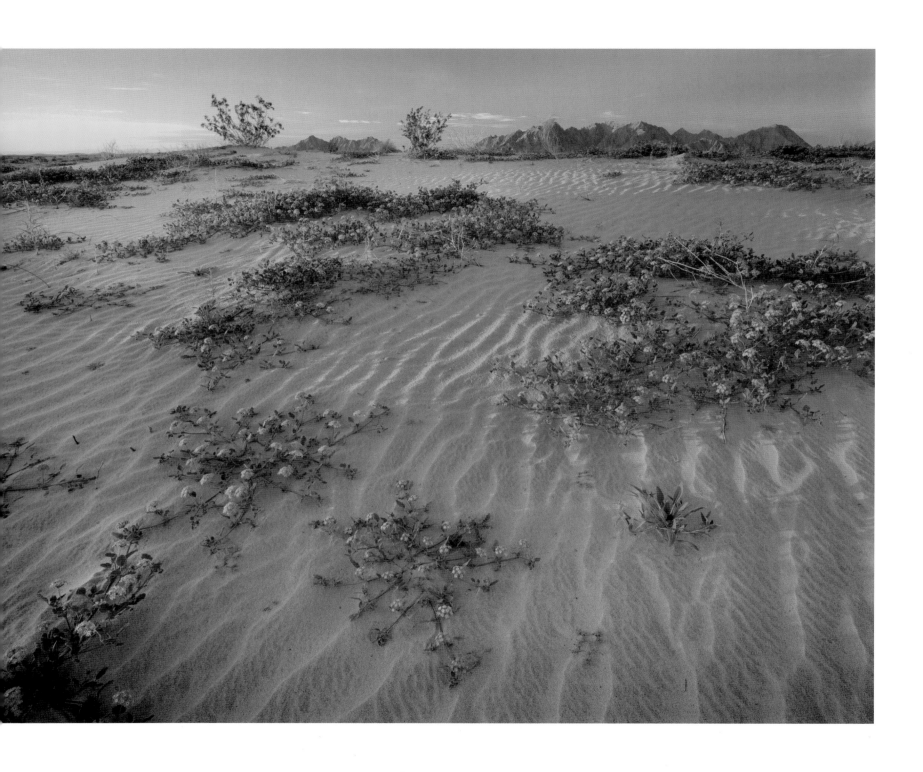

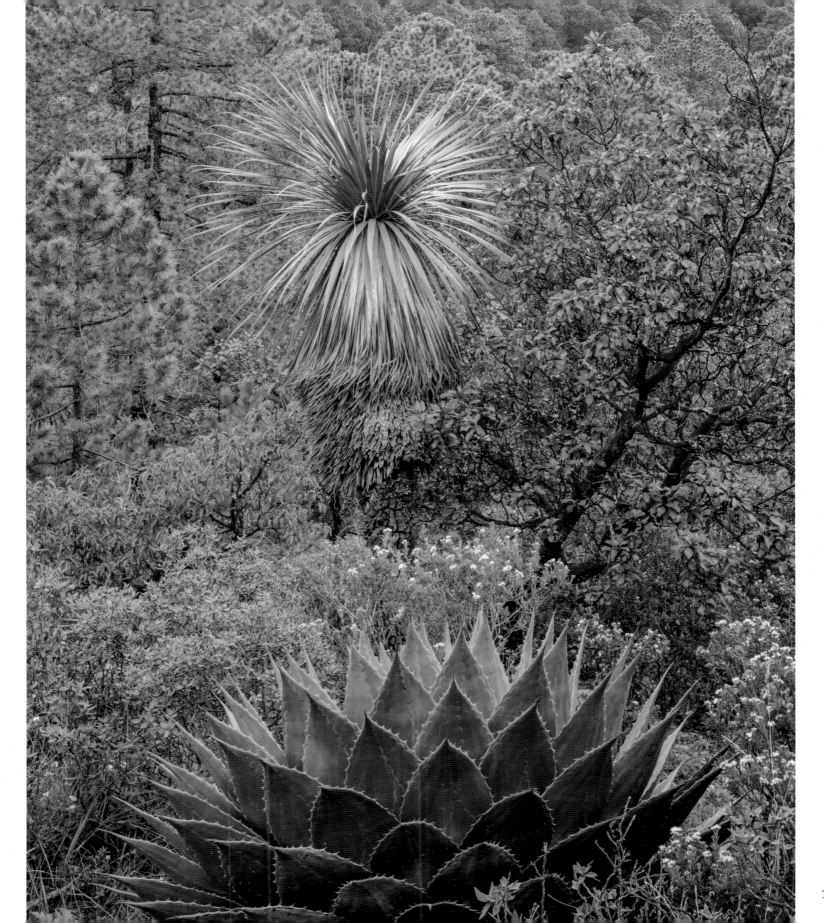

▶ Dolphins at Dawn

The Sea of Cortez, an area my friend Patricio Robles Gil calls the "Watery Serengeti," is a marine wilderness. Islands, each with unique characteristics, dot the turquoise waters bordering channels that are home to the largest animal on earth: the blue whale.

We plied the waters in the early morning hours because the angle of the sun can illuminate the blue whale's towering spout of water as it surfaces. Everyone on board our boat had binoculars trained in all directions, searching for the slightest hint of a whale.

This was a time to savor. The golden light intermixed with the blue waters, and birds were becoming active. A huge pod of dolphins was streaking though the calm sea. This was a scene analogous to a wolf pack hunting on the tundra. The dolphins, acting together, are herding their prey in a huge semi-circular attack. The beauty of the moment was beyond measure. Patricio nervously eyed the captain, urging him to get us closer because though it's amazingly beautiful to see, our lenses needed to be much closer before quality images could be made. Slowly, we begin to close the gap. Yet we seemed to be moving in slow motion while the dolphins were in hyper drive.

There's a time when you simply hedge your bet and begin photographing, knowing full well the technical limits of your equipment. The boat was moving, the light was low, the subject was in flight, and the lens wasn't long enough. Yet I squeeze off several bursts.

The dorsal fins were slashing the water, leaving trails of backlit wakes hanging in the air.

I continued firing bursts from the Nikon D800e, knowing I really needed my Nikon D3s with its low-light capabilities. Yet I continued.

And . . . the moment was gone. There was no second chance. For the rest of the week we tried to place our ship in just the right spot, but we found nothing

But, what is an image but a memory that burns bright?

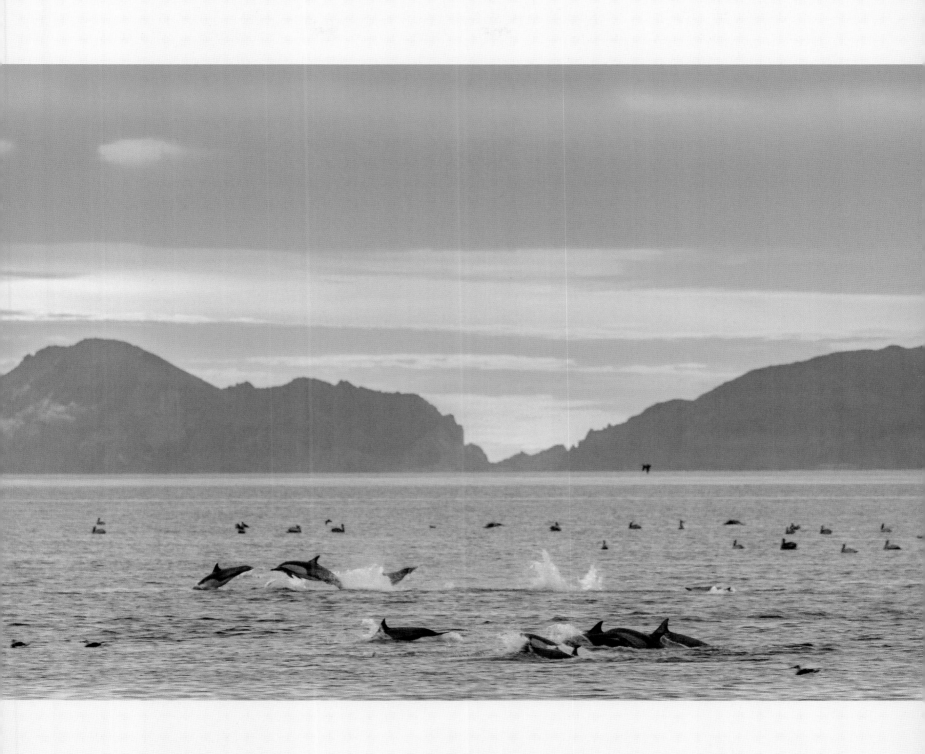

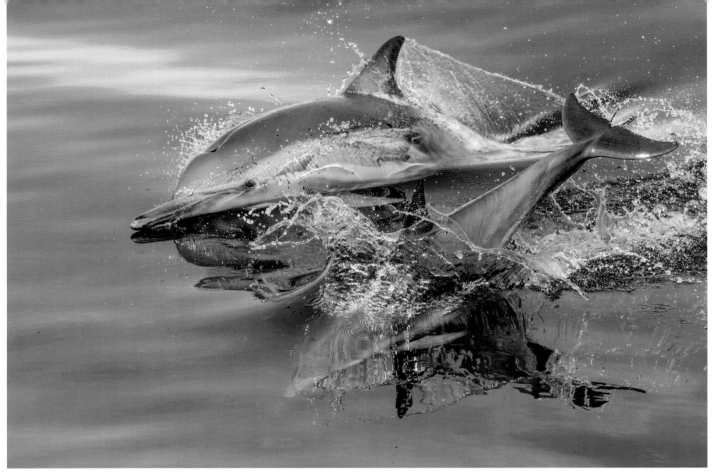

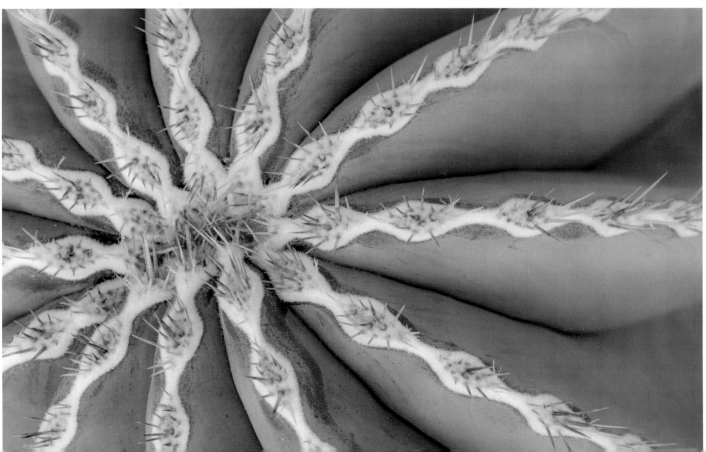

146

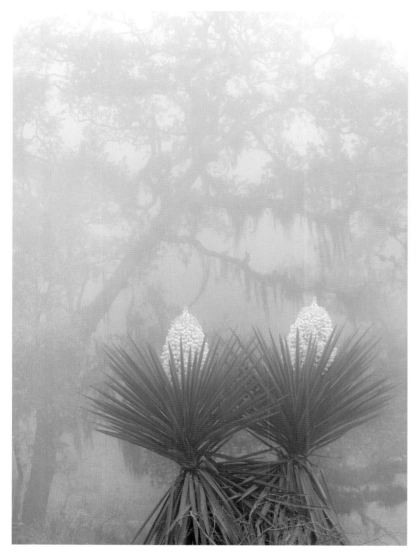

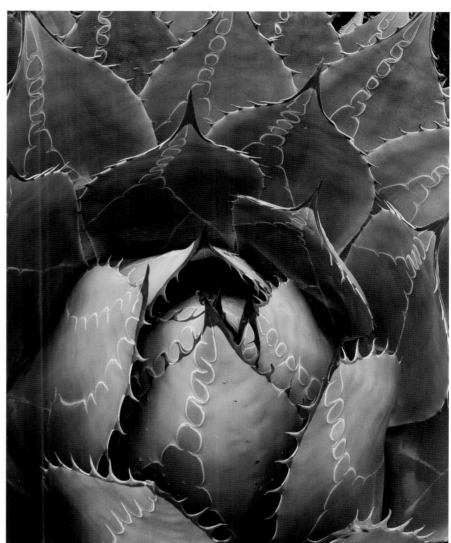

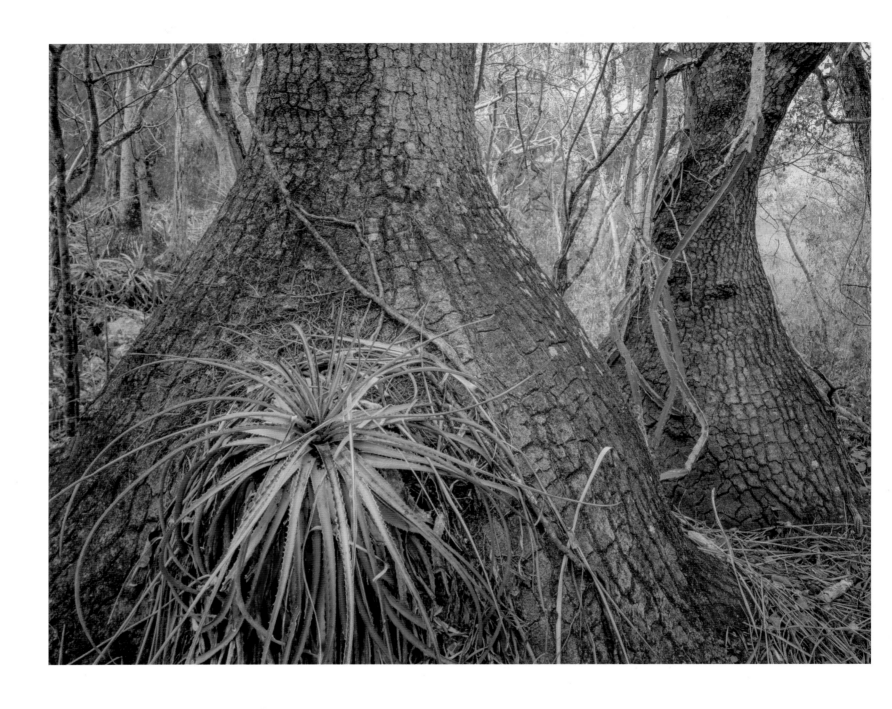

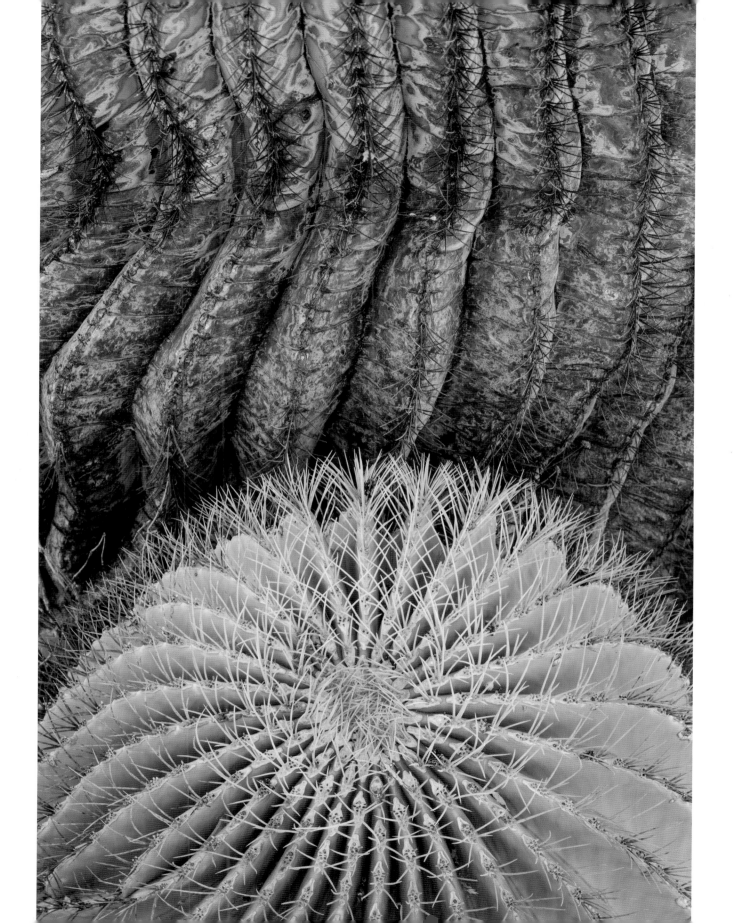

◀ Laguna Madre

En route back to the U.S. and the crossing at Matamores, Patricio Robles Gil, Jesus Lopez, and I decided on a brief detour to assess potential locations where we could illustrate coastal wetlands. We immediately encountered lagoons that were carpeted with flowers and with cacti bordering the wetland.

I had been carefully listening to the NOAA weather radio forecasts, and their warnings for the Padre Island area, Texas, and Laguna Madre, Tamaulipas were becoming increasingly dire. Warnings of tidal surges and high winds were on my mind as I conferred with Patricio. I insisted that we needed to bolt for the border. He was incredulous. He pointed out that clouds and the sky looked favorable and the gringos were usually wrong.

I felt very uneasy as I set up my 4×5 view camera. This was to be the end of our trip that had reached the southern-most part of Tamaulipas, and my film supply was nearly gone.

Nonetheless, I continued my search for a scene to best illustrate this wetland paradise.

That's precisely when the attack began. Like a brown veil rising from the still water, mosquitos covered my body. I was cooking in my own juices with the 100% humidity and had tried to cover every inch of my body in long pants, shirts, and hats. A lavish coating of repellent seemed to only encourage the attack. Fortunately, I quickly exhausted my 4×5 film supply. I was ready for a cold beer, but professionalism and guilt sent me back for a roll-film back, which allowed more photos to be recorded . . . but it also prolonged the insect agony.

To this day, Patricio gloats about the storm that never was and how certain gringos need to relax. Of course that was an amazing situation and one that was gone days later. Sometimes there's no going back. There are no "do overs."

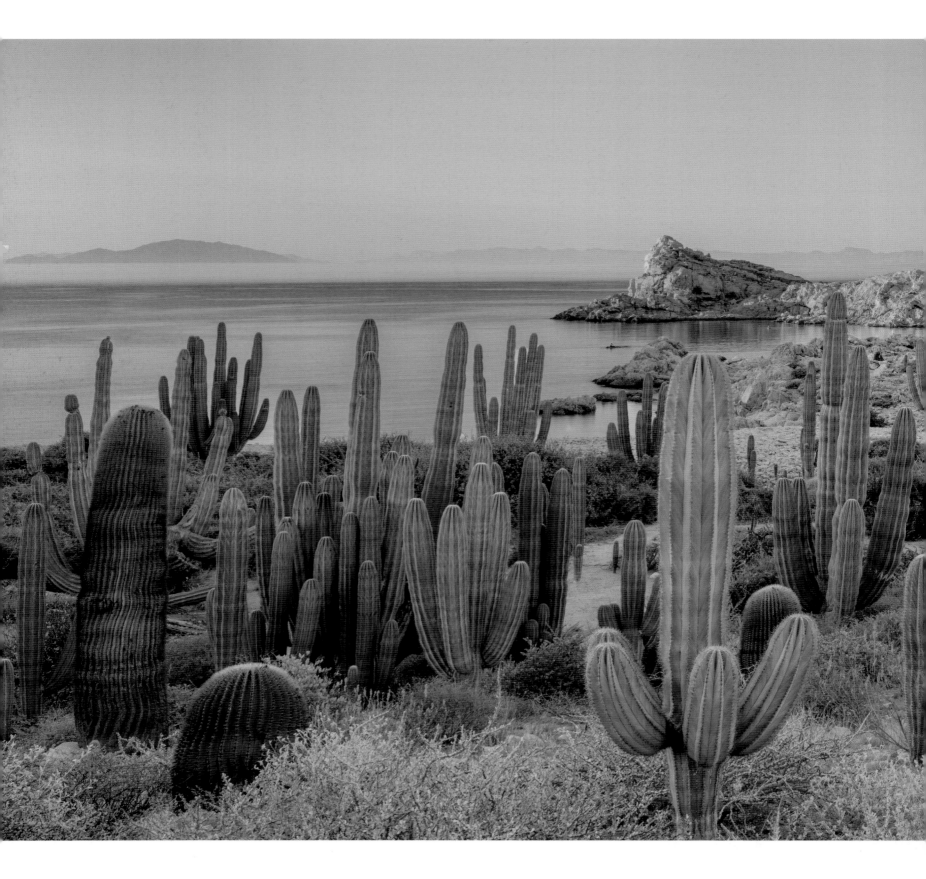

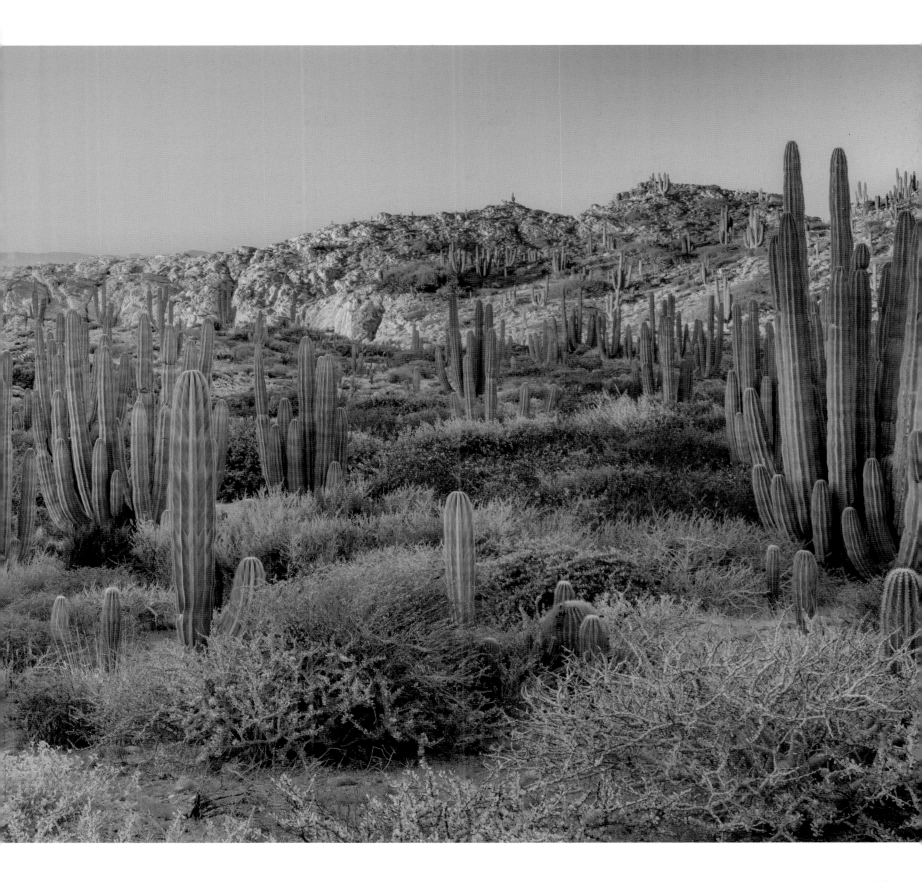

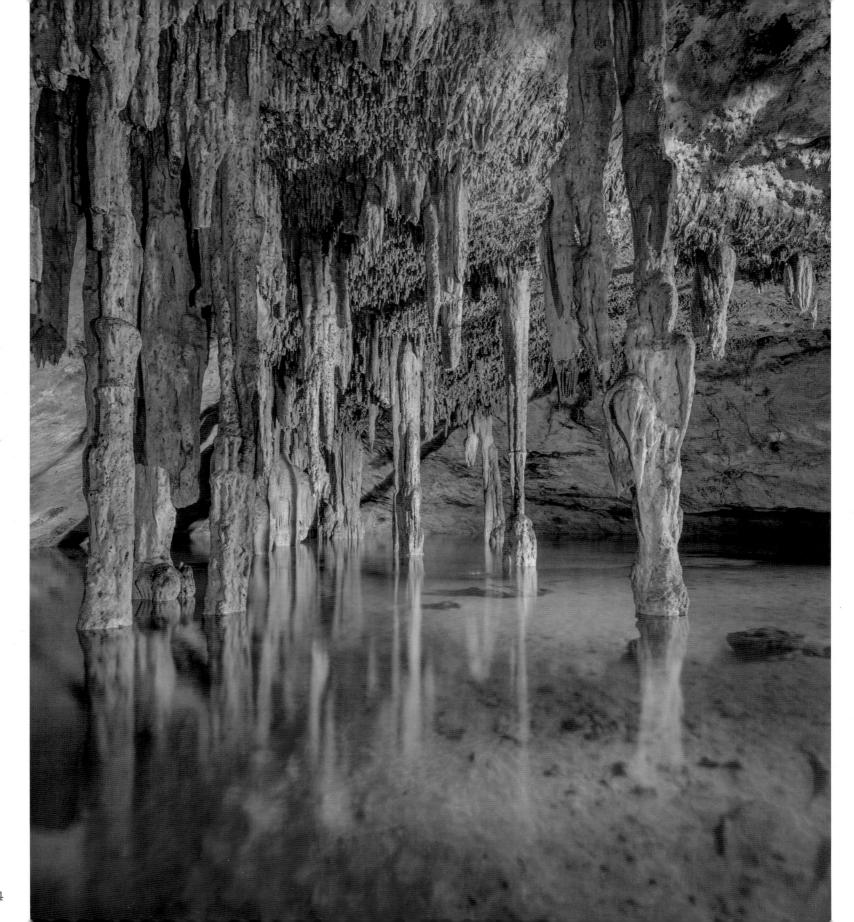

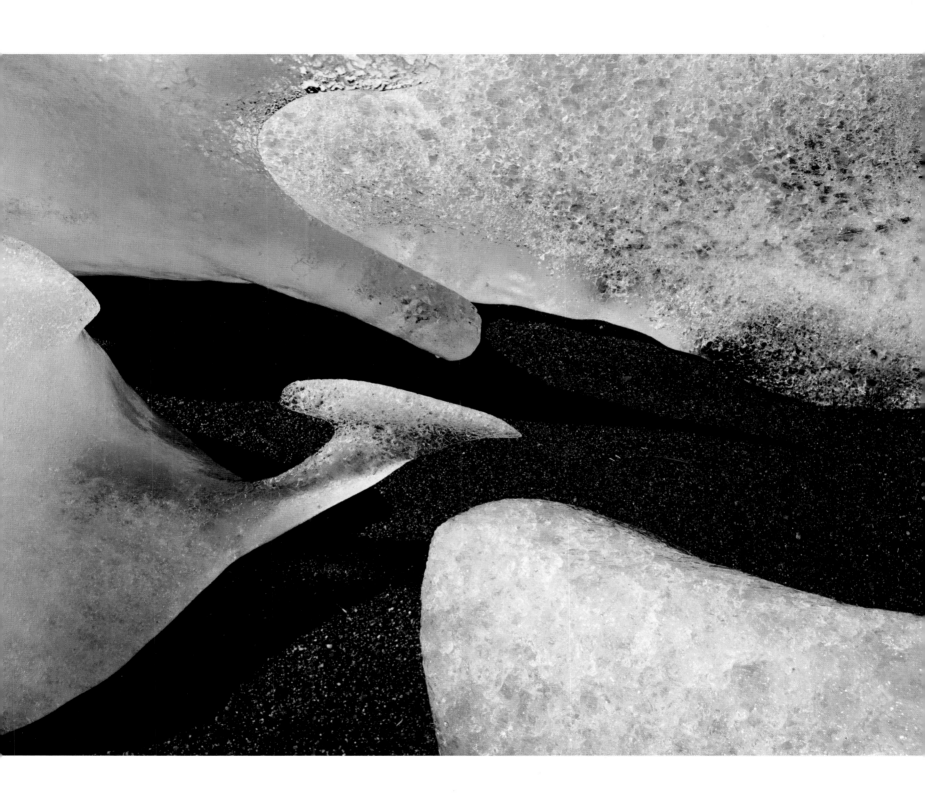

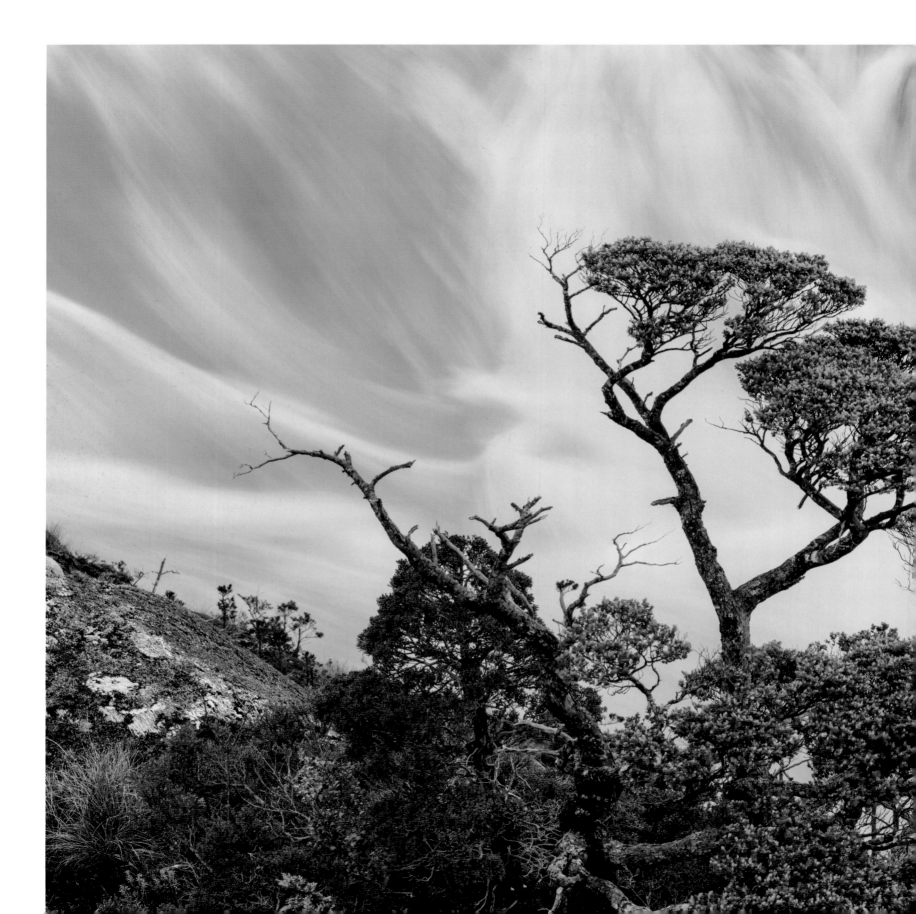

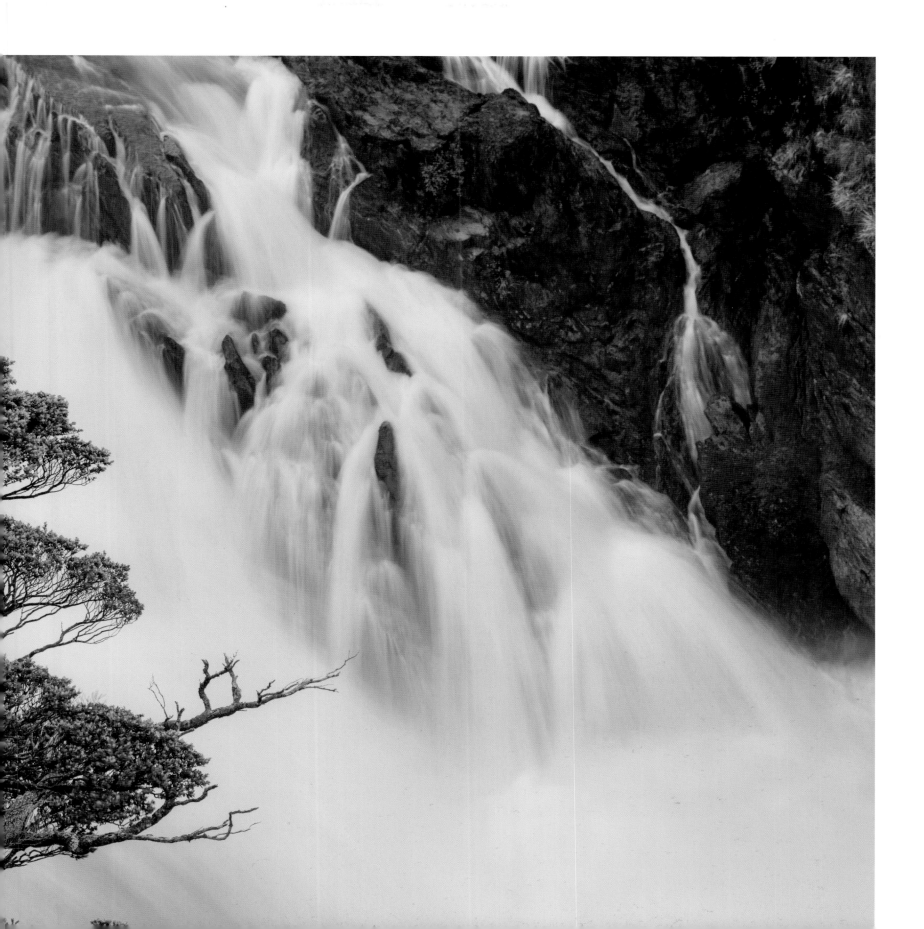

CHAPTER 11 The Pinnacle

People ask me with a sense of awe, "How long did it take you to become a *National Geographic* photographer?" My reply is, "Not long, but I needed a 50-year apprenticeship."

At some point the *Geographic* became more amenable to featuring landscape-photography-driven stories. In response to a conversation with former photographer Chris Johns (the newly appointed Editor in Chief), I suggested a story that focused on the protected areas lining Mexico's border with Texas. After the idea sat on the back burner for months, approval was finally granted.

The *Geographic* is one of those rare institutions that truly nurtures photographers. To outsiders, it appears that they coddle their stable of contract photographers with vast amounts of time and lavish expenses accounts to work on a story.

Yet, to do assignments for the *Geographic* is to be embedded in the process of photojournalism from start to finish. You must "sell" the story. You must be able to defend the story with background facts, and you must budget the story's financial costs. While executing the story, of course, you must produce the most unique images on your chosen subject. Each image needs to be an integral component to a compelling narrative. At the halfway point, you must again defend your work and face editors who can reject the work and cease coverage.

Photographers work with assigned illustrations editors to pare down the selection until only the strongest photographs remain. Finally, when the assignment is completed, the photographer flies to Washington, finishes the final edit, and takes it into layout. No other magazine keeps photographers involved throughout the entire process. And they actually listen to the photographer's concerns.

But, like making sausage, somehow it comes together with the photographer's byline and is circulated worldwide to as many as 30 million viewers.

However, care must be exercised to avoid missteps while negotiating the magazine's system of department hierarchies. Mistakes can lead to banishment and misspoken phrases can reverberate.

My second feature story recorded the Native American tribe's land stewardship and illustrated the incredible conservation efforts of reservation lands that often go unnoticed.

The final presentation of selected images in layout is called "the wall walk."

The Editor in Chief oversees a presentation where photographers defend and explain their work, laid out on pages, to the senior editorial staff. This is a process designed to turn photographers into nervous wrecks. I was no different. After defending and explaining my work, the story was

scheduled to run. With a sense of relief, I was ready to bolt for the door, when the editor announced to the room, "One more thing." My heart stopped, knowing the other shoe was about to drop. "This is the kind of story I want to see more of," was all he said. Dennis Dimick, Executive Editor, leaned over and whispered, "It's nice to see elegance back in the magazine."

I was incredibly gratified and felt more assignments would come my way.

My friend Patricio flew to Washington to propose a story to *National Geographic*, which was anchored with his superb images showing wild sheep in remote locations around the world. The editor who had invited him to Washington passed Patricio off to his assistants, who summarily and harshly dismissed my talented, ethical friend. He was heart broken.

Later that year, I had dinner with another editor from *Geographic*, and with a couple of drinks in me, I told him how my friend had been devastated by the *Geographic* experience. He badgered me for the names of the offending editors and kept insisting that I tell him. I said I didn't want to get into naming names, but when I finally gave in, I could almost see my words floating toward him and I wanted to pull them back. I knew I was about to go down in flames.

And so it happened. Weeks later, the Director of Photography called, informing me bluntly that I'd never work at the magazine again. In speaking with fellow contract photographers, I learned that my experience was not at all unique.

Still, having done assignments for *National Geographic*, one's chest does inflate a bit. Their circulation and credibility allows photographers' images to both inform and influence a global audience.

But over time all things change. Both the Editor and the Director of Photography are gone. Sarah Leen, my former intern, is now the Director of Photography. She's applying her immense talents and will put her stamp on the magazine's future.

I learned that our dreams might not always work out. But to quote the Rolling Stones, "You can't always get what you want, but if you try sometimes you find . . . you get what you need."

There are always other dreams. I also would add that standing by one's friend trumps all.

▶ Big Bend

I had talked to Chris Johns, the newly minted Editor of *National Geographic Magazine*, about the protected areas on both sides of the Rio Grande in Texas and Mexico. I proposed a story that would examine Big Bend National Park, Big Bend Ranch State Park, Black Gap Wildlife Management Area in Texas, and The Santa Elena Protected Area in the Sierra del Carmen in Mexico.

Chris and I shared a long-standing love affair with the Chihuahuan desert region, so in early 2005, my camper headed into Texas to fulfill a contract for *National Geographic Magazine*. My method of buying guidebooks and maps of the region started the process.

The story I wanted to tell was centered on the Rio Grande as being both a corridor and border for two nations. I learned that the land was also defined by volcanic activity with long dormant volcanoes, lava flows, and hillsides of smooth volcanic tuff.

Multiple attempts and multiple times visiting a certain area is key to making great images. However, this time it was different. As I hiked around the base of Cerro Castelon, I watched the volcanic tuff (solidified volcanic ash) turn from brilliant white to pink as the clouds reflected the rosy hue of sunset. I found myself concentrating on the solitary ocotillo rooted in the tuff formation. Red blocks of lava formed an interesting design in the foreground. But my excitement was heightened as the clouds began to make a "V" shape that mirrored the shape of the ocotillo. I raced to set up my 4×5 view camera, centering on the clouds over the lone ocotillo . . . or so I thought. The cloud drifted right and the composition vaporized.

I seized the camera, opened the lens to make a quick composition check, and re-shot the image. I picked up the camera and tripod and repeated the process until I had traversed five yards. Only one of my attempts produced what I was after.

I thought back on a favored expression of my photo editor Chuck Scott: You can't turn a dinosaur on a dime. That aptly explained trying to compose quickly with a view camera.

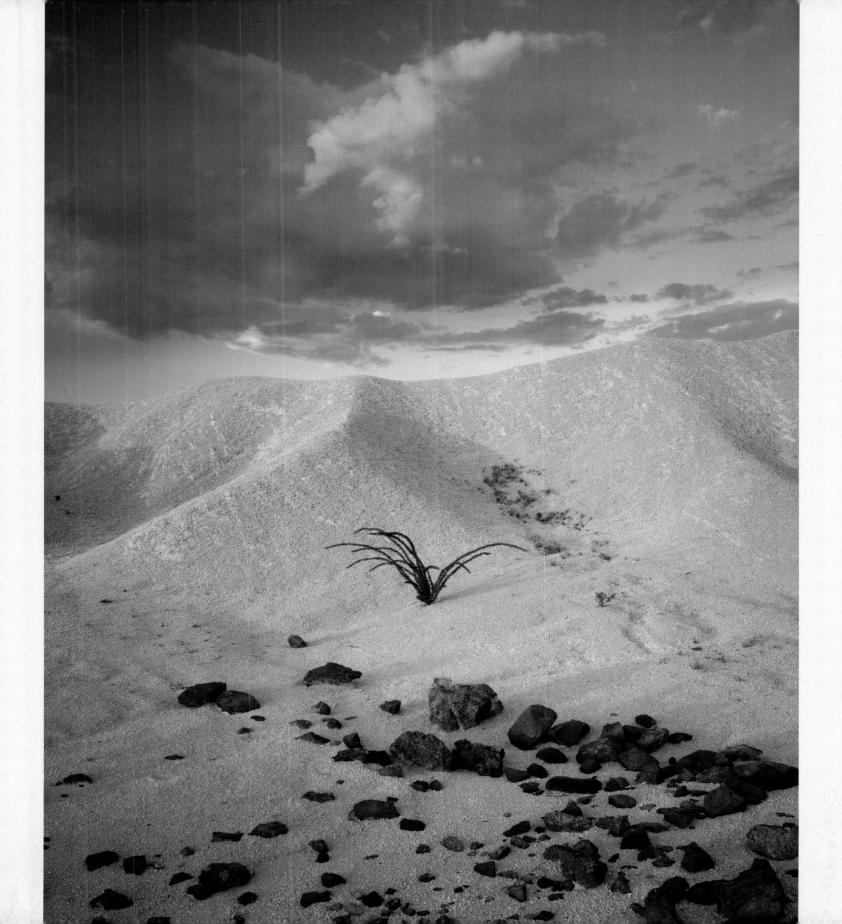

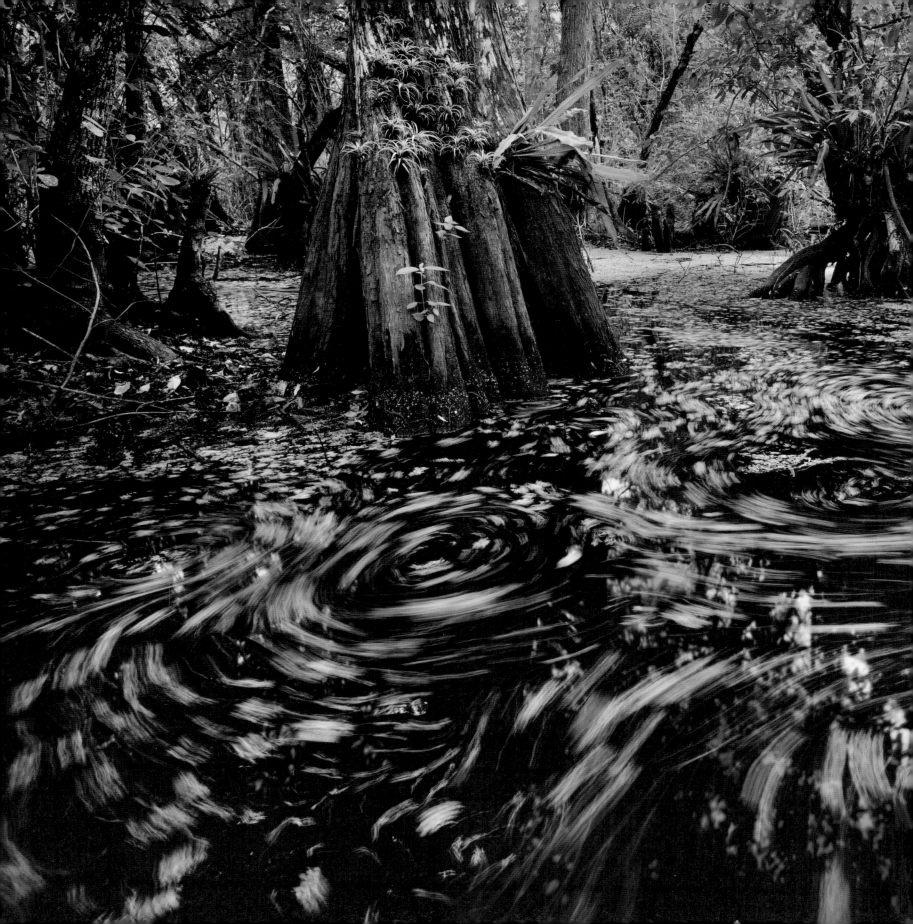

Big Cypress Seminole

The August air was thick with humidity. I had driven my camper to The Big Cypress Seminole Reservation. The reservation was a truly different ecosystem defined by the hydrology in a swamp environment. But the cypress domes were subject to the whims of upstream agricultural needs. A series of canals diverted the water away from the tribal swampland, changing the habitat.

The tribe elected to work with the Army Corps of Engineers to redirect the outflow to a place where it could once again percolate into the cypress dome swamps.

When you work the *National Geographic*, you become painfully aware of previous images illustrating stories about swampland. Like any assignment with the *Geographic*, one must present images that illustrate the subject but do so in a way that's both fresh and compelling.

I must begin by saying, "I don't much care for snakes . . . or alligators," which were abundant in this region. My solution was to hire an assistant who could load my cameras for aerial photography when flying over the reservation, and who could watch my back when I crouched down under a focusing cloth in the swamp.

Krista Schlyer, armed with ski poles, joined my Seminole guides, and we waded into the swamp. I had seen every possible image of cypress swamps and knew I needed something different if the *Geographic* would choose to run it.

I decided on "slow." That is to say, instead of freezing the action, I exposed film with exposures as long as possible. By using neutral-density filters and small apertures, I was able to make two- to three-minute exposures. A glance at the water's surface looked completely calm, yet upon closer inspection, slight movements could be seen.

I selected my wide-angle lens and tilted the back, changing the plane of focus so that the spangles on the water's surface were in sharp focus from near to far. We were dripping with sweat as we all held our collective breaths until two minutes elapsed.

Days later, I received the report I wanted from *Geographic's* film review in Washington. The water moved through the frame in a series of swirling paisley patterns. The result was even better than my preconceived notions . . . and not a single cottonmouth or gator rippled the water.

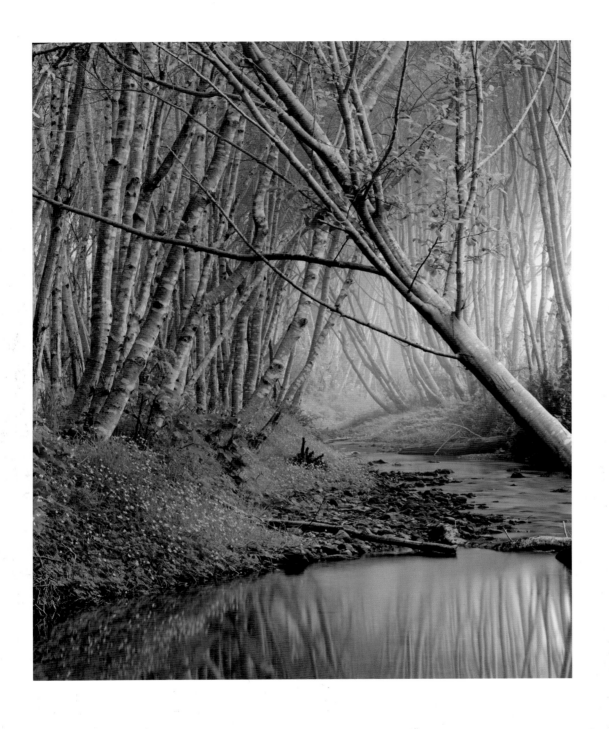

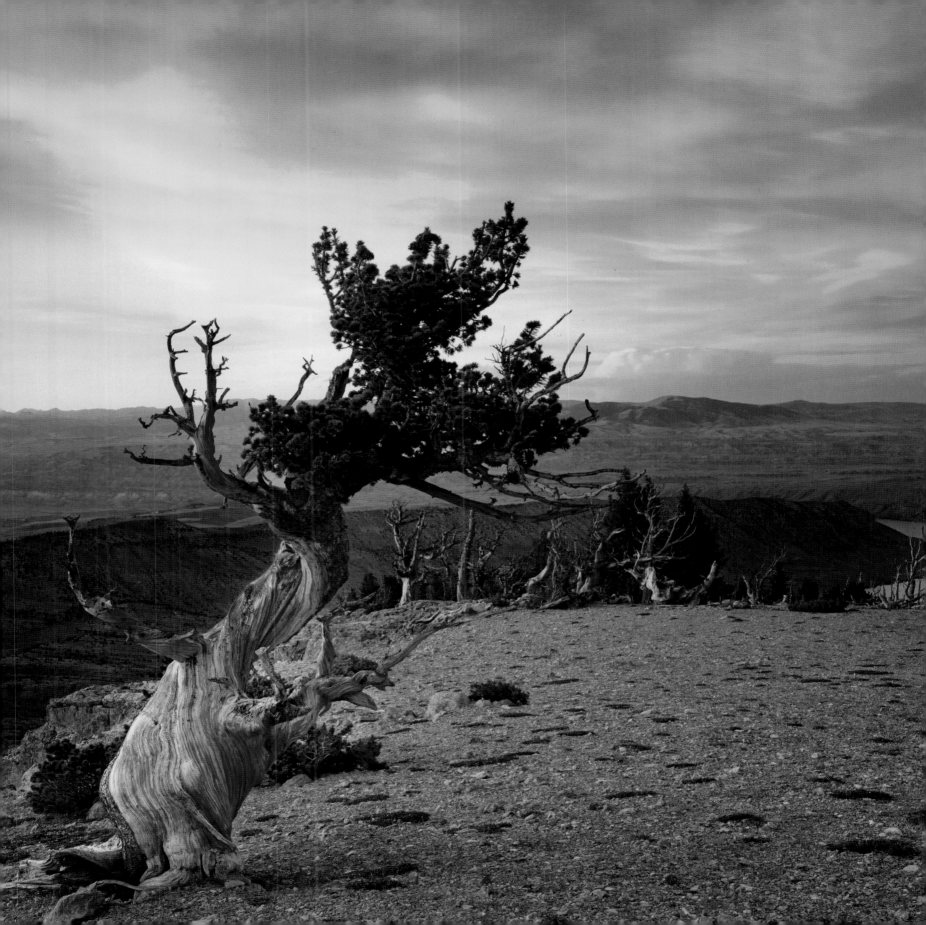

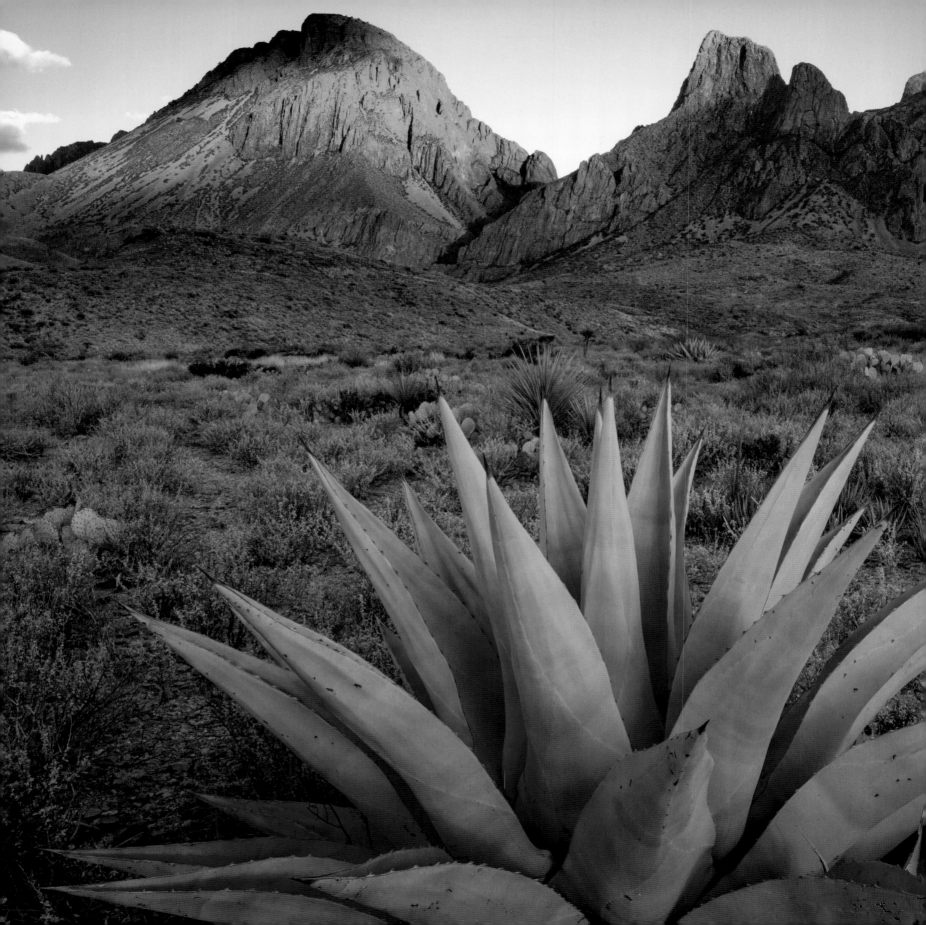

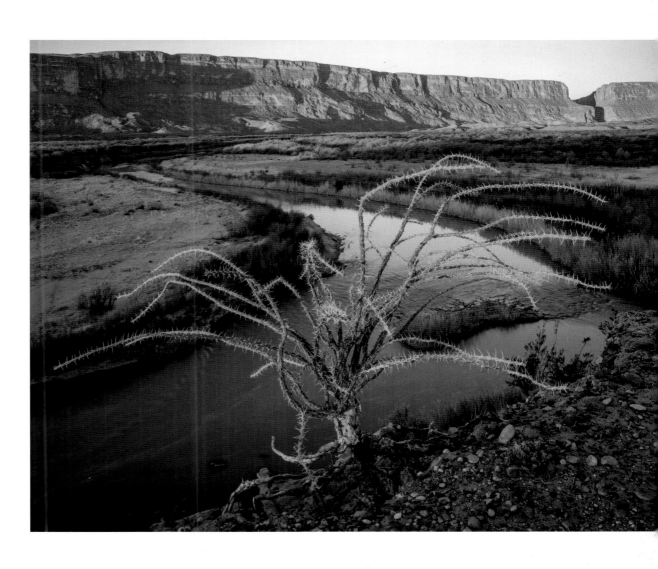

▶ Cheyenne River Sioux

My decision to visit the high plains to illustrate a planned bison reserve on the Cheyenne River Lakota Reservation was timed to coincide with the arrival of fierce tornado-like thunders storms. I remember pulling into a small town on the Wyoming grasslands and finding no motel rooms available. As I drove through the town I began to notice every car looked like someone had used a ball-peen hammer to dent every smooth surface.

Motels were filled to capacity by insurance adjusters. Apparently, I was following the path of a summer storm's hailstone barrage that had left havoc in its wake.

I pulled into the town of Eagle Butte, South Dakota with amber grasslands in every direction. Working on assignment for *National Geographic* opened the doors at the tribal headquarters. Eager tribal members had responded to my letters and arranged access to their lands of rolling hills of grass, soon to become a bison reserve.

I had camped out near the local motel, spending daylight hours exploring the land and searching for potential vistas in the event a storm headed my way. The reservation is about 100 miles × 80 miles and is crisscrossed by dirt roads. This is a landscape that is only occasionally punctuated by boulders left by receding glaciers. I needed the drama in the sky.

Several days of meandering gave me merely a glimpse of the wind-swept grassland. By day four, however, things began to change dramatically. Billowing clouds tracked across the western sky headed right for Eagle Butte. I intently watched the storm forming and carefully plotted its path. This can be a bit tricky. There were only a few roads running perpendicular to the storm's path. If I committed to the wrong path, the storm would pass me before the sunset light really lit up the heavens.

I made the choice, opened the cattle gate, and drove into increasing winds that shook my trusty Toyota. I was in full-on panic mode trying and not finding a composition I could commit to. The storm was towering over me as the evening light began transforming a cumulous monster into a work of art. The colors drew me into the scene even as the winds were causing my camera to dance after each impulse.

I did my usual self-talk. I willed myself to remain calm as I mounted a 75mm Nikkor lens on my trusty Arca-Swiss field camera. I pointed the camera slightly to the right of the oncoming storm to allow it to slide into my frame.

I wrapped my body around the camera, spreading shirt and focusing cloth into a makeshift windbreak. Fortunately, there was no rain. There were lulls between the sharp blustery bursts. During moments of calm I exposed several sheets of film. As fast as it came . . . it was gone.

The film was shipped to the *Geographic* where the film review editors let me know all was well.

Fast-forward several months. The image was all I had hoped for. The central idea of the Native American land stewardship piece was to illustrate tribal land stewardship in varied landscape biomes. The *Geographic* is known for its commitment to both great images and an honest portrayal of subjects gracing their pages.

So it was that I found myself fact checking the original concept of my grassland image. Illustrating the plains of the Native Americans and the plan of creating a preserve for bison was central to the story. I had made several calls to the tribal headquarters to confirm the status of the project. After several calls with only vague answers regarding the future of the preserve, I finally pressed for a straightforward yes or no response. I loved the image and really wanted to see it in print.

The following day I learned the tribe had a change in leadership and their plan for a bison preserve had evolved into a miniature golf course and RV park. I was devastated.

So it was that this image was never used. The truth had set my image free.

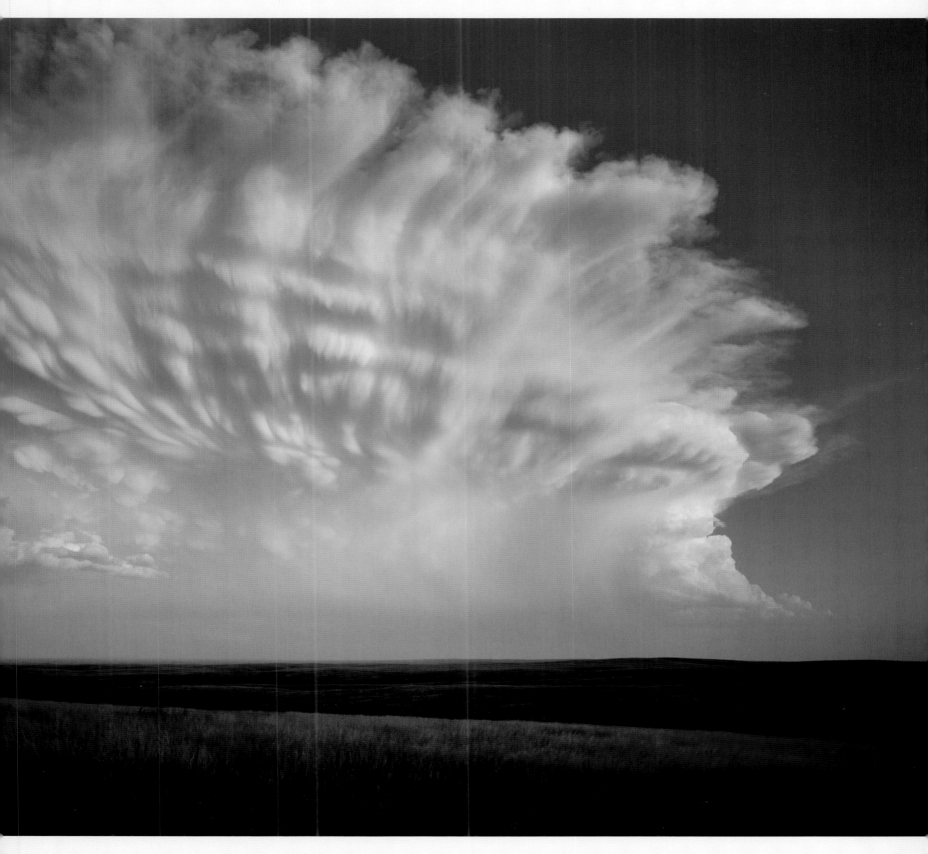

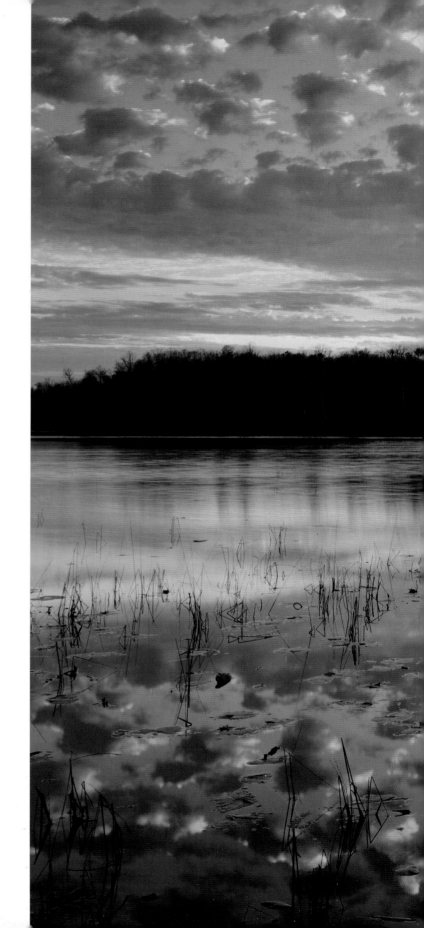

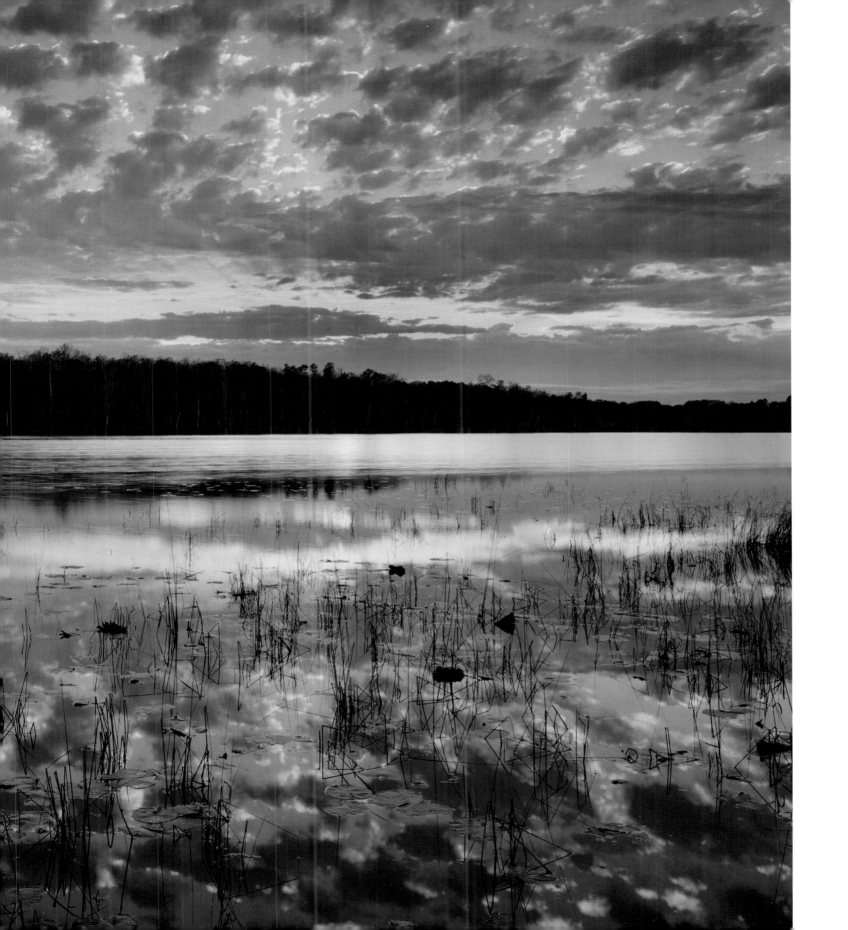

PART 6 **Sharing and Gratitude**

CHAPTER 12 John Shaw

While leading Mountain Light Workshops, I suggested that John Shaw would be a terrific addition to their faculty. John's ability to synthesize essential elements of highly technical aspects of digital photography would bolster Mountain Light's credibility. Justin Black agreed. John is a digital guru who had transitioned from a highly competent film photographer to one of the most qualified proponents of new technology.

Though we've been friends for a very long time (or maybe *because* we were friends), I unleashed a broadside assuring him that his "toy cameras" would never be a serious tool for professional landscape photographers. Back in 2006, our on-going banter delighted workshop attendees who relished passionate divergent opinions that reinforced the notion that there was more than one way to succeed. It was all good fun, though some workshop spectators were nervously choosing sides . . . film vs. digital. It remains a parallel universe at times.

Each of us had paths to the mountaintop. For instance, back in the film days, we got into a discussion of how to meter the light of a brilliant sunset to maximize results. John insisted that one should meter the brightest spot in the sky and open the lens one stop. I, with absolute authority, insisted that best results were achieved by metering 10 to 15

degrees away from the brightest light. Regardless of which method we used, our exposures were identical.

As John transitioned early on into digital photography, he realized that an incredible revolution was coming that would be the death knell for film-based image making. Our phone conversations involved John politely listening to my assault on small cameras in general and digital in particular. My resistance to digital resembled an aging curmudgeon's final act of defiance. Like a drug dealer, John kept patiently urging me, "Hey kid . . . try one of these."

Finally, in an exasperated tone John simply said, "Do it now!" He had just finished field testing the new Nikon D3 and had concluded it was indeed a game-changer. After explaining his current test results, he ordered me to buy one. I did.

It was indeed a game changer. Combined with constantly improving Adobe software that allowed "stitching" several images together to create immense file sizes with incredible detail, I could foresee digital photography reaching parity with large format film photographs. Ultimately, the camera is merely a tool. It's the vision behind the tool that can produce inspiring work.

John jokes (at least I think he's joking?) about giving me a "900" number to call whenever I have burning

questions regarding digital technique. Our combined interests often evolve from a digital processing capability or newly developed cameras and lenses, which in turn offer opportunities to make images never before possible. Perhaps it's our combined years of having been stymied by the technical limitations of film photography that allow us to immediately envision applications for creating new images as technology advances. An example would be the ability to photograph stars using high ISOs and fast shutter speeds, making images of the Milky way—formerly not possible—ubiquitous.

Together we have hacked out solutions by testing various auto-focusing modes, optimum ISO and exposures, use of Tilt/Shift lenses for "stitched" panoramas, image processing workflow and presets, and even which tripod support to chose for specific applications. Since both of us love ferreting out ways to solve problems, I regard combining our thoughts as a vital and unique way to produce "cutting edge" images. Techniques perfected in this manner often expand into an integral part of our classroom presentations.

Staying current is something we have grown accustomed to as newer more amazing technology multiplies exponentially. John is never shy to evangelize about the merits of new equipment.

Of course it's not always useful to have a friend like John. He's what my wife would call an "enabler." Just last week, John (ever the crack dealer) after hearing me complain about unsuccessful attempts at photographing owls, offered, "You know, a fella really ought to have that new Nikon 600mm lens!" I now own one. So it goes.

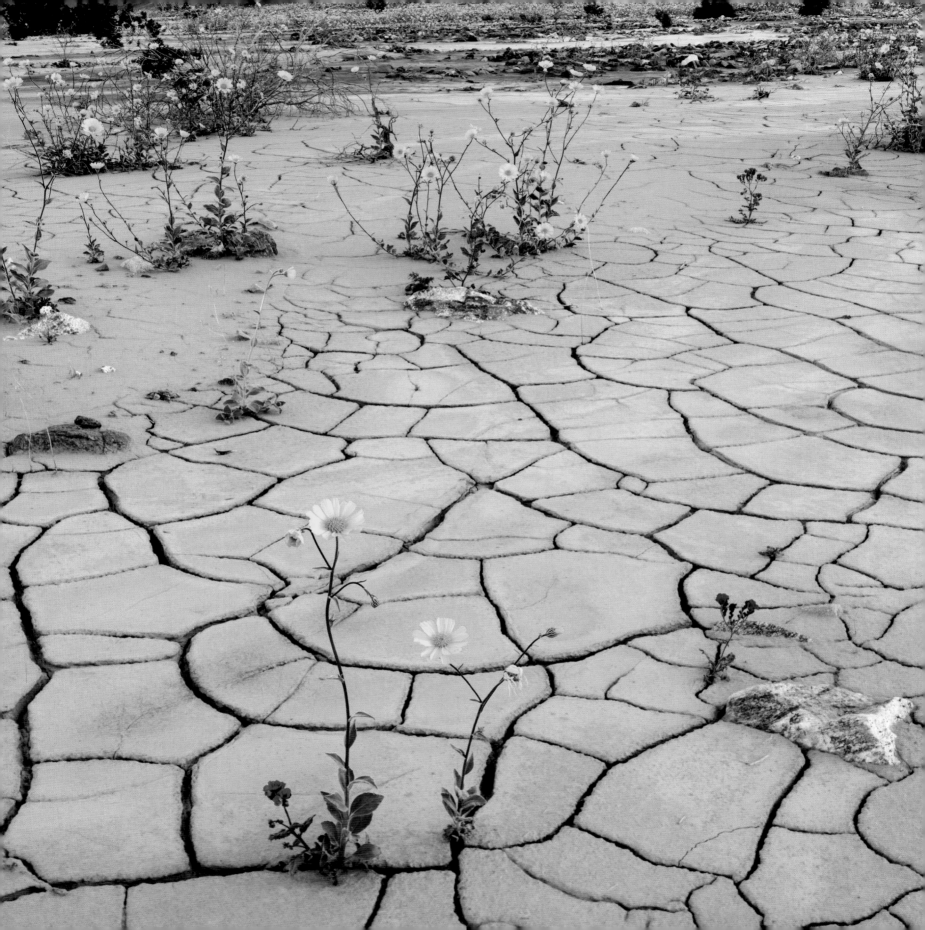

◀ Death Valley Gold

Photographers who chase light across the great American landscape are always optimistically saying, "this is it . . . this is the big one." In 2016, the El Nino gods smiled and it really was the "big one." The rains caused Death Valley's barren alluvials to be colored with sheets of desert gold that burst forth as if being released after decades of pent up life had been placed on hold.

Like lemmings, any camera with two legs attached poured into the Valley. Traffic jammed the park's narrow roads adjacent to distant sheets of flowers. It was a celebration of life and at the same time a display of crowds released from the cities, trying to reconnect with nature.

I spent several days photographing hillside gardens trying to blend into the crowds.

Yet my heart wasn't in it. In a calculated retreat, I found areas where drying was transforming muddy ponds into cracked clay remnants of watercourses. In the quiet of the early morning, minus the rush and crowds, I regained my feeling of joy. I could concentrate on the life springing forth from the desert.

Perhaps it's my journalistic background nurtured in the quiet moments that informed my vision, but I was attracted to the juxtaposition of life amid the desert harshness. It's the universal metaphor for what we all face. I just needed a moment when nature held its breath and the delicate flowers were still. My patience paid off.

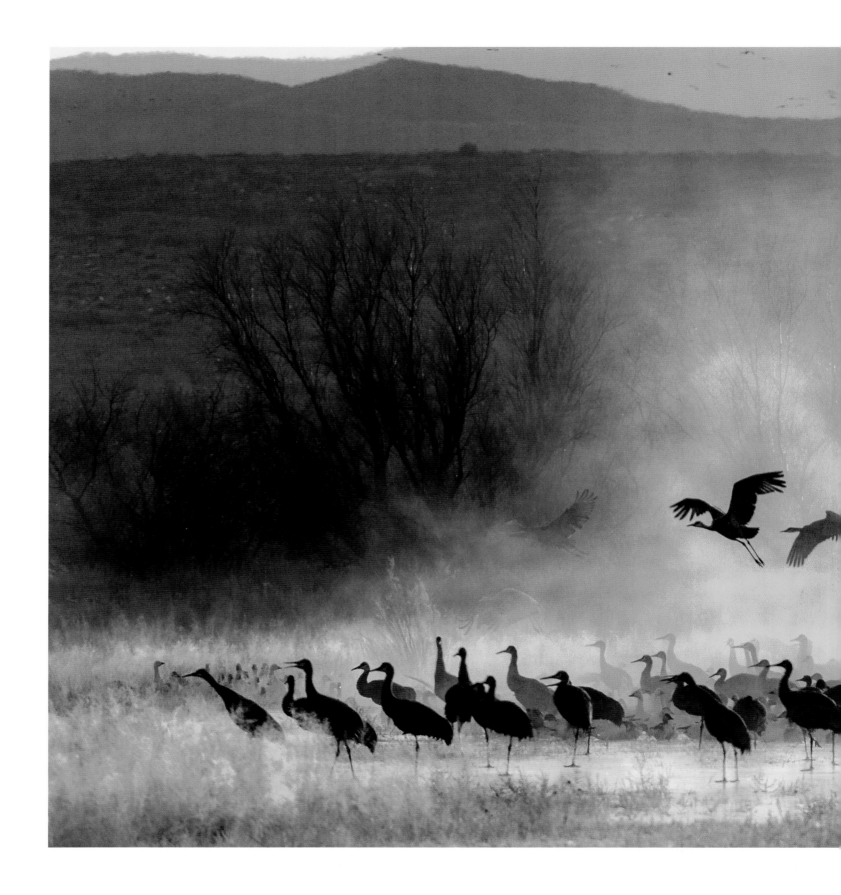

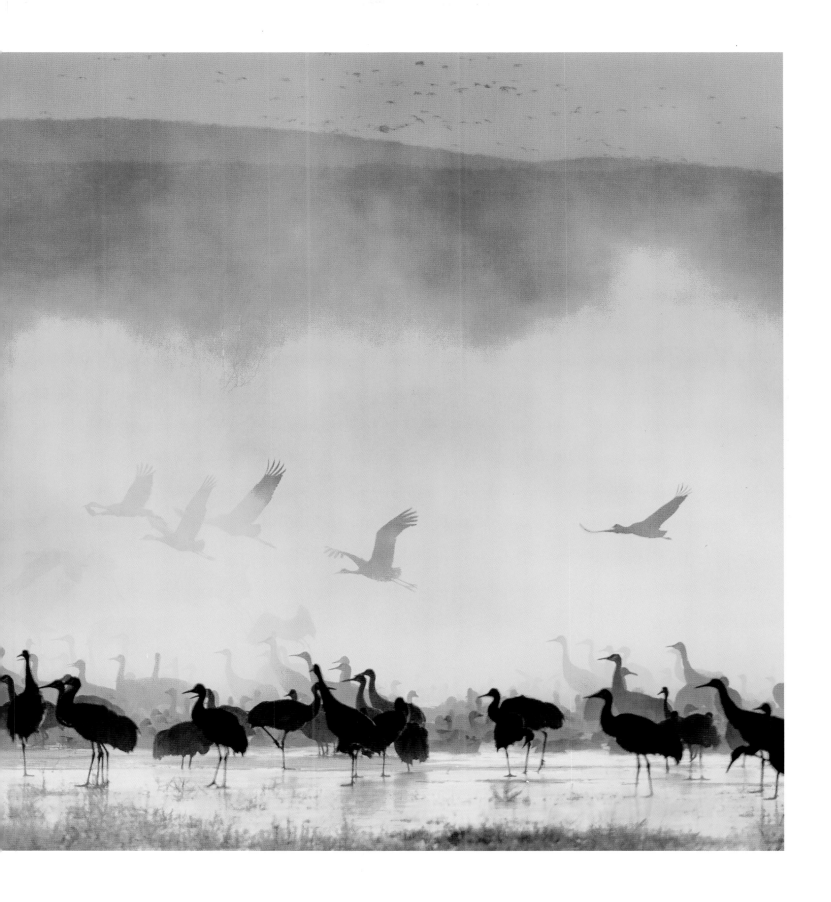

◀ Sandhills in Formation

There are moments when photography is pure joy: When it's an incredible celebration of just being alive, seeing, smelling, and listening to life whirling around me. Bosque del Apache is a birder's Mecca. Frigid ponds team with migrating birds. The noise can overwhelm the senses as the snow geese and sandhill cranes take to the air as the sunlight kisses the land.

The sandhills return to the ponds each evening for a night of predator-free rest. They spiral down in formation with wings like parachutes, gracefully gliding in as they seem to hang in the sky. The advent of digital photography has allowed me to spread my wings as well.

Feeling as though my career has come full circle, I have taken John Shaw's words to heart and embraced digital photography, reawakening my inner photojournalist. This time there are no rocks flying at me and no protest marches; just flying feathers and birds marching to warmer climates.

When anticipating action and calculating speed and trajectory to determine success, I find a similarity to photographing sports during my time at the *Chicago Sun-Times*.

The new telephoto lenses, and cameras with instant auto-focus and auto-exposure, at first seem too easy. Yet to perfect a technique that captures fast-moving dramatic moments is as elusive as ever. Perhaps because I come to wildlife photography from a landscape background, I place more emphasis on composition. The tendency in wildlife photography is to "bull's eye" the subject. And, why not? When action is fast moving, just keeping the subject in the frame is hard enough, let alone making split-second decisions on composition. My feeling is that centering the subject is my insurance policy. I make a few exposures centering my subject, and then I improvise, knowing there will be a certain percentage of failures. Ah . . . but the ones where composition and action come together are worth the effort.

Taking the chances that may fail may also foster growth.

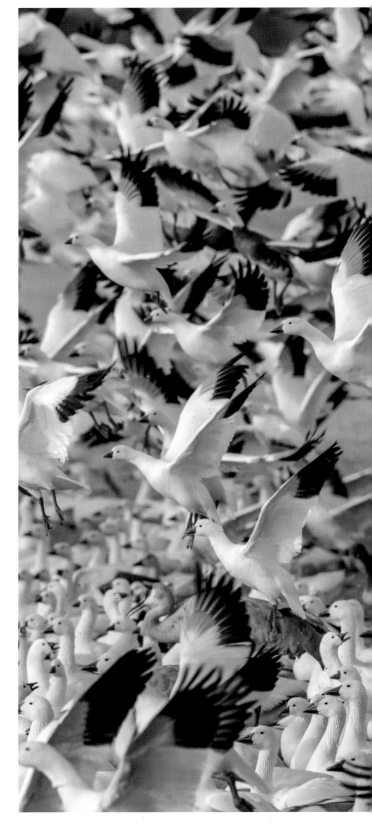

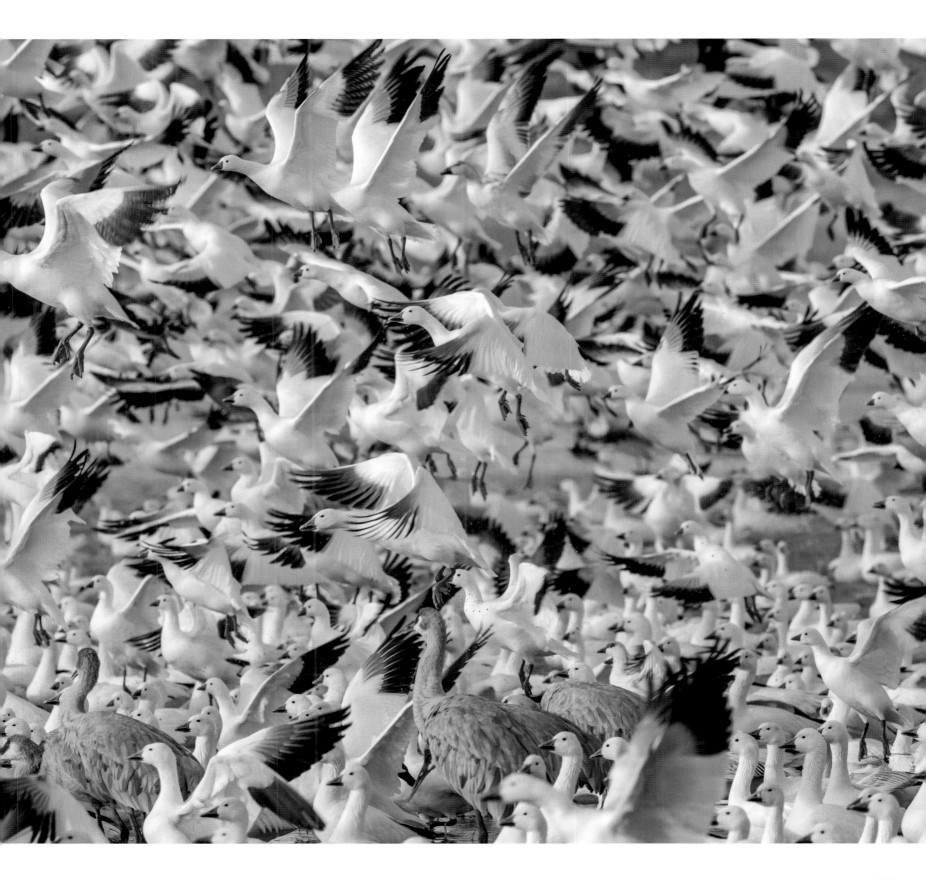

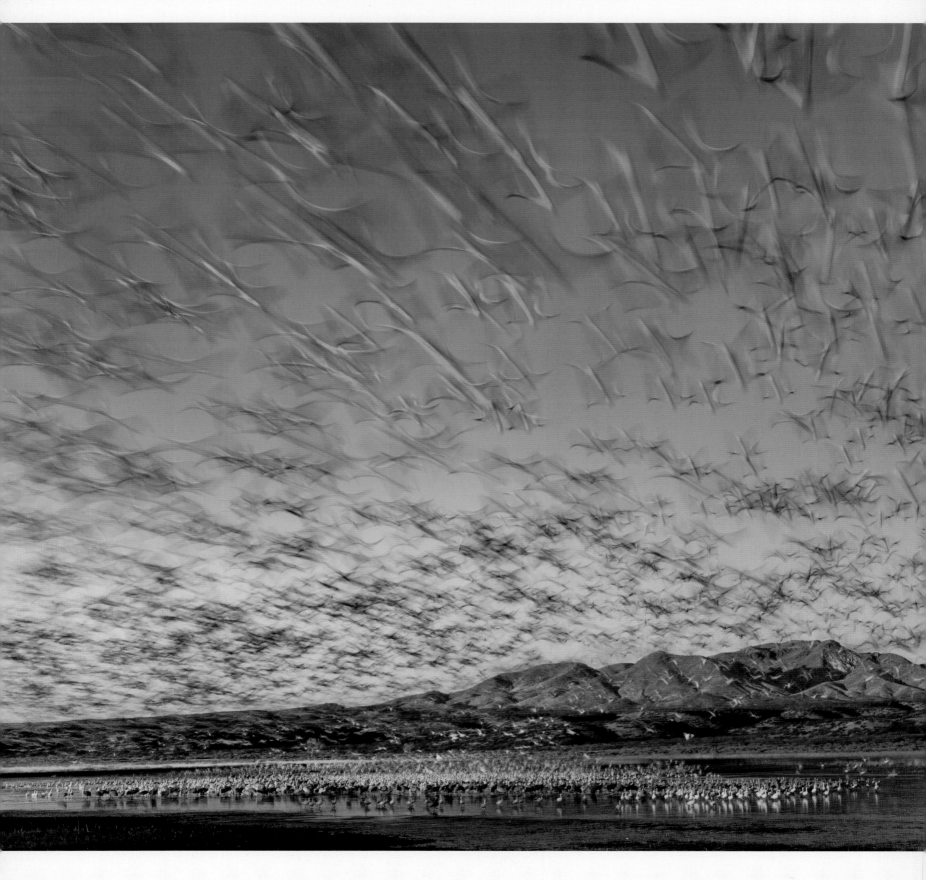

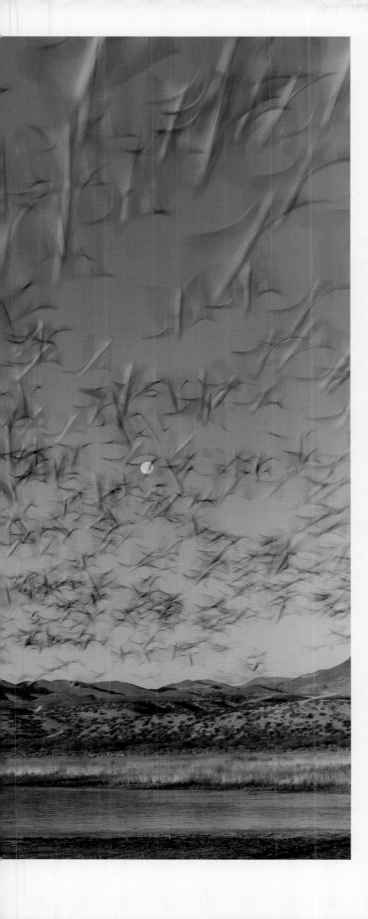

◀ Snow Geese Lift Off

I often approach a subject, especially one that's been recorded many times before, saying to myself, "what if?" By posing the question, I begin a process where I try to employ every technique assimilated over the years, to solve the visual problems to create a "different" image.

I had already made panned exposures at slow shutter speeds of flying birds creating the sense of motion. I had frozen moments with high ISOs and high shutter speeds. But, I wanted something that captured the feeling I have when thousands of crazed snow geese blast off in unison into the morning light.

My solution was to set up my Nikon D800e with a 24–70 zoom lens pointed skyward locked into position on a very substantial tripod. I experimented with various shutter speeds and finally picked a speed that allowed the birds nearest to the camera to be blurred while the ones still on the water remained in sharp focus. I then attached an electronic cable release to the camera. A second camera—my Nikon D3s and 500mm lens on another Wimberley mount tripod—was poised for tight action with a very high shutter speed.

My plan was simple and elegant. The reach of the 500mm lens would be my first priority to capture the dense masses taking off. And with any luck the geese would fly directly over my position and I would fire bursts from the pre-focused D800e.

With the moon setting and the crimson light of dawn upon them, the explosive hysterical takeoff climbed in the sky right above my waiting camera.

To complete the moment, my good friend and digital advisor, John Shaw, was smiling five feet to my left.

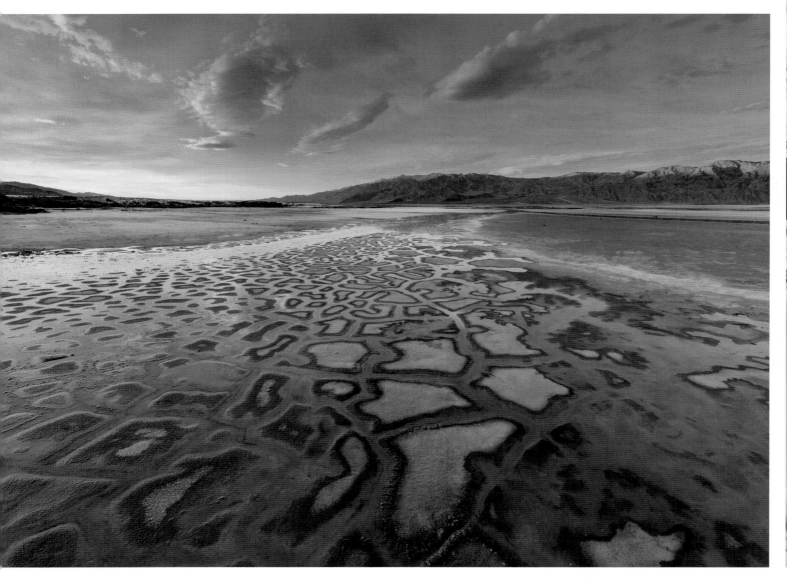

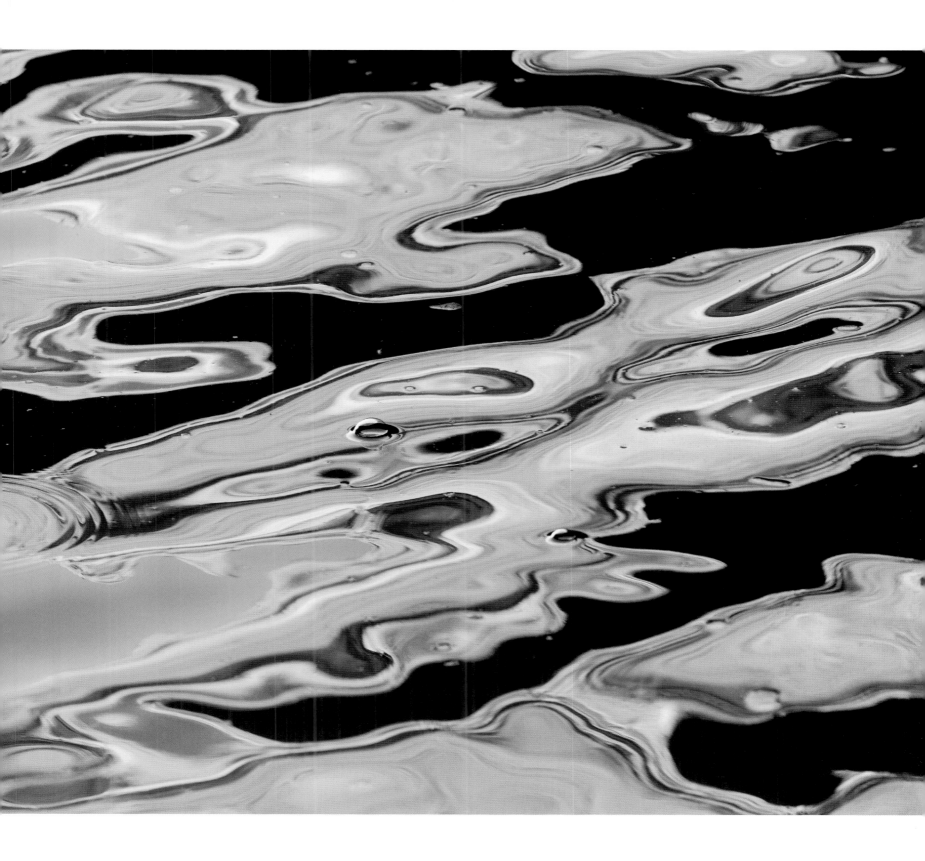

CHAPTER 13 **Teaching**

The operating assumption governing my landscape photography business was simple. I would create an immense, ever-expanding archive that would provide a secure retirement for me as well as an inheritance for my family. It offered a fantastic way to work with my son, Peter, who would manage the archive and do the selling, allowing me to continue amassing more images.

In 1981, my dabbling with being a wilderness photography guide, trekking through canyons, didn't work out as I wanted. Thankfully, the freelance assignments I got allowed me to make an income. By the new millennium, however, several companies were beginning to host photography workshops in wilderness settings. It was a way to teach armies of new photographers while imparting my love of special wilderness locations. The organization, Friends of Arizona Highways, was formed and I was urged by the magazine's dynamic publisher Hugh Harelson to become a board member. Part of their outreach efforts included me venturing into Arizona backcountry while teaching photography. I also co-led trips in 2004 with Joe Van Os, and in 2005 I traveled to Chile and Argentina with Janie Bullard's "Distinctive Journeys." Following Galen and Barbara Rowell's untimely deaths in 2002, Mountain Light Galleries began to expand their workshop programs. In an effort to preserve

their legacy, Rowell's good friend Frans Lanting urged me to meet Justin Black at Mountain Light.

Despite his youth, Justin possessed knowledge and business acumen well beyond his years. In one of those rare life moments, we formed an instant bond that remains strong to this day. I eagerly began leading photography workshops, with a large-format camera as the primary teaching tool. Its ground glass viewing under a focusing cloth became the perfect way to share my vision. My book, *Large Format Nature Photography,* became a textbook illustrating view camera technique.

Digital cameras were on the horizon, but we large-format photographers smugly scoffed at their poor quality and vowed that 4×5 film photography would remain at the pinnacle of image quality. I even rather publicly and loudly proclaimed there was "no way" digital would replace silver-based film photography. With wonderful access to Arca-Swiss cameras, Schneider lenses, and Fuji film products, there was no reason to see the coming seismic paradigm shift.

I wasn't a complete Neanderthal though. Russell Sparkman and I initiated a project using a Phase One scanning back in conjunction with my Arca-Swiss F-Field camera. We schlepped two packs with about eighty pounds

between us, and photographed with a cable directly connecting the Phase One back to Russell's MacBook. Our then "gigantic" 144 MB files were at times breathtaking, but fraught with difficulties associated with the long exposure process that a scanning back required. Together, we produced a series of images for Seiko Epson Japan. Though praised by many, it confirmed to me that digital would never be a viable replacement for film-based photography.

However, subtle signs were soon becoming apparent. The stock photography business that generated my income began to stall before making a slow decline. Though lacking in quality, ever increasing numbers of digital images started to flood the market. My assessment regarding image quality remained, even as the marketplace was changing.

Justin Black left Mountain Light and after a brief stint at the International League of Conservation Photographers, he formed Visionary Wild. Justin's commitment to quality was well known. Both John Shaw and I eagerly joined Visionary Wild, and we led photographic workshops in our favorite magical places.

Photography is an amalgamation of extremely technical devices capturing images that aspire to be an ethereal art form. This dichotomy creates a push-pull relationship between the *art* and the *engineering* aspects of photography. We felt that by teaching together, John and I could bridge that gap by combining both intense classroom work and field sessions in spectacular locations. We could jointly address diverse problems students experienced, along with holding critique sessions designed to sharpen skills. And we could pass on the infectious joy that we feel about being out in nature along with working among friends, to our workshop attendees.

At this stage in my life, my fierce competitiveness is mostly gone and has been replaced by a sense of wonder I feel when I see others succeed. It's simply fun.

I have always been a strong hiker. However, in the fall of 2010, I began to feel out of breath when climbing the foothills near my Tucson home. It felt as though I was laboring to breathe. My doctor suggested I meet with a pulmonologist to assess the problem. My fear was that I had lung cancer.

After CT scans and x-rays, I was told that I did not have cancer. I felt an incredible sense of relief. But, that was short-lived. The doctor continued to say I had a condition called "idiopathic pulmonary fibrosis." To me, it didn't matter. I was basking in the joy of not having cancer. Yet the doctor persisted, telling me this diagnosis was very serious and that it was a fatal condition. Like many who face bad news, I simply chose to ignore it. I'd get a second opinion. I'd "Google" the disease to learn all I could.

I learned that idiopathic pulmonary fibrosis was incurable and that my life would probably end in three years. Still, I felt strong and was only at the early stages of the disease's crippling effects. At the urging of my friends, Jay and Sandy Smith, I called the Mayo Clinic in Scottsdale, Arizona, and met with pulmonologist Lewis Wesselius. Soon afterwards, I was enrolled in a double-blind clinical study for a new drug that could potentially slow the devastating effects of the disease. I later learned that I was indeed on the drug and not the placebo, and it probably gave me an extra year by slowing the disease's progress, and I continued leading workshops.

▶ Boulder Mountain Storm

Nothing was going according to plan. We chased storms and arrived late. Or overcast sky blocked the sun. Rain and sleet peppered our lenses. I worried this would be the workshop from hell. We were on that fine edge between absolute failure and the best images ever.

My new lungs were pumping oxygen into my body at a rate I hadn't experienced in four years. I had hiked above our parking area at 10,000 feet. I was in heaven.

My first notion of concentrating on new snow and autumn colored aspens had morphed into something grander. Powerful updrafts transformed my landscape into a cloudscape.

The sheer scale of the storm cloud demanded a retreat, putting more distance between the storm and me. I climbed still higher and urged others to climb as well.

I wanted to align the coming monster cloud with the isolated stand of aspens. Finally, even my new lungs decided it was time stop. Leveling the camera, I began the process of creating a panoramic image.

Months later, in pouring over images for this book, I started to notice patterns emerging.

My recent images frequently had a feeling of a contrast in scale. Many images like this one appeared to show puny earthbound subjects against incomprehensible powers of nature. I've always felt a privileged sense of awe working in wild places. Following my camera has led me to feelings of transcendence, but since my transplant operation my feelings are raw and frequently on the surface.

My eyes well up with tears of joy for my very fortunate life.

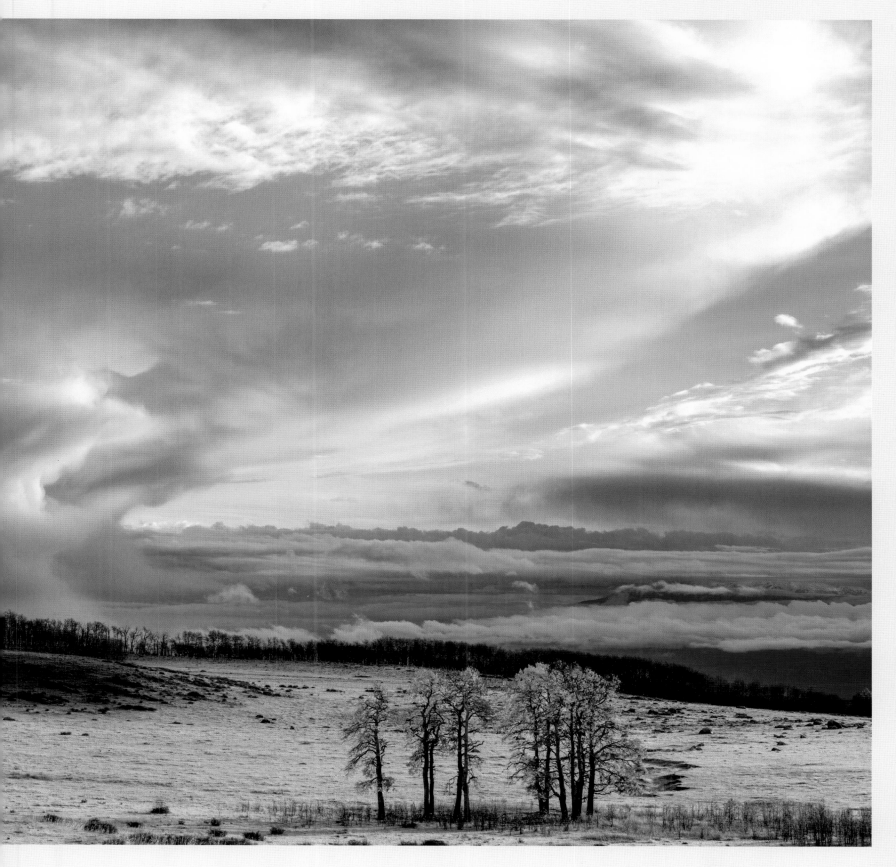

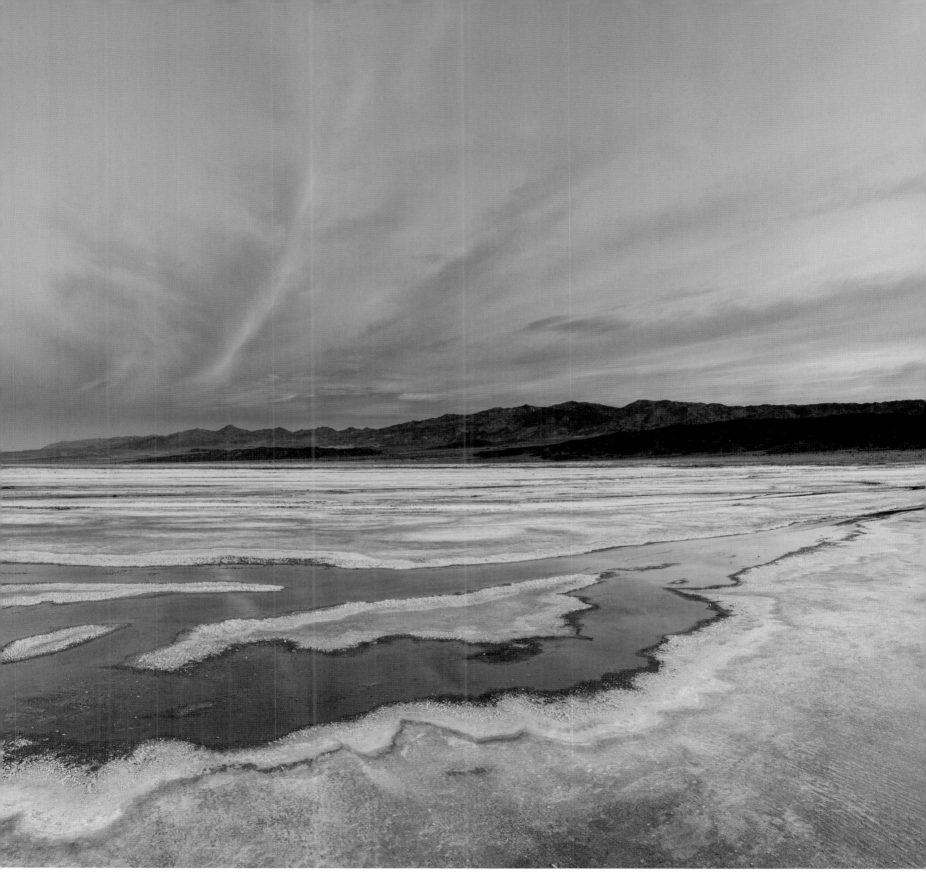

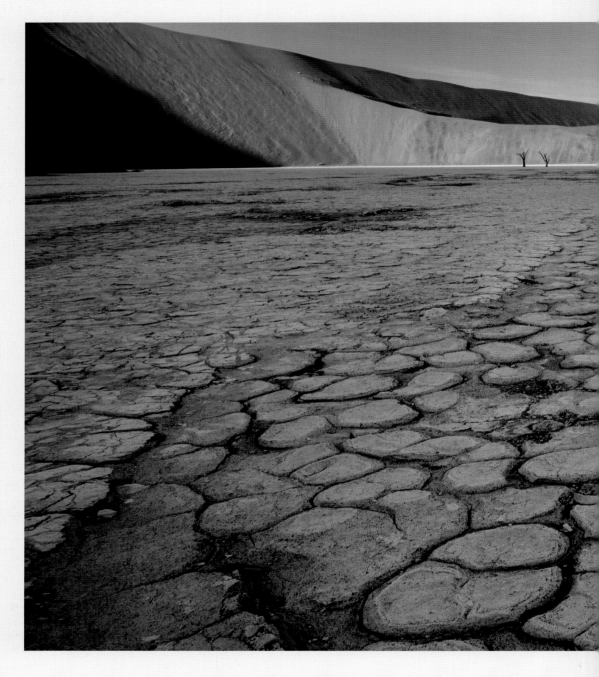

▶ Teaching

The years have been good to me. Teaching workshops has allowed me to travel the globe seeing amazing places while traveling with people who want more from life. People whose vision and curiosity make them kindred spirits. I have worked with Joe Van Os, The Great American workshops, Distinctive Journeys, Arizona Highways Workshops, Mountain Light, and Visionary Wild.

I'm at that point in my life when I'm eager to pass on my passion and joy for this art form. Some people simply want to see distant corners of the world, while others wish to explore the distant internal corners of the self.

So it was that I found myself squatting low on the baked salt pan of the Dead Vlei in Namibia. I wanted to capture the breathtaking expanse of this other world. The desiccated, nine hundred year old forest had appeared in countless publications, yet I was after something different. Our workshop class had endured the three-mile trudge into this spot, with my newly adopted method of cramming canned oxygen into my faltering lungs. I had been here years before,

but this time it looked different to me. Before, I hadn't noticed the dry salt pan punctuated by former pools that had turned into a solid mass of clay plates. That foreground immediately grabbed my attention.

The sunrise light is the most ephemeral, and it was racing me to complete a composition before overwhelming the scene with intense white light. I had to work fast in unison with the students. Some watch

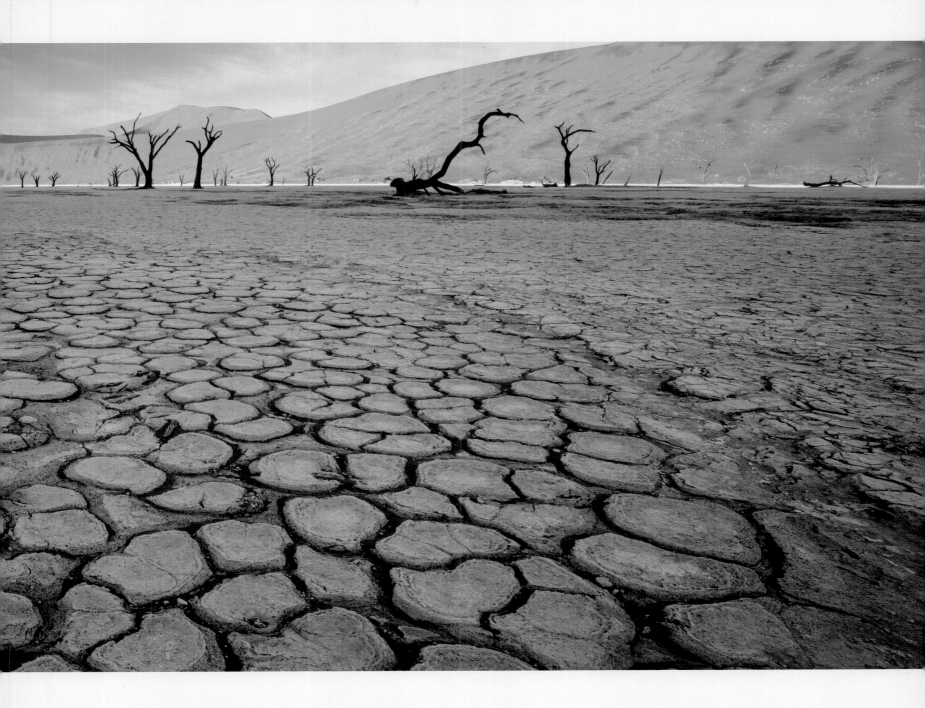

my technique, some try something different, and some are still searching for their personal vision.

There's always a point where commitment carries the day. Even though there's a belief that over the next hill lay photographic nirvana, experience tells me I will lose the race for perfection to a triumphant sun. I make my exposures.

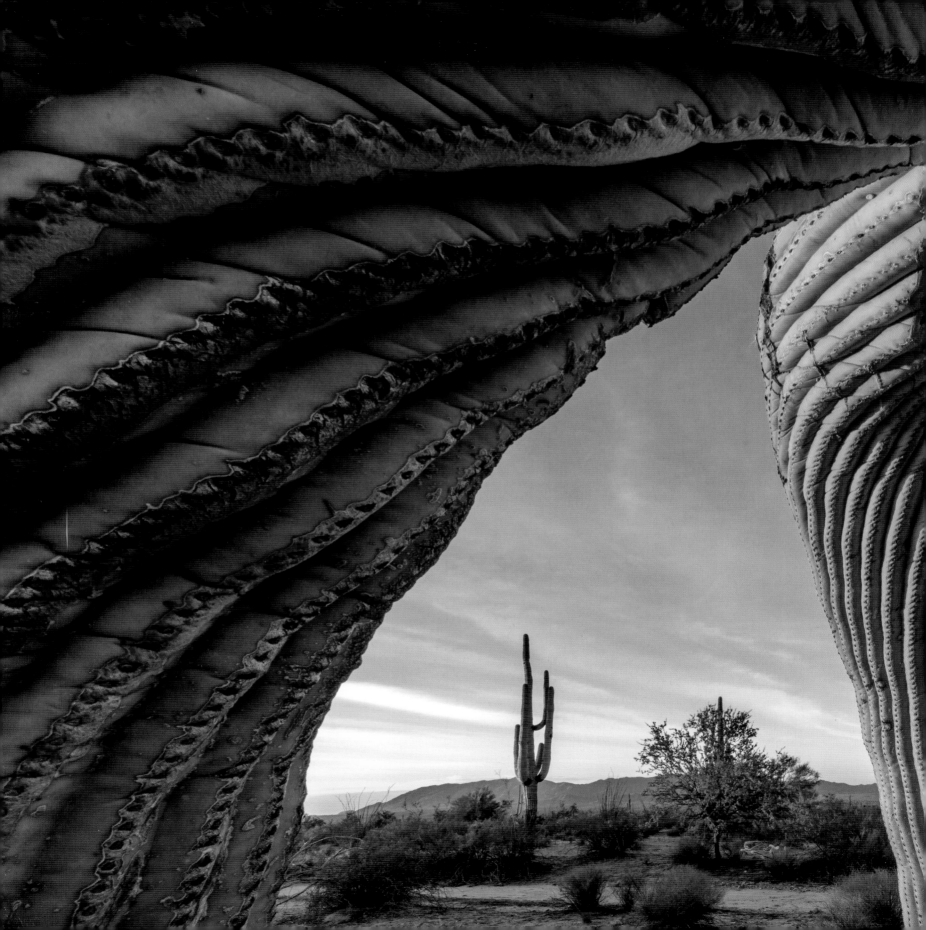

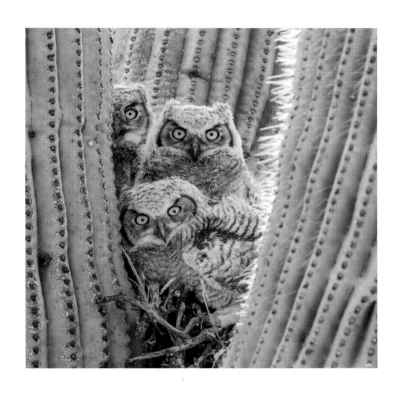

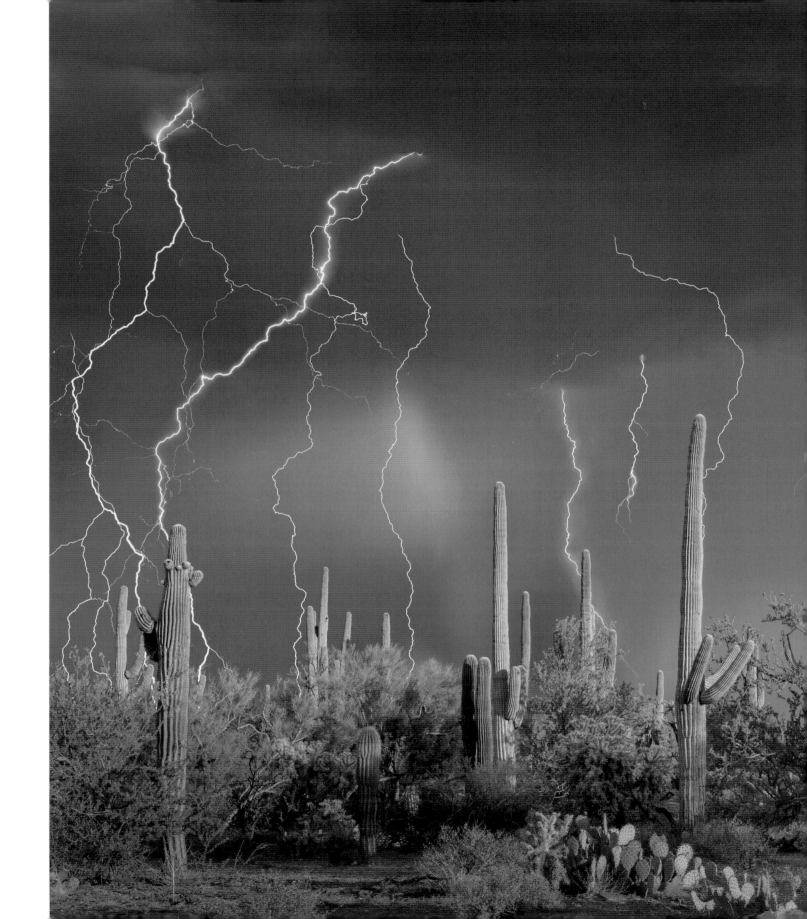

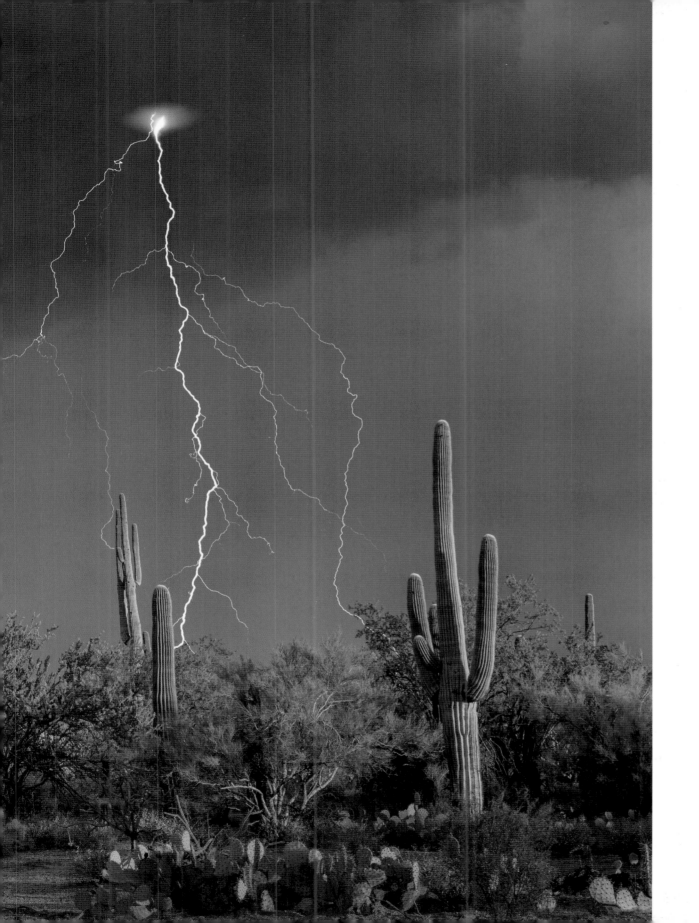

▲ Los Torres

Torres del Paine rises like jagged teeth biting into the sky. The windswept Chilean Patagonia is frequently home to the mother of all clouds. Here, lenticular clouds can assume shapes from whimsical to ominous. But when we climbed the foothills in the predawn light, seeing clear sky to the east, there was a feeling that our days of waiting were ending. Our workshop attendees had been through the drill before with no results.

This time it felt different.

I have taught the practice of creating large panoramic images rotating the camera on a level axis to both capture the horizontal shape of the mountain range and to create huge files. Our group had the process committed to memory, and they dispersed to several

overlooks as the sky transitioned from black to blue.

With light building, the leading edges of wispy clouds emerged at the left of the frame. With the light show beginning to turn into warmer shades of red and yellows, the cloud became still more muscular. It was transformed into an alien spaceship as we watched. Our local guides were dumb struck, having never seen a lenticular like this. I couldn't help but chuckle as I watched our group feverishly taking pictures of something we would never again witness.

It's what we do. We choose to be witnesses and we wait for the magic. Sometimes it happens.

Epilogue

On the final night of our 2014 Visionary Wild Colorado River Rafting photography workshop, our group gathered in a circle of chairs on the sandy beach. I was acutely aware of how badly idiopathic pulmonary fibrosis had compromised my lungs. I knew my condition had worsened but I didn't realize how much the workshop participants knew.

The wind was howling, we had finished a sumptuous dinner, and we were passing several flasks and savoring the canyon. The group had witnessed my decline and they knew this was my last river trip. In spite of sand ripping through our exposed camp, we began a conversation about why we photograph. I began by telling how photography is my personal way to tell stories about the land. I went on about the power of images to shape opinions and advocate for change. There were many long pauses and I could see deep concentration around this circle of people who had come from all walks of life. Some were captains of industry.

There were doctors, a venture capitalist, some scientists, a systems engineer, and even a retired Navy officer. As the libation loosened their tongues, my friend Daniel Beltrá began to speak.

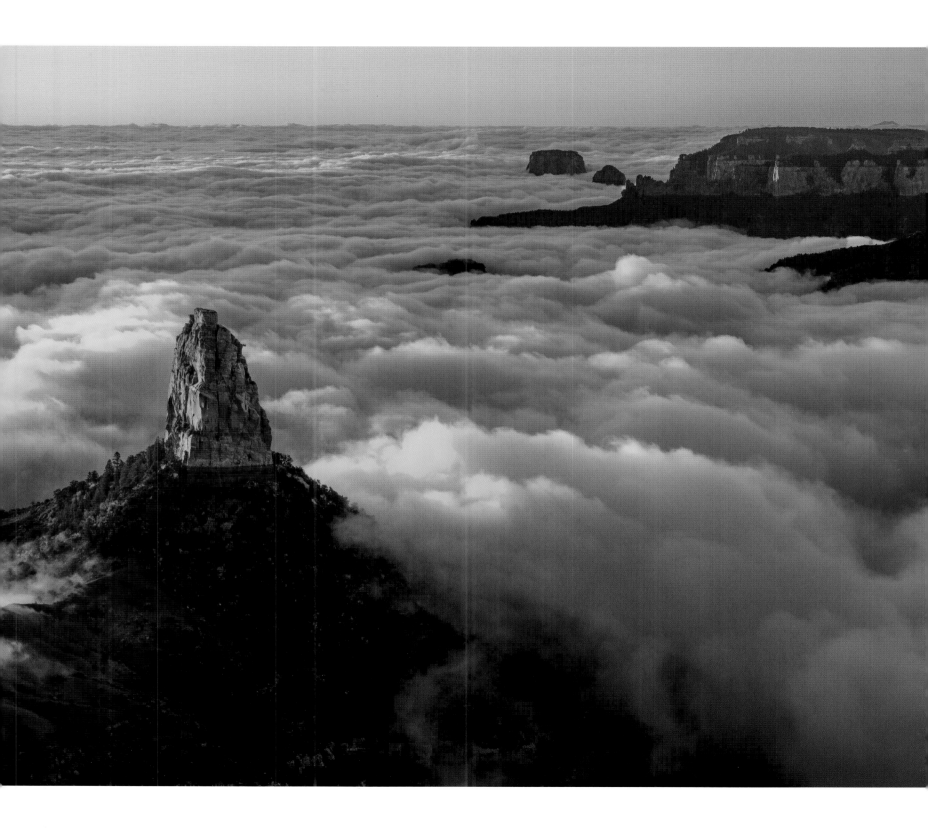

Daniel is a photographer whose work with Greenpeace gained him considerable notoriety for his searing images of the BP oil spill in the Gulf of Mexico. He echoed my words and explained his experience with the power of images.

Again, there was a long pause and flasks made their rounds. One by one, each person expressed in heart-felt terms the importance of creating images. Suddenly, huge men were sobbing. It seems we had tapped into something very powerful. As each person continued their personal story, the raw emotions were in plain sight. Many tears were shed, and Daniel and I nervously eyed each other . . . not sure what we had unleashed. Justin Black remained deep in thought. Something profound was occurring.

We humans need the creative side to feed our soul. We need the bond with others. The emotions poured as freely as the liquor among this group of strangers who had become united in the quest of wildness and exquisite light. Men and women alike were fused together by the simple act of sharing feelings about creativity. It was a joyous celebration of tears.

The night brought increased winds and blowing sand. I pushed deeper into my sleeping bag in a futile effort to avoid the onslaught. By morning my moans awakened Paul Hinton and Jim Matiko. My lungs were damaged beyond repair.

Now, two years later, with that horrible time of surgeries behind me and with new lungs pumping out 98% oxygen, the memory of how strangers bonded in a celebration of love, kindness, and creativity still burns in my consciousness.

It's tough to be flexible in the face of constant technological changes. Yet as I age, I know it is more important than ever to maintain an open, curious mind. I believe the images I'm producing now are at the highest level. One of the startling things I noticed in preparing images for this book was the increased numbers of images that have a "spiritual" feeling, with the camera's angle slightly tilted skyward. It's not something I can really quantify. Could my work now be infused with a deeper, stronger, more passionate sense of gratitude?

Perhaps.

About the Author

Jack Dykinga's photographic style blends fine art photography and documentary photojournalism. He won the Pulitzer Prize in 1971 for Feature Photography, and is a regular contributor to *Arizona Highways* and *National Geographic* magazines. He has published nine wilderness advocacy books, including *Frog Mountain Blues, The Sonoran Desert, Stone Canyons of the Colorado Plateau,* and *Desert: The Mojave and Death Valley.* He also authored and photographed *Large Format Nature Photography,* a guide to color landscape photography. Other books include *ARIZONA,* a compilation of Dykinga's best Arizona images, and *IMAGES: Jack Dykinga's Grand Canyon,* which reflects his love for this fantastic location.

Dykinga's fine art images have been displayed at the Center for Creative Photography, and the Museum of Northern Arizona. They were also featured along with the work of Ansel Adams in an *Arizona Highways* retrospective at the Phoenix Art Museum. In April 2010, the International League of Conservation Photographers selected Jack's image, *Stone Canyon,* as one of the forty best Nature Photographs of all time. He also received the Outstanding Photographer of the Year Award from the Nature Photographers of North America in 2011. And Jack was recently named by *Outdoor Photography* magazine as one of the 40 most influential nature photographers.

Jack has donated his talents to the International League of Conservation Photographers' RAVEs (Rapid Assessment Visual Expeditions) in Mexico, Chile, Canada and the U.S. At each RAVE, Jack joins teams of celebrated photographers from all over the world to highlight potential environmental degradation.

Shortly before sending this book to print, it was announced that Jack would be the 2017 recipient of the prestigious Lifetime Achievement Award in Nature Photography from the North American Nature Photographers Association (NANPA). The award will be presented to Jack in March 2017.

Jack and his wife, Margaret, live in Tucson, Arizona.

Appendix

Technical Information

Page iii Utah Juniper at Sunrise – Grand Staircase-Escalante National Monument, Utah – 2016
Nikon D810, Sigma 24mm Art lens, f/16, 1.6 sec., ISO 64

Page 22 Dixon State School – Dixon, Illinois – 1970
Leica M4, 35mm Summicron lens, f/4.0, 1/125 sec., Tri-X film, ISO 1200, © Chicago Sun-Times

Page 23 Dixon State School – Dixon, Illinois – 1970
Nikon F2, 85mm lens, f/2.8, 1/125 sec., ISO 1200, Tri-X film, © Chicago Sun-Times

Page 24 Dixon State School – Dixon, Illinois – 1970
Leica M4, 21mm Super-Angulon lens, f/5.6, 1/60 sec., Tri-X film, ISO 1200, © Chicago Sun-Times

Page 25 (top) Dixon State School – Dixon, Illinois – 1970
Nikon F2, Nikkor 180mm lens, f/2.8, 1/125 sec., Tri-X film, ISO 1200, © Chicago Sun-Times

Page 25 (bottom) Dixon State School – Dixon, Illinois – 1970, Nikon F2, 85mm lens, f/4.0, 1/125 sec., Tri-X film, ISO 1200, © Chicago Sun-Times

Page 26 Cabrini Green Projects, Chicago, Illinois – 1968
Nikon F, Nikkor 300 lens, f/11, 1/500 sec., Tri-X film, ISO 800, © Chicago Sun-Times

Page 28 Buyer's League Evictions – Chicago, Illinois – 1970, Nikon F, Nikkor 180mm lens, f/11, 1/250 sec., Tri-X film, ISO 1200, © Chicago Sun-Times

Page 29 Contract Buyer's League – Chicago, Illinois – 1970
Nikon F, Nikkor 180mm lens, f/8.0, 1/250mm, Tri-X film, ISO 1200, © Chicago Sun-Times

Page 30 Buyer's League Protests – Chicago, Illinois – 1970
Leica M4, 35mm Summicron lens, f/11, 1/500 sec., ISO 1200, Tri-X film, © Chicago Sun-Times

Page 31 Contract Buyer's League – Chicago, Illinois – 1970
Nikon F, Nikkor 85mm lens, f/11, 1/500 sec., Tri-X film, © Chicago Sun-Times

Page 32 Grant Park, Chicago, Illinois – November 1971
Leica M4, Elmarit 90mm lens, f/11, 1/500 sec., ISO 800, Tri-X film

Page 40 Mothers of Two Classes – Mexico City, Mexico – 1978, Nikon F2, Nikkor 200mm lens, f/8, 1/500, Tri-X film, ISO 1200, © Arizona Daily Star

Page 42 Tarahumara Indians – Sisoguichi, Mexico – 1981
Leica M4, 35mm Summicron lens, f/2.8, 1/60 sec., Kodachrome 64 film, ISO 64

Page 43 Oaxaca, Mexico – 1978
Leica M2, 35mm Summicron lens, f/8.0, 1/125 sec., ISO 1200, Tri-X film, © Arizona Daily Star

Page 44 Tohono O'Odham (formerly Papago Reservation) Arizona – 1977
Nikon F3, Nikkor 180mm lens, f/8, 1/500 sec., Kodachrome 64 film

Page 49 Saguaro National Park, Arizona – May 1991
Toyo Field camera, Nikkor 75mm lens, f/39, 4 sec., Fuji Velvia film, ISO 50

Page 50 Saguaro Cacti on Snow – Santa Catalina Mountains, Arizona – December 1987
Wista DX-II Field camera, Schneider Symmar 210mm lens, f/45, 4 sec., Fujichrome film, ISO 50

Page 51 Saguaro National Park, Arizona – January 1987
Wista DX-II Field camera, Nikkor 120mm lens, f/39, 1 sec., Fujichrome film, ISO 50

Page 52 Sand Verbena on Pinta Sands – Cabeza Prieta National Wildlife Refuge, Arizona – February 2004
Arca-Swiss F-Field camera, Schneider 110mm Super Symmar lens, f/49, 6 sec., ISO 50, Fuji Velvia film

Page 53 Yucca – Buenos Aires National Wildlife Refuge, Arizona – June 1990
Toyo Field camera, Schneider APO HM 120mm lens, f/45, 4 sec., Fujichrome film, ISO 50

Page 54 Saguaro Cacti with Volcanic Mount Pinatubo's Ash Creating Lurid Sunset – Cabeza Prieta National Wildlife Refuge, Arizona – November 1991
Toyo Field camera, Schneider APO Symmar lens, f/39, 4 sec., ISO 50, Fuji Velvia film

Page 55 Saguaro Cactus Detail – Cabeza Prieta National Wildlife Refuge, Arizona – March 2003
Arca-Swiss F-Field camera, Schneider APO Symmar 210mm lens, f/45, 4 sec., Fuji Velvia film, ISO 50

Page 56 Boulders at Dawn – Joshua Tree National Park, California – April 1989
Toyo Field camera, Rodenstock Sironar S APO 150mm lens, f/32, 4 sec., ISO 50, Fuji Velvia film

Page 58 Cholla Cactus – Kofa Mountains, Kofa National Wildlife Refuge, Arizona – February 1989
Wista DX-II Field camera, Nikkor 75mm lens, f/45, 4 sec., Fujichrome film, ISO 50

Page 59 Playa at Sunrise – Willcox Playa, Arizona – November 1987
Wista DX-II Field camera, Nikkor 75mm lens, f/39, 2 sec., ISO 50, Fuji Velvia film

Page 60 Joshua Forest Parkway Lightning – Joshua Tree National Park, Arizona – March 1988
Wista DX-II Field camera, Nikkor 210mm lens, f/16, 30 sec., Fujichrome film, ISO 50

Page 61 Croton Growing on Kelso Dunes – Mojave National Preserve, California – March 1997
Toyo Field camera, Schneider APO Symmar HM 120mm lens, f/39, 4 sec., Fuji Velvia film, ISO 50

Page 62 Boojum Silhouetted at Sunset – Desierto Central, Baja California, Mexico – September 1998
Toyo Field camera, Nikkor SW 120mm lens, f/22, 6 sec., Fujichrome film, ISO 50

Page 63 Boojum Silhouette – Desierto Central, Baja California, Mexico – March 1991
Toyo Field camera, Schneider APO Symmar HM lens, f/39, 3 sec., ISO 50, Fuji Velvia film

Page 64 Boulder Field – Desierto Central, Baja California, Mexico – February 1990
Wista DX-II Field camera, Nikkor SW120mm lens, f/39, 5 sec., Fuji Velvia film, ISO 50

Page 65 Boojum in Coastal Fog – Desierto Central, Baja, Mexico – February 1990
Toyo Field camera, Schneider APO Symmar 210mm lens, f/55, 8 sec., ISO 50, Fujichrome film

Page 66 Phacelia and Agave – Anza Borrego State Park, California – March 1992
Toyo Field camera, Schneider APO HM 120mm lens, f/32, 6 sec., Fuji Velvia film, ISO 50

Page 67 Cardon Cactus Looking Down from Above – Puerto Lobos, Mexico – March 1989
Wista DX-II Field camera, Nikkor 120mm SW lens, f/39, 3 sec., Fujichrome film, ISO 50

Page 68 Saguaro and Brittlebush – Sierra Pinacate, Mexico – March 1988
Wista DX-II Field camera, Nikkor 360mm lens, f/39, 2 sec., ISO 50, Fujichrome film

Page 69 Tres Virgenes, Baja Sur California, Mexico – January 1989
Wista DX-II Field camera, Schneider APO Symmar HM lens, f/50, 5 sec., Fujichrome film, ISO 50

Page 71 Agave – Baja California, Mexico – August 1988
Toyo Field camera, Fujinon 400mm lens, f/45, 1 sec., Fujichrome film, ISO 50

Page 72 Sea of Cortez, Loreto Channel, Baja Sur California, Mexico – February 1990
Wista DX-II Field camera, Nikkor 75mm lens, f/39, 8 sec., Fujichrome film, ISO 50

Page 77 Bridalveil Falls in Fog – Yosemite National Park, California – January 1998
Toyo Field camera, Schneider G-Claron 240mm lens, f/45, 12 sec., converted to B&W, Fuji Astia film, ISO 100

Page 79 Limber Pine with Snow – Bryce Canyon National Park, Utah – February 1999
Arca-Swiss F-Field camera, Schneider Super Symmar 80mm lens, f/45, 4 sec., Fuji Velvia film, ISO 50

Page 80 Aspen Grove – Boulder Mountain, Utah – October 2014
Nikon D810, Nikkor 500mm lens, f/14.0, 2.5 sec., ISO 64, 6-exposure composite

Page 83 (top) North Canyon, Grand Canyon National Park, Arizona – September 2005
Arca-Swiss F-Field camera, Rodenstock Sinonar S 180mm lens, f/32, 12 sec., Fuji Velvia film, ISO 50

Page 83 (bottom) Little Colorado River Confluence, Grand Canyon National Park, Arizona – May 2000
Arca-Swiss F-Field camera, Schneider Super-Symmar lens, f/45, 12 sec., Fuji Velvia film, ISO 50

Page 84 Petrified Forest National Park, Arizona – February 1986
Wista DX-II Field camera, Nikkor 210mm lens, f/32, 4 sec., Fujichrome film, ISO 50

Page 85 North Kaibab, Grand Canyon, Arizona – October 1990
Arca-Swiss F-Field camera, Nikkor 300mm lens, f/45, 5 sec., Fuji Velvia film, ISO 50

Page 86 Del Norte Redwoods State Park, California – May 2000
Arca-Swiss F-Field camera, Schneider APO Symmar 180mm lens, f/13, 20 sec., ISO 50, Fuji Velvia film

Note: As a large-format landscape photographer, I have always been interested in the detail within the landscape that large-format files provide. Since my conversion to digital I apply the same ethos, and my method for achieving incredible detail utilizes tilt/shift lenses for their ability to "shift" side-to-side on the optical plane. I also use prime lenses from Nikon and Sigma to capture image files with amazing resolution. I am then able to stitch together several exposures in Lightroom's Panorama mode, and I can create final image files that equal the quality I have achieved using my 4×5 view camera.